SUFFOLK COUNTY, LONG ISLAND

IN EARLY PHOTOGRAPHS
1867-1951

BY

Frederick S. Lightfoot

Linda B. Martin

Bette S. Weidman

DOVER PUBLICATIONS, INC.
New York

ACKNOWLEDGMENTS

This book was conceived by Frederick S. Lightfoot, a Long Island historian and owner of the Lightfoot Collection, who is also the author of *Maritime New York in the Nineteenth Century* (with Harry Johnson; Dover 23963-2) and *Nineteenth-Century New York in Rare Photographic Views* (Dover 24137-8). After the original manuscript was submitted, the publisher decided that the material contained was of such interest that it warranted enlarging the book. Accordingly, Linda B. Martin and Bette S. Weidman, authors of *Nassau County, Long Island, in Early Photographs* (24136-X), collaborated with Mr. Lightfoot in securing additional photographs and writing captions. Mr. Lightfoot's specialized knowledge of past maritime and industrial activity in Suffolk County dovetailed well with Ms. Martin's and Ms. Weidman's knowledge of social history, resulting in the present volume.

The task of collecting pictures from so many sources would have been impossible without the generous assistance of many people. Special thanks are due Wallace Broege, director, and Betty Carpenter, librarian, of the Suffolk County Historical Society; Edward J. Smits, director, and Richard Winsche, historian, of the Nassau County Museum; Davis Erhardt, former librarian, of the Long Island Division of the Queens Borough Public Library; Jerry McCarthy, archivist, of the Stirling Historical Society; Mitzi Caputo of the Huntington Historical Society; Elodie Dibbins and Seth Purdy, Jr. of the Amityville Historical Society; Carole Bloomgarden of the Greenlawn-Centerport Historical Society; and Dorothy King of the East Hampton Free Library. Individuals who contributed pictures include Louis Black, Viola Campbell, Helene Gerard, Miriam Hartley, Vincent Quatroche, Mrs. Max Reutershan, the late David Rothman, and Ron Ziel. Ron Ziel also made prints from difficult glass plates. Ray Jacobs accomplished the photographic reproduction required for the Korten images.

Lois Tyte DeWall and Wesley Balla of the Suffolk County Historical Society helped with information, as did Jeff Kassner of the Department of Environmental Conservation at Patchogue, William Howe of the Patchogue-Medford Library, Leila Mattson of the Great Neck Library and staff at the Suffolk County Marine Museum.

Credit must also be given to the countless men and women whose researches and writing have preserved and organized the historical data which are indispensable for a book of this type, and to the rarely acknowledged individuals whose sound instincts and alertness saved the Fullerton negatives and other images from careless destruction.

Published in Canada by General Publishing Company, Ltd., 30 Lesmill Road, Don Mills, Toronto, Ontario.
Published in the United Kingdom by Constable and Company, Ltd.

Suffolk County, Long Island, in Early Photographs, 1867–1951 is a new work, first published by Dover Publications, Inc., in 1984.

Manufactured in the United States of America
Dover Publications, Inc., 31 East 2nd Street, Mineola, N.Y. 11501

Book design by Carol Belanger Grafton

Library of Congress Cataloging in Publication Data

Lightfoot, Frederick S.
　Suffolk County, Long Island, in early photographs, 1867–1951.

　Includes index.
　1. Suffolk County (N.Y.)—Description and travel—Views.　2. Suffolk County (N.Y.)—History—Pictorial works.　I. Weidman, Bette S.　II. Martin, Linda B.　III. Title.
F127.S9L53　1984　　　974.7'25042　　　83-20563
ISBN 0-486-24672-8

INTRODUCTION

Eastern Long Island has been seen in very different ways by the people who have lived or visited there in the past, but the men and women who took their cameras sixty to ninety years ago to photograph its land and waters clearly saw it as an area of rare natural beauty, dotted with charming old villages and offering countless picturesque scenes of the workplaces of inhabitants who staunchly preserved traditional ways of life in farming and fishing.

Preceding these camera artists—and as far back as the 1850s, when some commercial photographers took daguerreotypes and ambrotypes of outdoor scenes—the approach to recording the island was primarily utilitarian. There are proprietary photographs of individual homes, stores and hotels, and scenes taken along the trackage of the Long Island Rail Road which give us some insight into the past, but as a rule they lack compositional grace and fall far short of the images we long for. We cannot, for example, learn what the docks of Sag Harbor looked like when a fleet of whaling ships was tied up at them.

It was not until the 1890s that a host of amateurs, taking photographs for their own amusement, and a number of gifted local photographers, producing pictures for sale to tourists, took advantage of the ease of working with improved dry plates to turn out a flood of images with a pictorial approach. This flood became a deluge with the advent of the picture postcard in 1898 and special cameras designed for its format. Everything thought worth photographing, and a great deal that really was not, ended up on prints which were sent to the publishers of cards, most of them in Germany.

Many of the finest pictures of this period were taken by Hal B. Fullerton, who was hired as a special agent for the Long Island Rail Road to provide the illustrations for a long series of pamphlets boosting Long Island for tourism. Using 5″ × 7″ and 11″ × 14″ glass plates, he assembled a file of images which, in its scope, size and quality, stands unrivaled for Long Island iconography.

Important work was also done by a number of capable local commercial photographers, including Feather, Gildersleeve and Ben Conklin of Huntington, Greene of Port Jefferson and Howard Conklin of Patchogue. Frank Hartley of Greenport, L. Vinton Richard of Orient, Jonas Newton of Stony Brook and others who worked in photography as a sideline are worthy of note and respect, as are some of the anonymous artists whom we know only through their pictures.

The major commercial photographers mentioned above were located in the larger villages of the county because taking family portraits was the bread-and-butter work of the average studio and the villages were where that business had to be carried on. Taking pictures for tourists had to be fitted into slack periods and generally was limited to the photographers' home territories, although Greene, who counted on postcards for a fair share of his income, ventured over a wide stretch of the North Shore.

The most extensive coverage of Long Island by a single postcard photographer is found in the work of Henry O. Korten, a resident of Sea Cliff, who advanced from being a postcard salesman to the more creative role of taking pictures himself and arranging to have them printed in Germany for sale to local stores. The best of his images are excellent documentary studies.

The well-known photographic firm of Underwood & Underwood assigned some of its staff to take photographs of the island as far out as Amagansett. The negatives were used to print both postcards and stereographs but, for some unknown reason, the sale of their beautiful prints was not aggressively pushed and they are therefore rarely encountered.

It was generally true for all the postcard photographers that their most effective work was done in the larger villages where concentrations of business and industry presented striking street and harbor views. The small hamlets often had but a few scattered buildings of little pictorial interest, and it might be but a single building, small landing or old mill that would catch the photographer's eye.

Following a pattern that had been set by their predecessors in the graphic arts, the photographers on eastern Long Island sought pleasing compositions that emphasized the beauty or picturesque character of their subjects. They were seldom imbued with the desire to record the "quality of life" images that some urban camera work of the same period offers. There is little or no intention of social commentary in Suffolk work.

The photographs for this book have been selected from the many thousands available with the desire of telling what life was like in Suffolk County in the period from 1890 to 1920, using the finest images possible. A few earlier and later images are samples of what went before or followed. While each illustration has an explanatory text, the overall setting may be better understood by a reading of the following brief account of how Suffolk County developed, from the time of its first European settlement up to World War II.

A BRIEF HISTORY OF SUFFOLK COUNTY

The original European settlers of Suffolk County (formed in 1683) were primarily of British stock, although some overflow from Dutch settlements in Manhattan and Brooklyn reached the western part of the county. After receiving grants of land from the British Crown and making whatever negotiations with the native Indian occupants of the land were advisable, the leaders of the colonists gradually subdivided the land, although some huge parcels, of which Gardiners Island is the most notable survivor, were kept intact in the possession of a single family. In the organized towns, land was distributed for individual homesteads and farms, but considerable acreage was reserved for common uses, such as grazing cattle and harvesting salt hay.

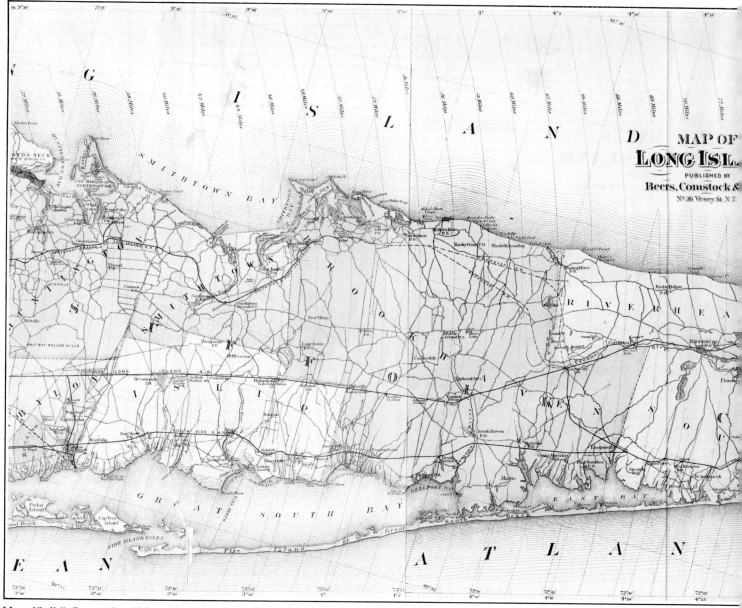

Map of Suffolk County, from *Atlas of Long Island, New York*, published by Beers, Comstock & Cline, New York, in 1873.

Eastern Long Islanders had the best of two worlds. Like New Englanders, they made money from the vast quantities of fish, shellfish and whales that were within easy reach of shore. Like the Virginians, they had rich soil and a moderate climate that enabled them to engage profitably in farming. Wheat and corn were their staples; flax and tobacco were produced for export. Huge herds of cattle and flocks of sheep provided meat, hides and wool for the farmers' own needs; a large surplus was sold. Salt cod and whale oil from their fisheries also were important trading commodities.

The merchants who sold Suffolk produce in Connecticut, Manhattan, the West Indies and occasionally to England often became wealthy despite grievous losses of cargo and ships to the sea, pirates and privateers. Their vigorous enterprise supported the men who sailed their vessels and those who were engaged in building ever-larger sloops and other craft for their shipping. And, of course, some of their profits paid for the work of men who built handsome houses for their families and for the local production of fine furniture by such craftsmen as the Dominy family.

Smuggling was common, as it was in New England, thanks to the crippling economic restrictions which the British government tried to impose on the colonies. A number of merchants also participated in the slave trade, bringing some of their captives to Long Island for sale. These slaves were freed early in the nine-teenth century; some intermarried with the dwindling population of Indians and, as recent research has shown, besides becoming farmers on their own, some of them played a significant role in whaling and other fisheries.

Although Suffolk County suffered severely from the depredations of British troops stationed on the island during the Revolution, it recovered quickly when independence was won. Skills learned in the shore whale fishery were transferred to offshore whaling, and Long Island ships ventured around Cape Horn to the whaling grounds of the far Pacific. The ports of Sag Harbor, Greenport and Cold Spring Harbor were especially enriched by this relatively short-lived episode of our marine past, while the shipyards at Greenport, Port Jefferson and Northport, once busied by building or repairing whalers, enhanced their prosperity by launching a remarkable number of vessels of all sizes for local fisheries, coastal trade and yachting.

The opening in 1825 of the Erie Canal, which brought cheap corn and grains from the fertile lands of the Midwest, gradually forced Long Island farmers to switch to other crops, with the emphasis on vegetables and fruit. However, wind-, water- and a few steam mills for grinding local grains and corn were operated as late as 1919. Meanwhile, the growth of New York City, accelerated by the business generated by the Erie Canal and the rise of the city's port, created a tremendous market for Long Island's garden crops, fresh fish and shellfish, firewood, sand and gravel.

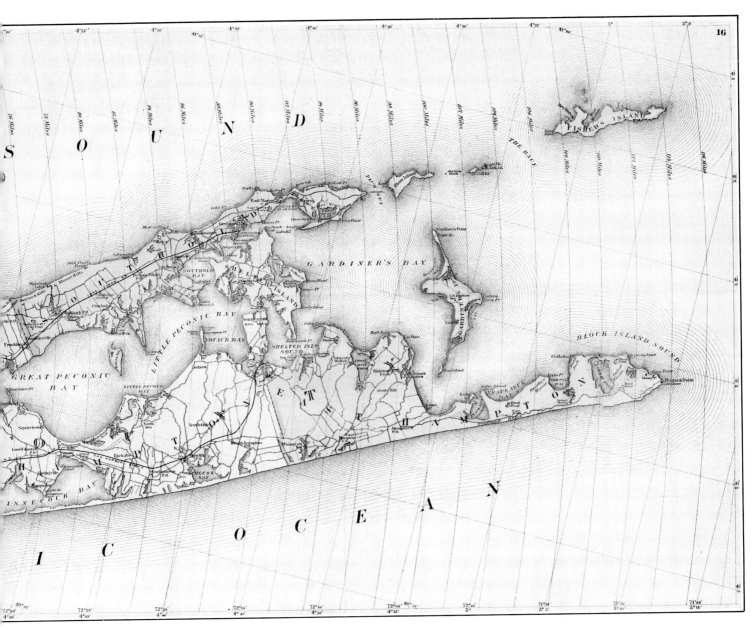

Expansion of the island's fisheries was relatively easy; only a tiny portion of the tremendous schools of fish that swam around the island had thus far been harvested. On the other hand, depletion of natural beds of oysters, once thought to be inexhaustible, necessitated their organized culture. The whale fishery declined in mid-century, but was soon replaced by a huge, though less romantic, "bunker" fishery which eventually employed thousands of men in the capture and processing of the mossbunker (menhaden). This oily fish once filled all the bays in season with schools of almost incalculable size; it supplied the raw materials for fertilizer and cheap paint.

In the Long Island pine barrens hundreds of men cut cordwood for fuel. Besides what was used locally and in the city for heating buildings, fantastic quantities were consumed in the brickyard kilns of the island and of the Hudson River communities.

All this business demanded more and better transportation. Unfortunately, the entrepreneurs who had built the main line of the Long Island Rail Road were not thinking of the potential freight to and from the island's villages, farms and fish docks but were intent only on running tracks by the shortest route possible between Brooklyn and Greenport. The reason for this was that they counted on holding a very profitable government contract for carrying the "Great Mail" from New York to Boston by a combination of rail to Greenport and steamboat from Greenport to Connecticut. Although no through trackage along the difficult Con-

necticut coast was built for some years, the Long Island Rail Road still lost its contract when the government got a better deal for a different steamboat–rail route. It then found itself with a strictly local railroad going down the center of the island where hardly anyone lived! This forced the line into receivership and the abandonment of its links with steamboats from Greenport. Although the economic growth of the island was hampered for many years by this turn of events, other companies were organized to build railroads along the shore communities. The eventual consolidation of these lines with the Long Island Rail Road under improved management produced a rail network with fairly robust financial health.

Water transportation by sailing vessel and later by steamboat played a very important part in the island's economy throughout the nineteenth century and, to a lesser degree, in the early twentieth. Because the geography of the island made it impossible for the railroads to come close to tidewater for locations like Huntington and Port Jefferson, where the old centers of business were close to the docks, water transportation to and from New York held a considerable advantage, especially for bulky materials.

The years after the Civil War were marked by the start of many new industries on the island. This helped induce new immigrants in New York to move to the island as well as to give older residents year-round employment. The fresh blood of Dutch, Scotch, Irish,

German, Italian, Polish and Jewish immigrants enlivened the island's economic and cultural life. Black and eventually Puerto Rican and other West Indian migrant workers came to the island for seasonal work on the farms, in fish-processing shops and in the sand and gravel works. They often decided to stay.

A significant tourist industry started quite early in the nineteenth century; it really prospered after the Civil War, when improved and more extensive rail and steamboat service made it easier to get out on the island in reasonable comfort. Superb trout fishing and gunning for birds attracted wealthy sportsmen who formed exclusive clubs on large tracts of land. Other early socialite vacationers devoted their time on the island to yachting.

A number of well-known artists who visited the East End in the 1870s wrote enthusiastic articles about its beauty in widely read periodicals. This spurred more people to explore the eastern reaches of the island, and a boom began in the construction of hotels and inns to cater to them, along with private summer homes of all sizes and prices. Golf, tennis and polo clubs followed. By 1900, hundreds of thousands of less-affluent newcomers had enjoyed day trips on the island, many of them carried to Suffolk on special trains that brought their bicycles along with them.

Real-estate developers enticed those who hoped to buy a permanent share in the island with a small pocketbook. Large parcels of land were carved up and offered in five-acre plots for as little as ten dollars an acre on easy terms. With a small cabin and the chance to do some gardening, fishing and swimming, a member of the lower middle class could achieve his dream of becoming a landowner, albeit in a sunbaked section of the pine barrens or on land imperiled by high tides.

The completion of the Long Island Rail Road tunnel under the East River facilitated commuting, turning parts of western Suffolk into "bedroom communities." Some commuters, tiring of the daily trip to the city, found ways to make a living where they lived. Others got jobs in research and experimentation projects when the invention of the modern submarine, radio and the airplane brought development companies out to the low-cost waterfront and large tracts of flat land available on the island. These early installations forecast the future industries of the island.

The prosperous decade of the 1920s saw new money pour into the county's tourism and real-estate schemes. Automobiles dropped in price and became so commonplace that long lines of Sunday drivers backed up on main roads in the summers. Many people who used to take the steamboats out to the Peconic Bay region now chose to drive out to their country residences, and long-distance trucks took away the steamboats' freight. And thus the steamboat lines died. However, the fisheries remained prosperous and unexpected if illicit wealth came to the few ports that harbored rumrunners.

The Depression of the 1930s impoverished the East End. Hard times depleted the fortunes of many of the families that either owned large estates on the island or frequented its more opulent hotels. Estates had to be sold for taxes in some instances. Others were held unused for years, while their buildings and grounds deteriorated, only to be sold in the end for redevelopment in smaller plots. The palatial hotels burned down or were abandoned and were not replaced, except by motels.

The hurricane of 1938 caused terrible damage to buildings and trees, and tore up the bay bottoms where oysters had been grown. Many important species of fish also began to decline in numbers from too many years of overfishing and other factors.

By the time World War II broke out, bringing prosperity to communities with important war-related contracts, Suffolk, no longer able to rely on its traditional fishing and farming to support its population, turned increasingly to manufacturing. Some factories were moved to Suffolk to evade the labor unions of New York, but the most durable and significant companies were those with higher-value specialties which would not be appreciably handicapped by the cost of shipping materials and components to Suffolk and finished goods back.

Although the flavor of old-time Suffolk can still be savored today in some places where change has been held at bay, often through the efforts of dedicated men and women who see what is left of rural Suffolk as a national treasure, the county, overall, abandoned its past in the 1940s.

FREDERICK S. LIGHTFOOT

Contents

VILLAGE LIFE

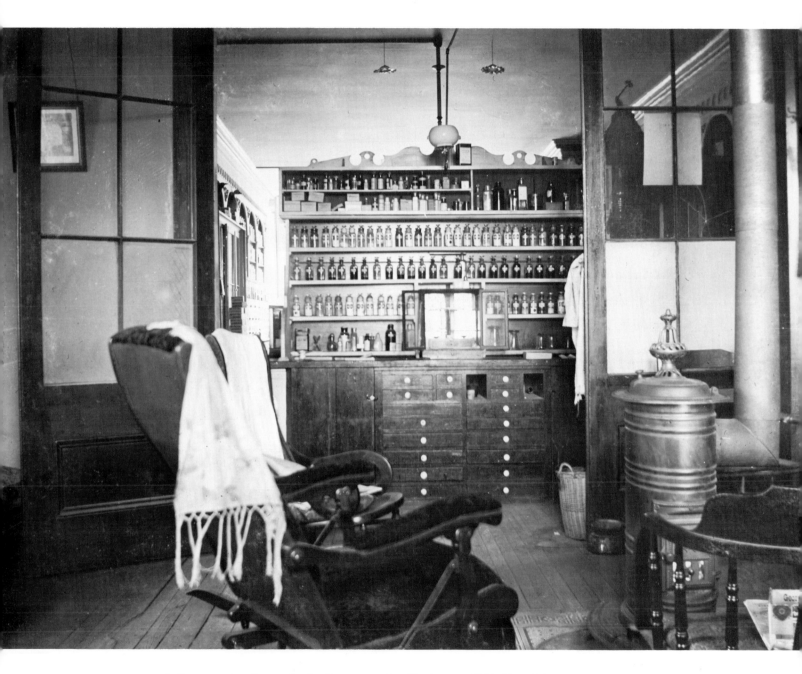

1. Conversation Center in the Drugstore, Sag Harbor, ca. 1900. Turn-of-the-century medicines were still not so far removed from the folk-cure remedies of Long Island colonists who used beaver oil, eel skin and snail water to cure their ailments. The years 1870–1900 were the height of the patent-medicine business, when every problem had its special elixir—from Egyptian Regulator Tea, said to bring "graceful plumpness" to flat-chested girls, or Rengo Medicine, which promised to turn flabby men's "fat into muscle," to Kickapoo Indian Salve for Scabby Scalps and Carter's Little Nerve Pills for "Nervousness and Dyspepsia." In addition to its medicines, the local drugstore also served as a community social center. Here, just as in many a country store or law office, chairs were gathered around the stove, ready for customers to share the latest gossip. *(Lightfoot Collection.)*

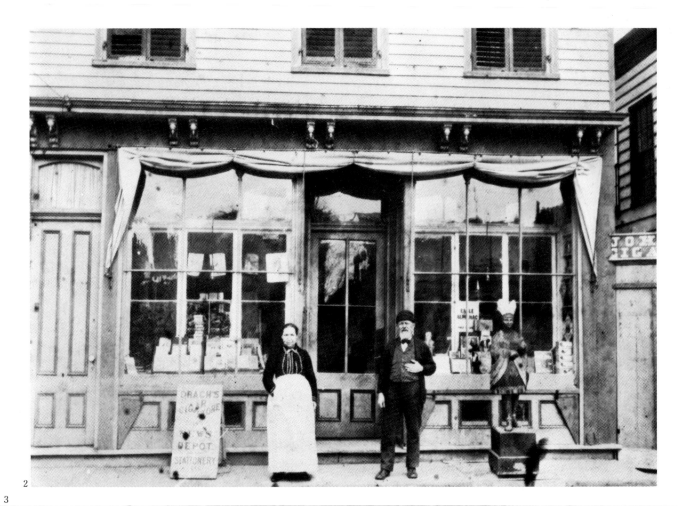

2

3

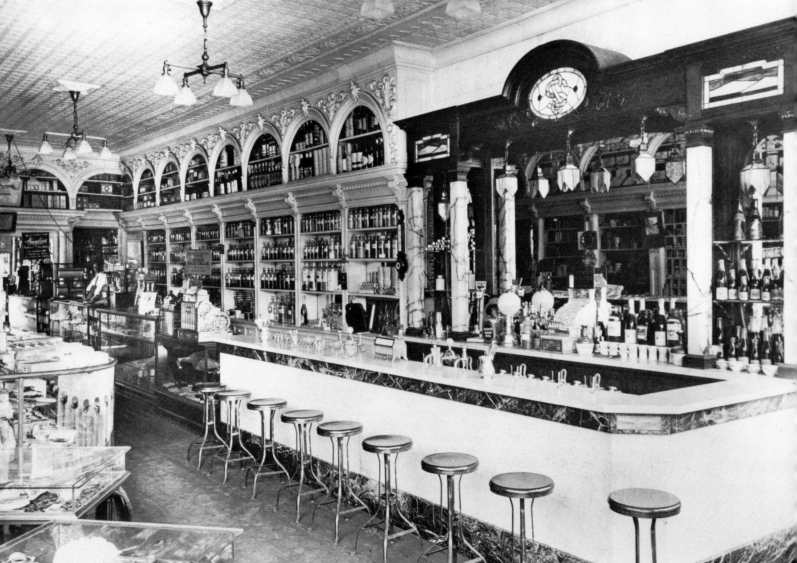

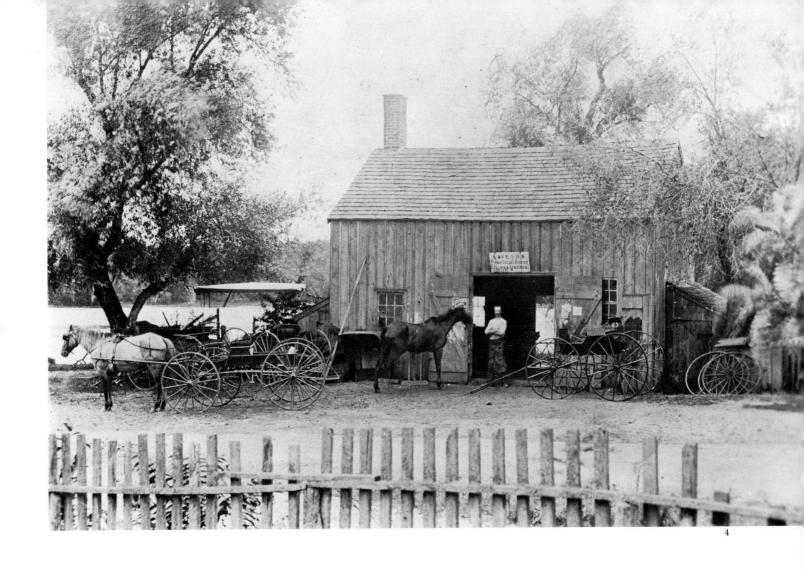

4

2. Drach's Cigar Store, Greenport, 1871. Mr. and Mrs. J. P. Drach pose alongside the handsome wooden Indian outside their store on Front Street. Mr. Drach, a German immigrant, ran Suffolk's first Lutheran Sunday school in his home behind the store. It is said that children who attended thought that the Indian was a religious symbol. Like the Drachs, many German immigrants settled in Suffolk County, forming such communities as Breslau and Bohemia. *(Collection of the* Suffolk Times.*)*

3. "Having a Soda Here, at Smith and Salmon's," Babylon, ca. 1910. Besides dispensing drugs, selling notions and offering conversation and sweets, drugstores displayed souvenir picture postcards. Capitalizing on the craze for postcards from 1905 to 1915 was Henry Otto Korten, an itinerant Sea Cliff photographer who traversed Long Island making glass-plate images which were then sent to Germany for reproduction as color postcards. Korten realized the advertising potential of these cards and especially sought out drugstore owners, such as Smith and Salmon, to publish and sell his work. The relationship was mutually beneficial, for through postcard views the drugstore could show off its neat and decorative interior, inducing customers to stop by, at least for a soda. *(Photograph by Henry Otto Korten; Nassau County Museum.)*

4. Blacksmith Shop of Alexander Iveson, Yaphank, ca. 1895. The skills of the blacksmith were essential for such tasks as shoeing horses, making and repairing farm tools and fashioning harpoons, clam rakes and eel spears for fishermen. Such specialized knowledge made the blacksmith an especially valuable member of the community. Liberal inducements were offered to attract men like Iveson, seen posing proudly in front of his shop ("Practical Horse Shoes & general Smith") located on the north side of the road east of Upper Lake. Blacksmiths were in such great demand that they were often given land on the condition that they remained in town for a specified period of time. *(Lightfoot Collection.)*

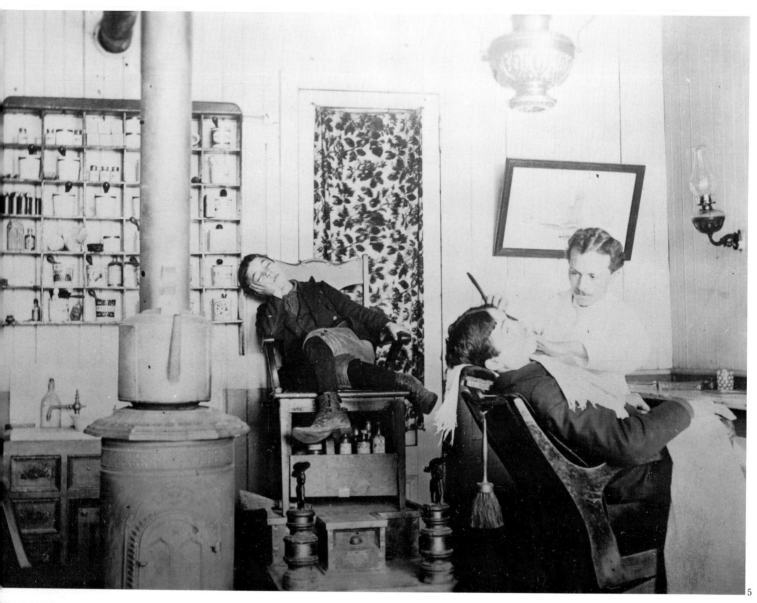

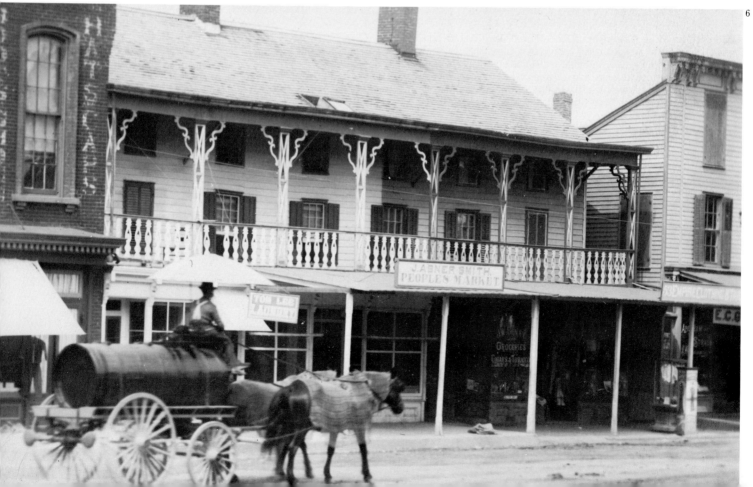

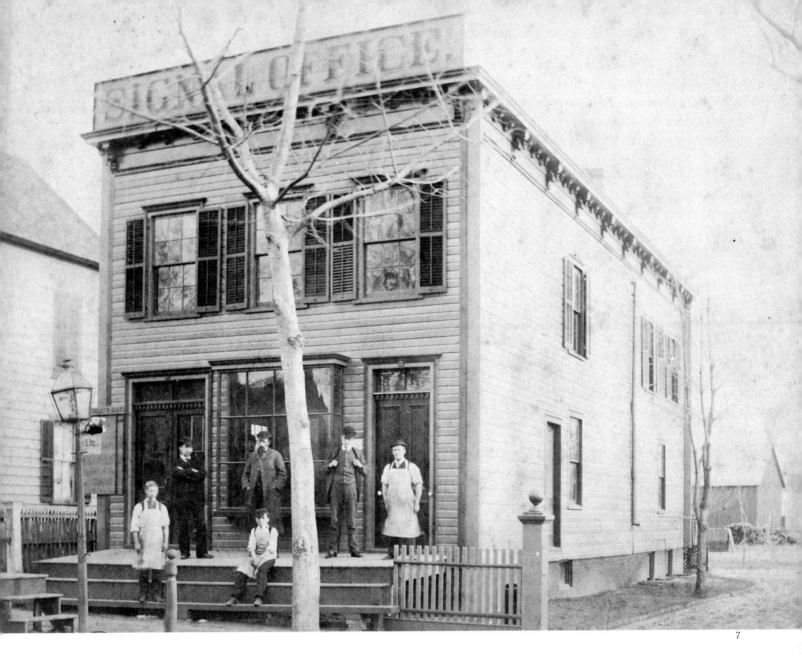

7

5. Sam Mazzo's Barbershop, Greenport, ca. 1900. The village barbershop was for centuries a center for the exchange of gossip and conversation. Barbers once practiced minor surgery, such as bloodletting. During the eighteenth century, it was common to see the sign "barber-chirurgeon" and the familiar red-and-white-striped pole (red represented spilled blood, white stood for bandages). Until the 1890s, when barbering schools were established, the barber's trade was acquired only by long apprenticeship. Here is a delightful image of a turn-of-the-century barbershop, one of the centers of town life for men. To the left of the boy drowsing in the shoe-shine stand is a typical rack for customers' personal shaving mugs. *(Stirling Historical Society.)*

6. Water Wagon, Huntington, ca. 1900. Prosperous villages often hired water wagons to wet the unpaved streets and rid them of annoying summer dust. Here, Sam Shadbolt sprinkles Huntington's busy commercial strip, known as the Empire Block. These shops, now gone, extended along the north side of Main Street from Wall Street to New York Avenue. In addition to buying dry goods, including boots, shoes, hats and caps, customers could bring items to the Tom Lee Laundry, shop at the Peoples Market owned by J. Abner Smith, or browse at the Empire Clothing & Tailoring Company, site of a small Abraham and Straus store. *(Photograph by Ben Conklin; Lightfoot Collection.)*

7. Office of *The South Side Signal*, Babylon, ca. 1890. Suffolk County had many well-prepared and long-lived newspapers, beginning with David Frothingham's *Long Island Herald*, which first appeared in 1791 at Sag Harbor. Founded by Henry Livingston, the *South Side Signal* (originally the *Babylon Budget*) published its first issue on July 7, 1869. It set a new trend in local journalism by being independent—not bound to any political party. One New York City editor described it as a "spicy country journal." Its popularity and interest were extended by assigning local editors to each village to report on weekly events. In 1870, it became the first newspaper in the country to print its issues with a steam press, an A. B. Taylor and Co. model. The newspaper passed out of family hands in 1910 and finally ceased publication in 1921. *(Lightfoot Collection.)*

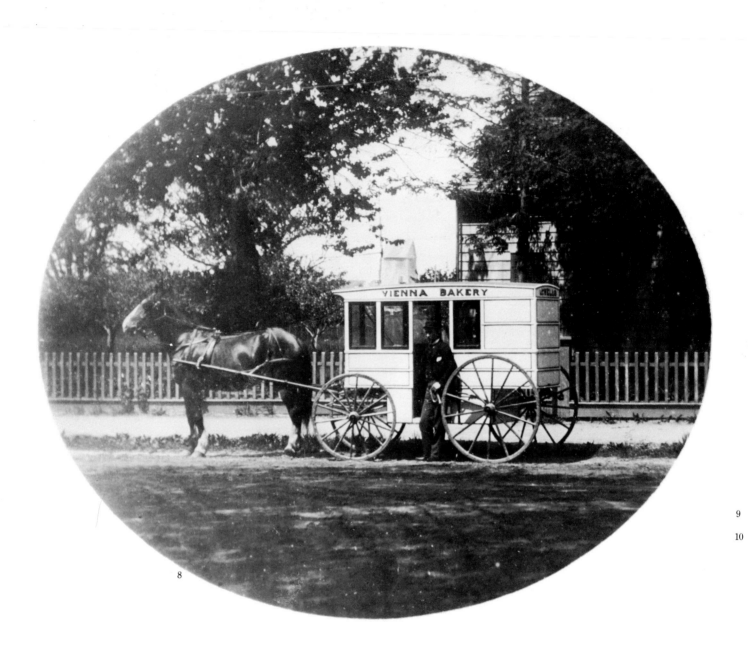

8

9

10

8. Vienna Bakery Wagon, Greenport, ca. 1905. Many food stores merchandised part of their wares by sending wagons down the village streets or onto the roads that connected the villages and hamlets. At least one day a week, wagons were circulated by the butcher, dairyman, fishmonger, produce seller and baker. Housewives who had no carriages or automobiles or could not drive appreciated this convenient way of shopping. It was traditional for the fishmonger to announce his arrival with a bugle call; the gentleman with horn in hand is proof that the Vienna Bakery adopted this practice as well. *(Stirling Historical Society.)*

9. Advertising Wagon of Johnson's Grocery, Patchogue, ca. 1905. Grocery stores, even those operated by the ubiquitous A&P chain, were mostly "mom and pop" size around 1900; a large village might have several, each serving a small neighborhood. This whimsical wagon advertising Johnson's Grocery in Patchogue is a most unusual sight. Perhaps it was a product of Wm. E. Ford's Carriage, Sign and Wagon Painting business standing behind it. *(Queens Borough Public Library, Long Island Division.)*

10. Gypsy Camp at East Lake, June 22, 1906. Peddlers and other itinerants were generally welcomed in Suffolk, especially because their arrival in spring marked the end of winter isolation. The notions peddler, who brought his pack to replenish the sewing table, often showed up with a wagon and opened a small shop in the village. The "tin-pan man" and chair peddler needed wagons to transport their wares. Organ grinders delighted the children with trained bears and monkeys, while knife sharpeners rang bells to attract customers to their heavy grinding wheels. Gypsies were a particularly colorful group, pitching their tents so the men could mend pots and the women tell fortunes. *(Photograph by Ben Conklin; Queens Borough Public Library, Long Island Division.)*

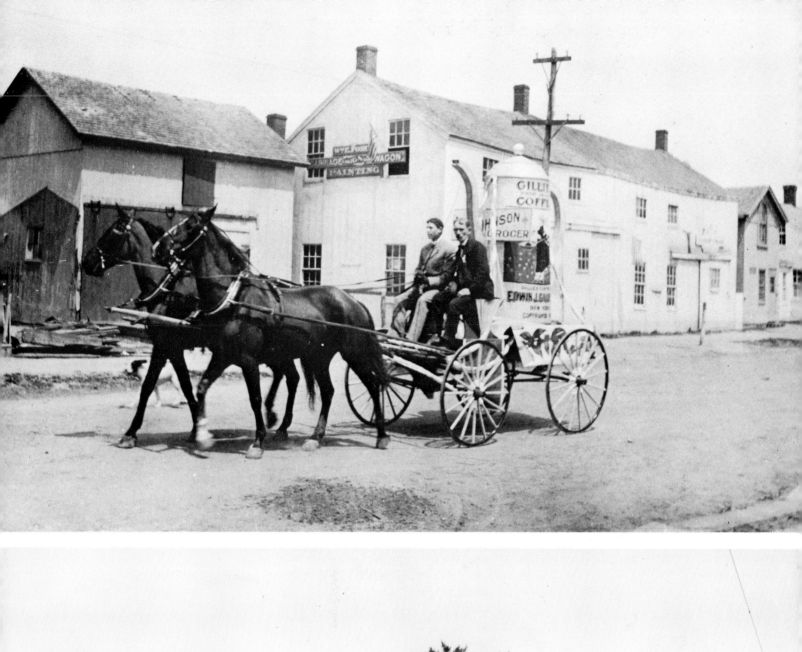

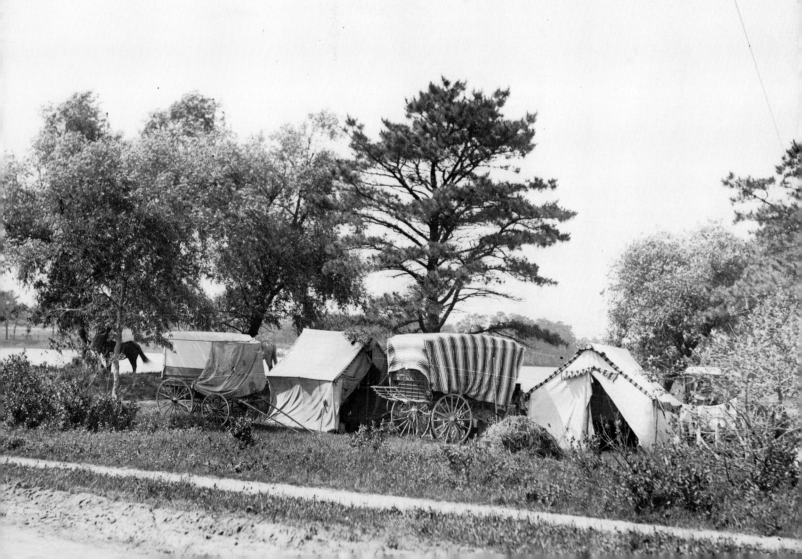

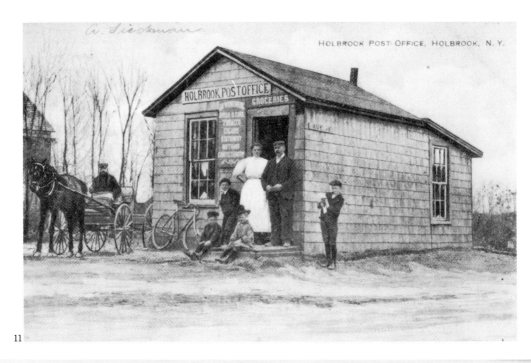

11

12

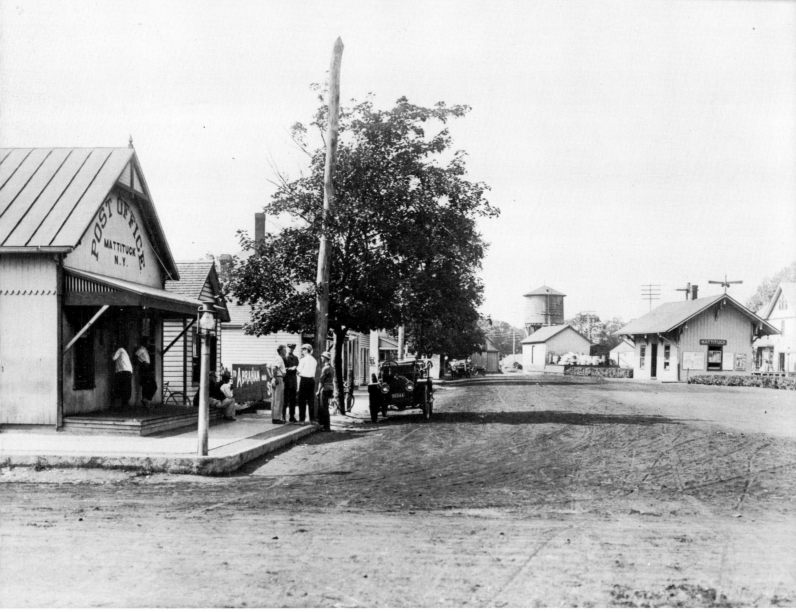

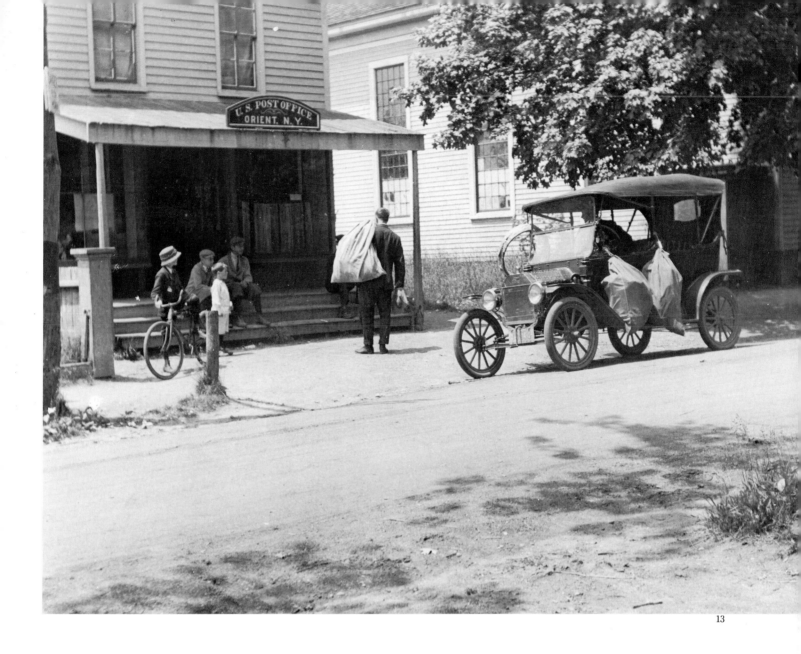

13

11. Post Office and General Store, Holbrook, 1910. Holbrook was a tiny hamlet started in 1848 as a development of 500 acres. By the 1860s it had its own school, church and fire department, but it remained a small farming community. Miss Adeline Siedeman mailed this image on a postcard to a friend in Brooklyn on July 16, 1910. From the Holbrook Hotel, she wrote: "I am having a nice time . . . this is where we get our mail." The little building pictured was also the local grocery—the place to buy bread and cake, tobacco and cigars, notions and confectionery. *(Lightfoot Collection.)*

12. Post Office and Depot, Mattituck, 1912. This view shows the close relation between railroad stations and post offices that was desirable in the days when the mails were delivered by rail. The railroad companies were responsible for hauling the bags of mail to the post offices if they were close enough to the depots. Otherwise a contract for the job generally had to be awarded to a local express company. At Mattituck, the post office at Pike Street was ideally located. *(Photograph by Henry Otto Korten; Nassau County Museum.)*

13. Mail Car at Post Office, Orient, June 2, 1916. Before the Revolution, private mail was delivered from New York to Long Island by a number of laborious routes. In 1844, daily mail was established by way of Greenport. By the time of this photograph, mail was being carried beyond Greenport by automobile. *(Photograph by L. Vinton Richard; Oysterponds Historical Society.)*

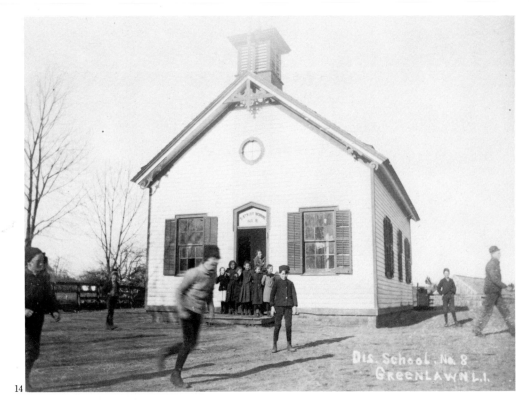

14

15

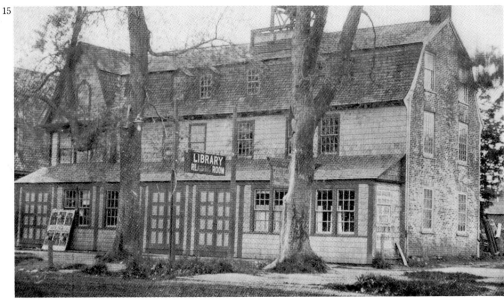

14. District School No. 8, Greenlawn, 1906. Stressing the "Bible, bench and birch," Suffolk County derived many of its early ideas on education from New England. Although school districts were formed in the early years of the nineteenth century, as late as 1838 schools consisted of a single drafty room, a few pine desks and a fireplace or cast-iron stove. Teachers were given room and board and paid in goods amounting to about $5–$7 a month. Greenlawn (then called Old Fields) had a school from about 1830, operating in a farmhouse. The school pictured here was built in 1873 on the east side of Huntington Road, west of Tilden Lane, at a cost of $1095—including desks. A single teacher served all eight grades. In 1909, the building was moved and a two-room schoolhouse, with two teachers, was built on the same site. Outgrown by 1924, it became the Broadway School. *(Lightfoot Collection.)*

15. Old Clinton Hall, East Hampton, 1917. One of the first and most important private schools on Long Island, Clinton Academy was founded in 1784 by Dr. Samuel Buell, an East Hampton pastor. Named for Governor George Clinton, who attended the opening ceremonies held in 1785, the school became, two years later, the first chartered academic institution in New York State. Enrollment swelled from an average of 80 to a record of 156 students in 1815. In that year, the academy boasted a classical library, telescope, microscope, air pump, quadrant, surveyor's compass and orrery. In the 1850s, with the increase in public schools, the number of patrons declined and by 1868 the academy ceased to report to the State Regents. In 1897, when the East Hampton Free Library was organized, it was located in the Clinton Hall annex on the north side of Main Street. Restored, remodeled and enlarged, the Old Academy now houses a museum operated by the East Hampton Historical Society. *(Lightfoot Collection.)*

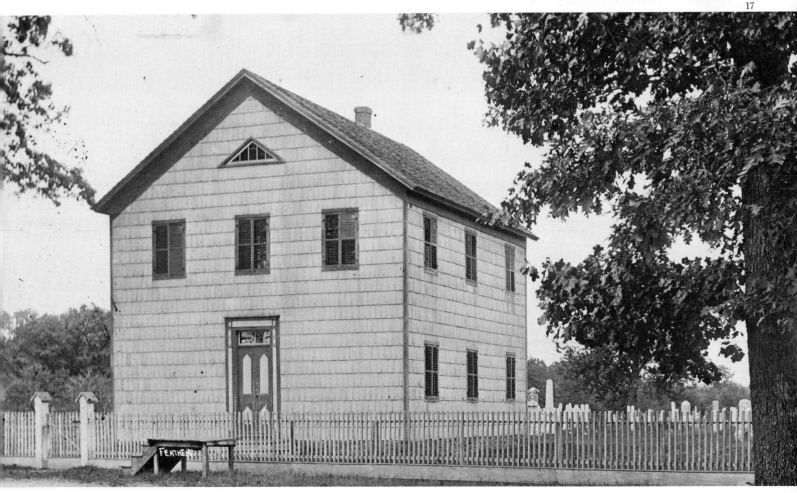

16. Whalers' Presbyterian Church, Sag Harbor, ca. 1905. Designed by the famous architect Minard Lafever and built in 1844, this Presbyterian church is one of the few surviving structures to document Sag Harbor's glorious whaling days. Ship's carpenters carved its beautiful interior trim by hand. The 1000-seat church, which incorporates Egyptian motifs into its remarkable design, is located on the south side of Union Street, one block east of Main Street. The landmark steeple fell in a 1938 hurricane. *(Lightfoot Collection.)*

17. Congregational Church, New Village, ca. 1907. With employment limited to cutting cordwood, making charcoal or working for the railroad, there was little affluence in the center of the island. The churches built there were small, yet, as this picture shows, not without the beauty of simplicity and good proportion. In such areas as New Village and Holbrook, churches often provided the only opportunities for enjoying music and social gatherings, especially during the winter months. *(Photograph by Thayer; Lightfoot Collection.)*

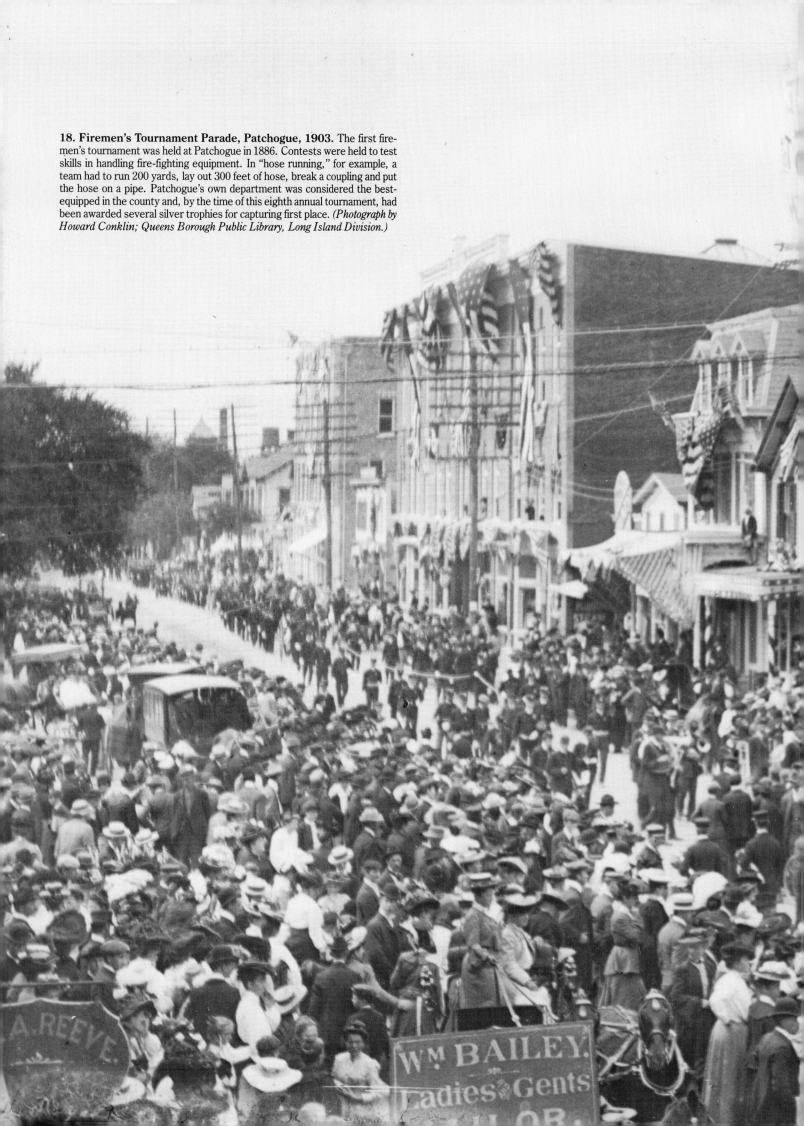

18. Firemen's Tournament Parade, Patchogue, 1903. The first firemen's tournament was held at Patchogue in 1886. Contests were held to test skills in handling fire-fighting equipment. In "hose running," for example, a team had to run 200 yards, lay out 300 feet of hose, break a coupling and put the hose on a pipe. Patchogue's own department was considered the best-equipped in the county and, by the time of this eighth annual tournament, had been awarded several silver trophies for capturing first place. *(Photograph by Howard Conklin; Queens Borough Public Library, Long Island Division.)*

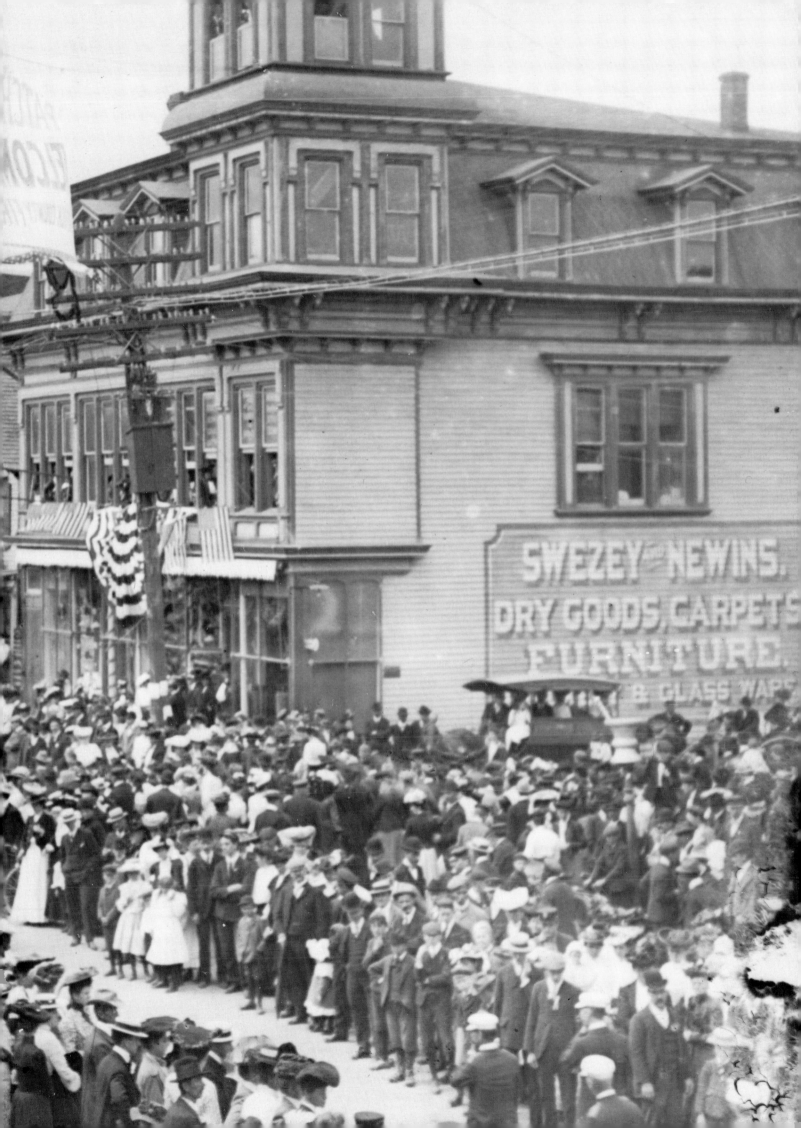

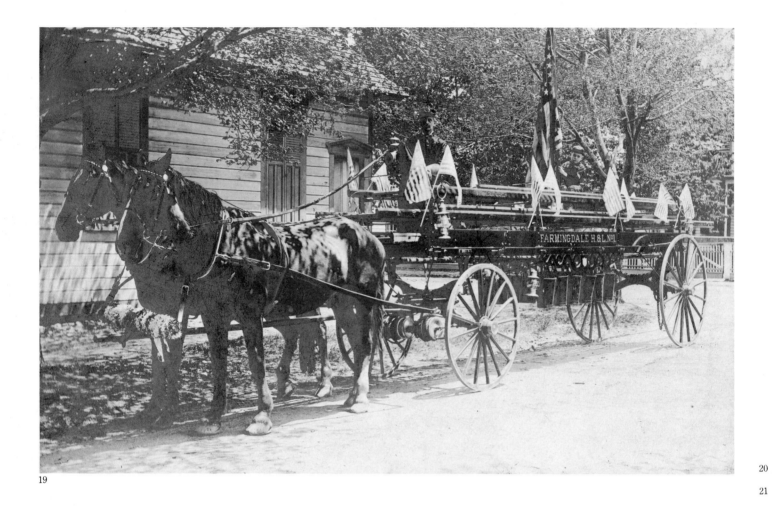

19

19. Farmingdale Hook and Ladder No. 1, ca. 1905. Local firemen saw lots of action because of the prevalence of wood-framed buildings, wood or coal stoves and kerosene lamps. Each village had its own volunteer fire company. Early fire-fighting equipment was limited to leather buckets and hand-powered pumps filled from cisterns until 1893, when fire hydrants were installed. Steam pumpers, hook-and-ladder wagons and rescue equipment further improved fire-fighting efficiency. *(Lightfoot Collection.)*

20. Sag Harbor Fire Department at Sayville, Firemen's Tournament, 1899. Competitive tournaments bolstered the morale of the men who served their communities as volunteer fire fighters. The camaraderie of the fire companies replaced that of the companies of militia which were part of the rural scene in earlier days. Many groups organized brass bands and showed off their brightly polished instruments on occasions such as this fourth annual tournament held in Sayville. Here, the Sag Harbor Fire Department marches past the shop of G. N. Woolner, Custom Shoe Maker. *(Photograph by Hal B. Fullerton; Suffolk County Historical Society, Fullerton Collection, #1030B.)*

21. Cornet Band, Greenport, 1895. Before phonographs, motion pictures and radios altered popular taste, town cultural activities were centered on debating societies, private subscription libraries, local auditoriums and "opera houses" which featured magic-lantern shows, plays and musical events. Most early nineteenth-century local performances of instrumental music were limited to the fiddle, flute and pianoforte but, by the time of the Civil War, brass instruments had become cheap enough to encourage the organization of brass bands. Greenport's first cornet band, which played for the 1844 opening of the Long Island Rail Road, "enlivened the occasion and frightened many horses hitched to nearby trees." *(Stirling Historical Society.)*

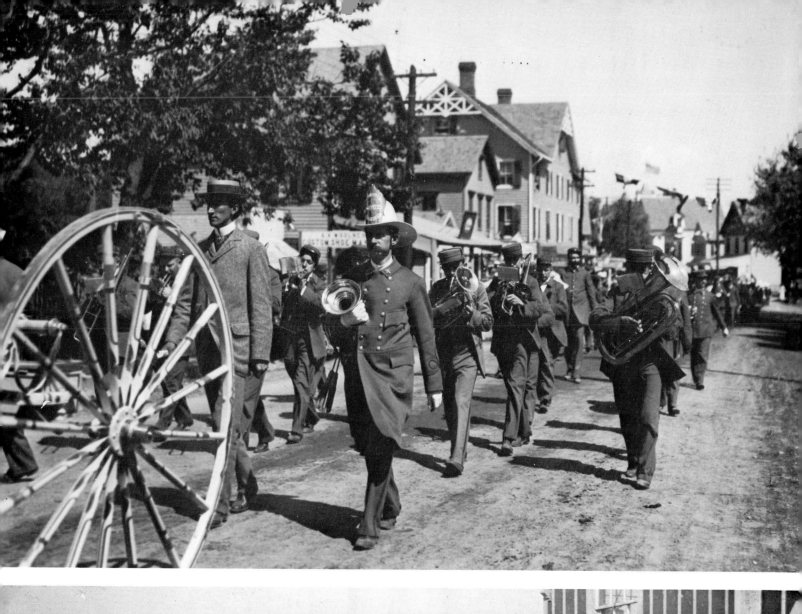
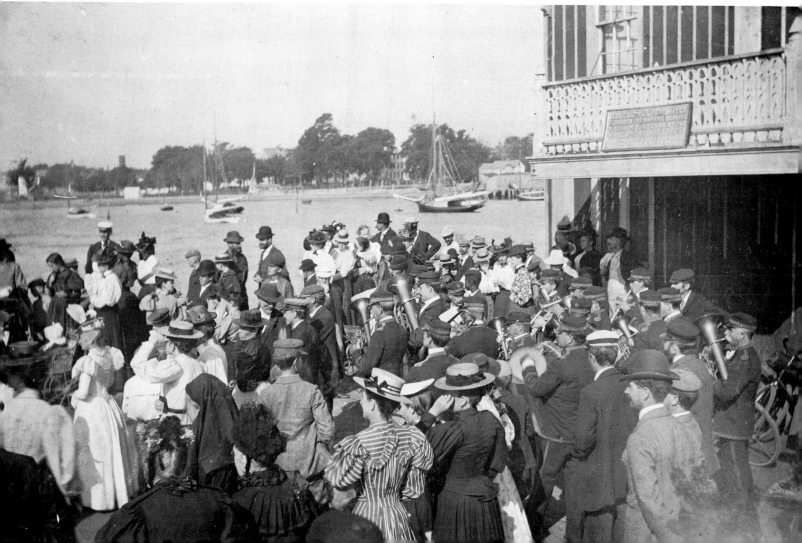

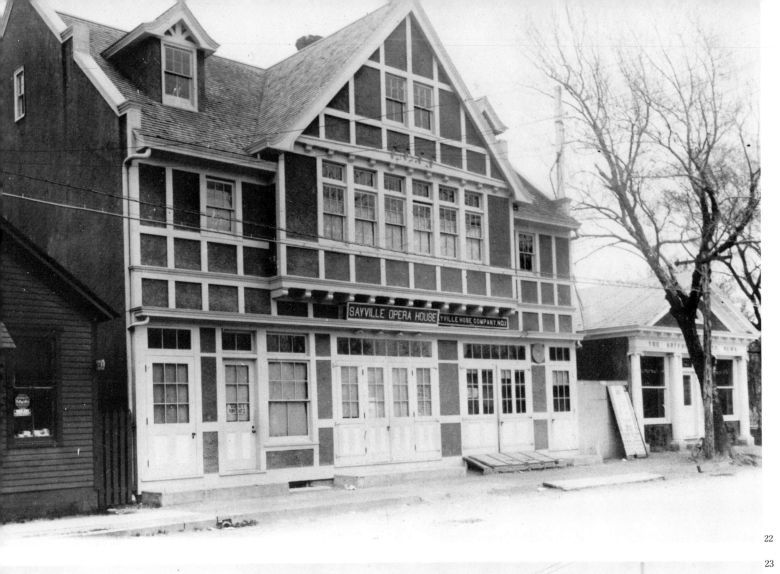

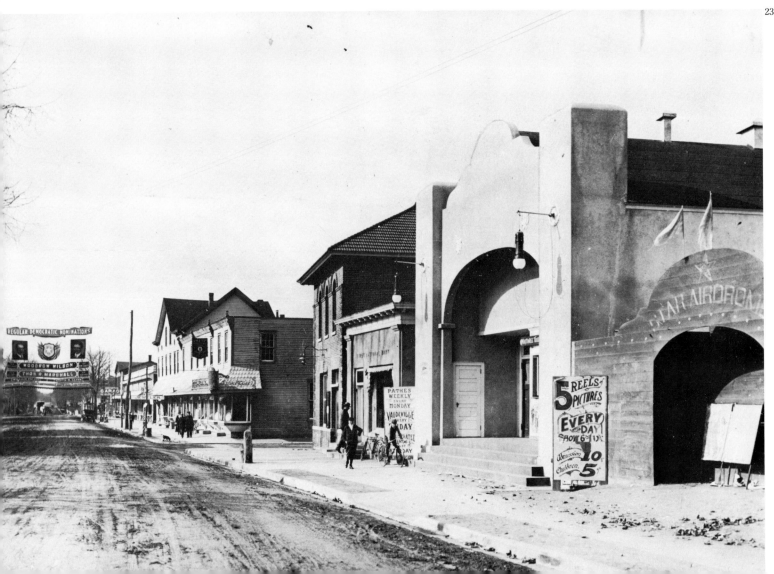

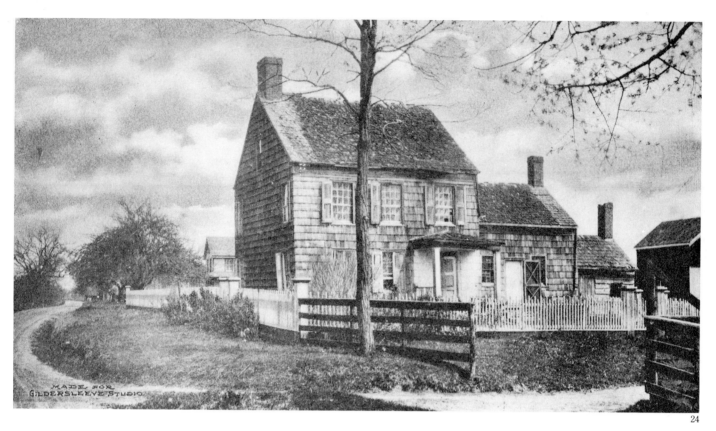

22. Opera House, Sayville, ca. 1900. When traveling groups such as the Kickapoo Indian Medicine Show came into town, public meeting space for their use was extremely limited. Formed in 1899, the Sayville Hose Co. No. 1 responded to the need for a community entertainment center. With funds from their annual Firemen's Fair, they purchased property on the east side of Candee Avenue, adjacent to the office of the *Suffolk County News*. Isaac H. Green designed the Sayville Opera House, seen in this photograph. The opening performance, held here on August 7, 1901, featured such acts as Charles Bloomer playing Sarah Heartburn, Bill Seeley in blackface and Al Laurence's "prismatic water fountain, illuminated with electric lights." For some years the Opera House was a popular stop for weekly road companies. Later, when movies threatened vaudeville, the building was used for assorted public functions. Sold in 1921, it was used as a lodge room by the Foresters of America. It was also converted to a motion-picture theater, but was eventually demolished. *(Photograph by Henry Otto Korten; Nassau County Museum.)*

23. Star Airdrome, Bank and Town Hall, Islip, 1912. Just as trolleys and cars eventually replaced stagecoaches and bicycles, movies soon lessened the enthusiasm for stage shows (although the sign in the background says "Vaudeville Every Friday"). Thomas Edison's Kinetoscope, and his 1895 moving-picture machine permanently altered the world of entertainment. By 1910, some 10,000 American movie houses had weekly audiences of 10 million people. Adjacent to the Town Hall and First National Bank, Islip's Star Airdrome showed five reels of pictures daily—all for ten cents (half that for children). Above unpaved Main Street, banners drum up votes for soon-to-be-President Woodrow Wilson. *(Photograph by Henry Otto Korten; Nassau County Museum.)*

24. Walt Whitman's Birthplace, West Hills, ca. 1905. Whitman, one of the greatest American poets, was born in 1819 in this small but sturdy farmhouse built by his carpenter father. It is still standing, near the Walt Whitman Shopping Center on Route 110, but the third wing of the building, shown here on the right, was lost in a fire many years ago. Much of the imagery in Whitman's poems is drawn from his childhood and young manhood in eastern Long Island and Brooklyn, which provided him with country and urban scenes. He adopted the native American name for Long Island, "Paumanok," in his collection, *Leaves of Grass. (Photograph by Gildersleeve Studio; Lightfoot Collection.)*

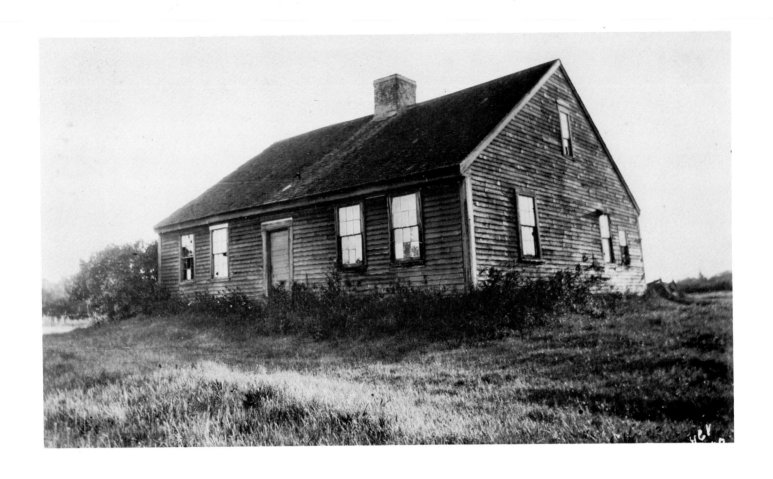

25. Holbrook's Oldest House, ca. 1910. Characteristic of the starkly simple life of the residents of the pine barrens was this oldest house of Holbrook, built in 1747. Holbrook itself was not founded until 1848, when a 500-acre tract was set aside for it along the line of the Long Island Rail Road in the town of Islip. Holbrook became the home of Dr. E. H. S. Holden, originally from Birmingham, England, who was one of the county's minor poets. *(Photograph by Thayer; Lightfoot Collection.)*

Main Streets and Town Centers

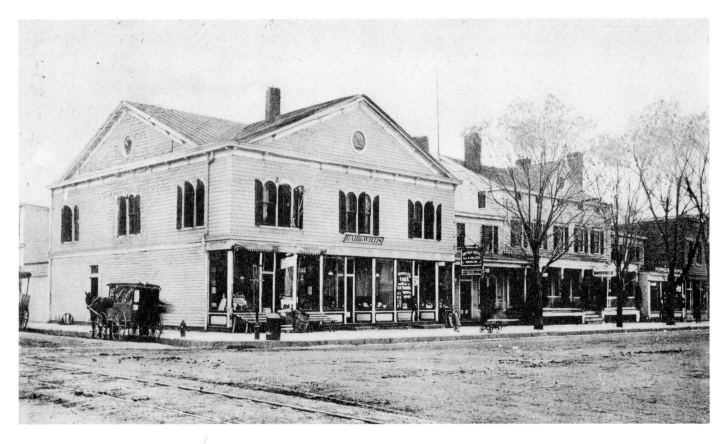

26. Corner of New York Avenue and Main Street, Huntington, 1908. Huntington's prosperity was based on rich farmlands and varied commercial activities such as pottery making and brickyards, thimble making, carriage shops and printing. Its waters were rich in clams and fish, and the beauty of the harbor brought wealthy summer residents to its shores. Nevertheless, the village retained a country-town ambience until after World War II. In this picture of the intersection of its two main streets, the Suffolk Hotel stands on the corner, combining residential and commercial quarters and including the store of D. W. Trainer, who imported and sold the postcard from which this view is taken. *(Photo by Gildersleeve Studio; Lightfoot Collection.)*

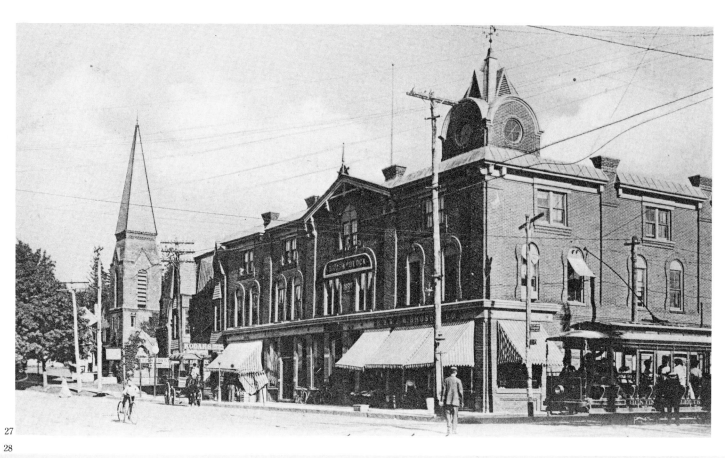

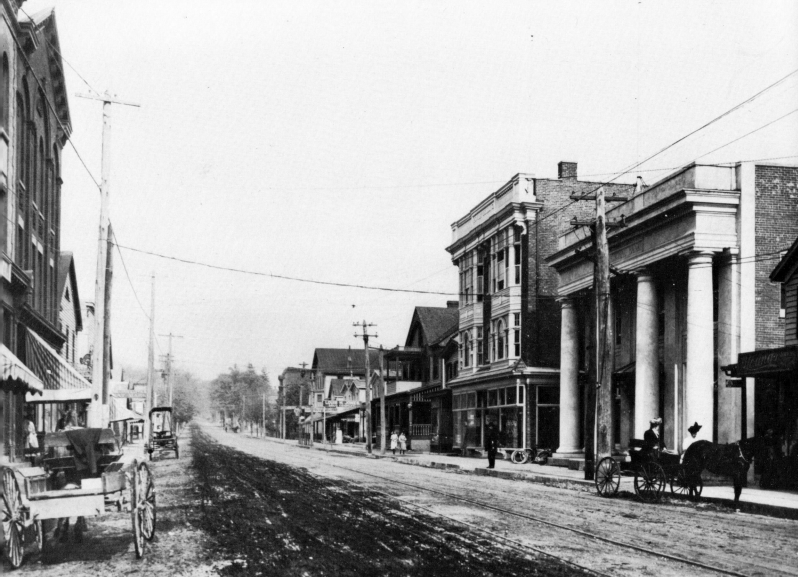

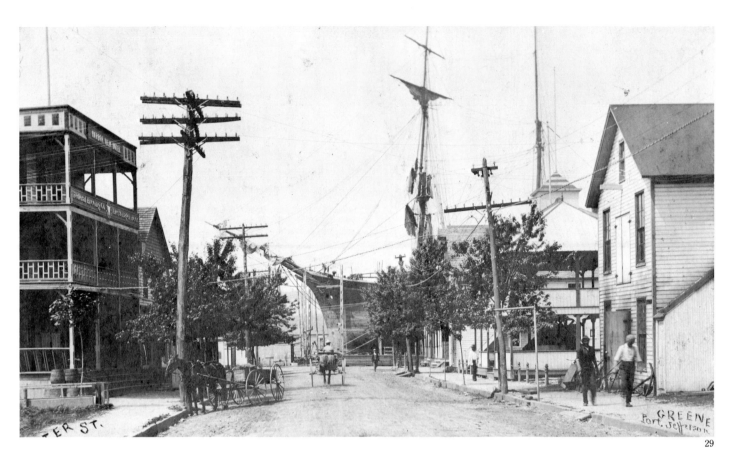

29

27. Brush's Block, Huntington, ca. 1907. This view of another corner of New York Avenue and Main Street is dominated by the "modern" three-story brick building of the Brush Company, which occupies the desirable corner location. At the right is an open-sided summer trolley car on the line that offered cheap and easy travel north to Halesite and southward up the steep hill to the Huntington railroad station. Eventually, the line was extended to Amityville. There was a tremendous interest in such long-line trolleys in the early 1900s, and many people took pleasure trips on these routes from terminal to terminal. At one time, it was planned to have a continuous trolley route from Manhattan across the East River and on along the South Shore as far as Brookhaven. This dream came fairly close to realization, but died when the South Shore Traction Co. went into receivership in 1910. A line proposed from Greenport to Orient also failed to materialize. (Photo by Gildersleeve Studio; Lightfoot Collection.)

28. Main Street, Northport, ca. 1912. Looking east on Main Street, with his back to the harbor, Henry Otto Korten caught this revealing picture of the mixture of old and new: horse and buggy on unpaved streets, but fine sidewalk curbs and tracks for the electric trolley (begun in 1902); old wooden structures setting off the new First National Bank (1911), with its massive columns. Opposite the bank, which is still in use today, is another architecturally distinguished structure, built as a bank but now an insurance company, which combines Dutch stepped gables with third-floor arches in a handsome pressed brick.

Northport was laid out as Bryant's Landing in 1790, before which it was known as Cow Harbor, with only a few dwellings. After the first dock was built in 1802, the sale and shipping of cordwood helped to develop it into the most flourishing village in Huntington township by the 1870s. At that time its population was 1060, and it boasted three shipyards, two hotels, six or eight general stores and the Northport Fire Clay and Sand Company, which contributed sand to the making of fine French chinaware. By the turn of the century, Northport was also home to the Edward Thompson Publishing Company, one of the largest law publishers in the country and employer of several hundred people. (Photograph by Henry Otto Korten; Nassau County Museum.)

29. Water Street, Port Jefferson, 1905. Until 1836, the village of Port Jefferson was called Drowned Meadow, because extensive tidal flats, later filled in, covered the present Main Street area. Its protected deepwater harbor made Port Jefferson a major center for trade and shipbuilding, especially from 1836 to 1885. Water Street, now the first block of East Broadway, led directly to this harbor. In the foreground, at the left in the photograph, is the three-story Harbor View Hotel. Across the street is the open-sided Bayview Pavilion and the F. F. Darling Store (with striped cupola). In the rear center is a two-masted vessel hauled up for repair in the famous Mather and Wood Shipyard. Mather and Wood, who became partners in 1879, installed Long Island's first steam-driven marine railroad able to haul vessels weighing up to 1500 tons. (Photograph by A. S. Greene; Lightfoot Collection.)

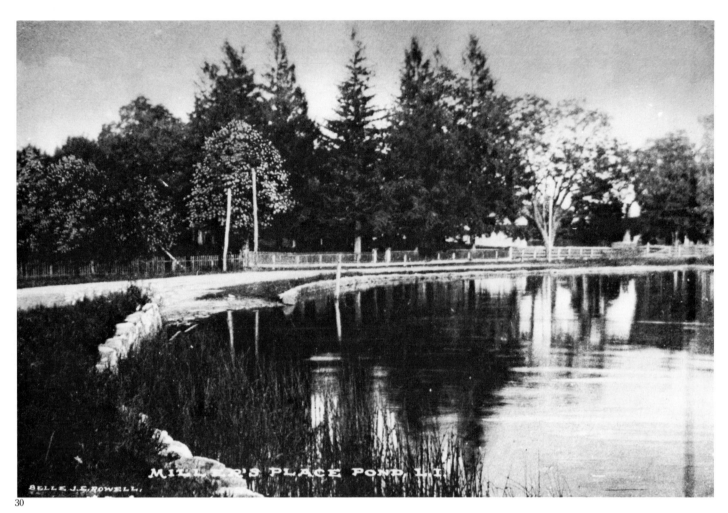

30. Miller's Place Pond, ca. 1905. At Miller's Place, near Mt. Sinai Harbor, an excellent water supply in springs and ponds lured settlers from nearby Setauket. By the 1670s, Andrew Miller, who previously lived in Salem, Massachusetts and East Hampton, had amassed considerable property at the location, then called "The Old Man's," in reference to a wealthy old Englishman who had previously purchased land there. A cooper, landowner and town officer, Andrew Miller built a house opposite this pond in the 1680s and established a family after which the town was named in 1730.

At the time of the Revolution, Miller's Place had 75 inhabitants of divided sympathies, living in eight households. Richard Miller, unlike most of his townsmen, refused to sign articles of association with the Provincial Congress. He recruited for the British Army and was shot by patriots on the same day in 1776 in which his relative by marriage, General Nathaniel Woodhull, of Washington's army, died on board a British prison ship of wounds sustained in the Battle of Long Island. Miller's Place experienced a large share of stirring and dangerous events during the seven years' occupation, when it was the target of whaleboat raids across the sound made by both patriot and British sympathizers. Today it still has many of its old houses, clustered near the pond. *(Suffolk County Historical Society.)*

31. Main Street, Riverhead, ca. 1912. The three-story brick and stone building on the left, used as post office and bank, was built in 1892. The small cigar, candy and newspaper building at the curb was removed in 1915, a fact which helps to establish the date of the picture. Another useful fact is a missing presence: a seven-foot-tall three-basin drinking fountain (one basin for men, one for horses, one for dogs) that had been installed by the Woman's Christian Temperance Union in the middle of the street in 1900. It was removed as a traffic hazard in 1911, narrowing the date for the photograph to the three-year period between 1912 and 1915. Riverhead, first called Accabog, was mentioned in an Indian deed of 1648. In 1659 a sawmill was established there at the head of the Peconic River, which courses for 20 miles from a series of ponds in the Manorville area east into Peconic Bay, draining 2000 acres.

Riverhead became the county seat in 1727 when a courthouse and prison were located there. In the course of the eighteenth and nineteenth centuries, other industries were established along the river, including grist, woolen, molding and planing mills and a soap factory. Riverhead township was divided from Southold in 1792 because of the inconvenience of travel from one end of the township to the other and because of political differences between western Federalists and eastern Jeffersonians. *(Photograph by Henry Otto Korten; Nassau County Museum.)*

32. Beckwith Street, Near the Intersection with Main Street, Southold, 1913. Southold, with Southampton one of the two oldest towns on Long Island, was founded in 1640 by colonists from Connecticut and Massachusetts who planned a theocratic community with their Puritan minister, Reverend John Youngs, at its head. The present Southold Burying Ground marks the site of their earliest church, adjacent to the present First Presbyterian Church on Main Street (Route 25), built in 1803. This photograph, taken on a bare day in late winter or early spring, shows a street in the historic district of the town, a block from the old minister's dwelling. Classic square and shingled New England-style buildings characterized the town at the turn of the century, as they do now, though we no longer see millinery shops among the commercial establishments.

The unpaved street, crisscrossed by wagon wheels, is a reminder of the seventeenth-century law of the village "that everie inhabitant havinge annoyed the town street by digginge any water pitts, makeinge any dangerous holes, layinge any blocks, loggs or trees in the same, to the prejudice or damage of any man or beast, shall forfeit and pay for everie week the same is neglected 1 s. per weeke." However, one could recoup the fine by receiving 15 shillings for making a pit or pen to catch some of the wolves that troubled the village in early times! *(Photograph by Henry Otto Korten; Nassau County Museum.)*

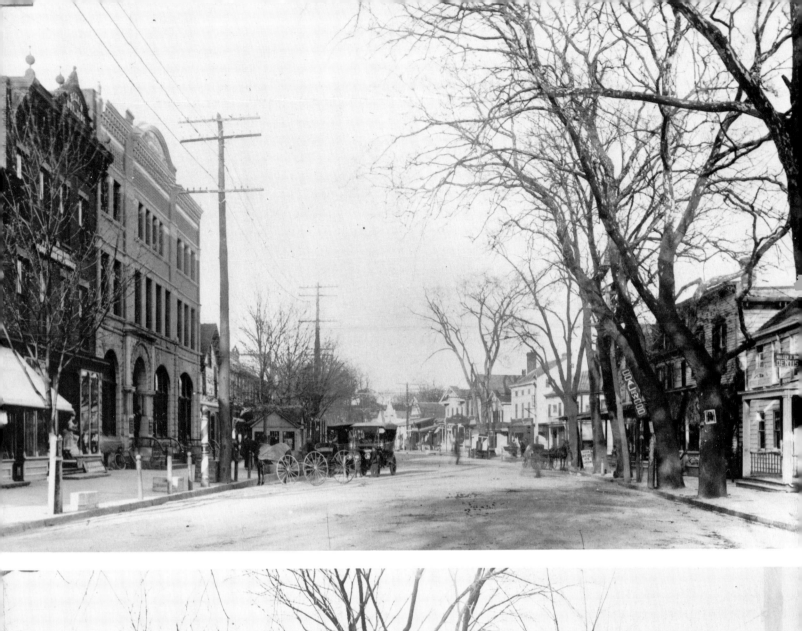

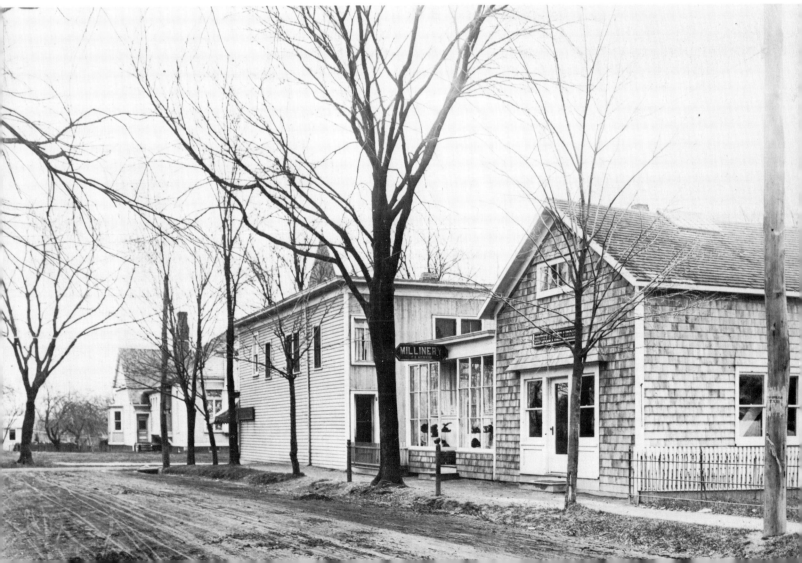

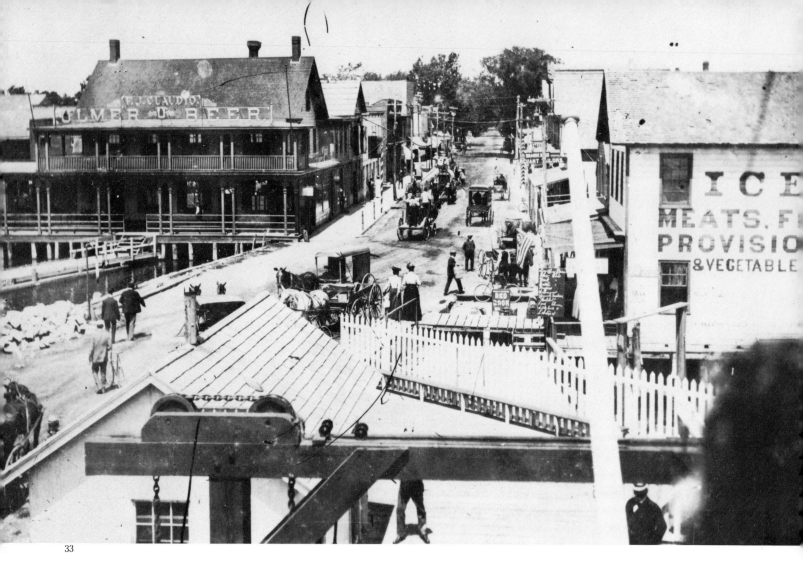

33

33. Looking Up Main Street from the Ferry, Greenport, ca. 1900.
Originally called Stirling, Greenport is the youngest of the larger villages in
Suffolk, as it did not begin to grow until the sale of a large farm along the
waterfront opened the way for development in the 1820s. Main Street Wharf
and a marine railway were built there in 1827, and boat and shipbuilding,
whaling, fishing and oystering added to the business brought to its harbor in
1844 by the terminal of the Long Island Rail Road. While the village did not
fulfill the prophecy of an Orient poet who hailed it as a future Boston, it had
well over 200 vessels operating from its harbor in the 1870s. Farming and
summer tourism also brought prosperity. The photographer climbed up on
the entrance to the ferry for Shelter Island to take this picture. The marine-
supply store at the right is still in operation today, as is the restaurant on the
left side of the street. *(Photograph by Frank Hartley; Collection of Miriam
Hartley.)*

34. Foot of Main Street, Greenport, March 7, 1911. Here is the same
street viewed from the other end, approximately ten years later. An auto-
mobile has replaced the horses and buggies. The horse-hitching posts re-
main, along with the preterence for Ulmer Beer. There is little architectural
change. Yet the shift to a street-level perspective facing Greenport Harbor
lets us see how the town's businesses filled the orderly block right up to the
wharf; the preceding aerial view gives a more intimate look at the bustle,
showing a different range of details: among them the blackboard list of
available seafood, and the chain-and-pulley at the dock. *(Photograph by Henry
Otto Korten; Nassau County Museum.)*

**35. Looking East Along Merrick Road from Broadway, Amityville,
1914.** Amityville is located in the southwest corner of Suffolk County, on the
shore of Great South Bay, its land cut into three necks by deeply penetrating
creeks. Once known as West Neck South, its current name was adopted in
1840 from the coastwise schooner *Amity*, owned by Samuel Ireland, a local
miller. The village began its development in 1780 with grist- and sawmills and
was a stopping place for George Washington during his 1790 tour of Long
Island. By the time of this photograph, it was known for its oyster industry, its
hotels and its sanitariums.

The most notable of these was the Long Island Home Hotel for the
mentally disordered, founded in 1881 by John Louden, formerly superinten-
dent of the Suffolk County Almshouse and general inspector of charitable and
correctional institutions of New York City. A man ahead of his time, Louden
discontinued the use of straitjackets, substituting kindly treatment of pa-
tients. Louden Avenue in present-day Amityville is named in his honor; it is
located a few blocks north of the site in this photograph. The photographer is
standing on the west side of Merrick Road (now called Montauk Highway),
looking east across the trolley tracks that ran north–south on Broadway
(Route 110). The few blocks of the surrounding district still contain a number
of fine nineteenth-century buildings, including the Carman House. *(Pho-
tograph by Henry Otto Korten; Nassau County Museum.)*

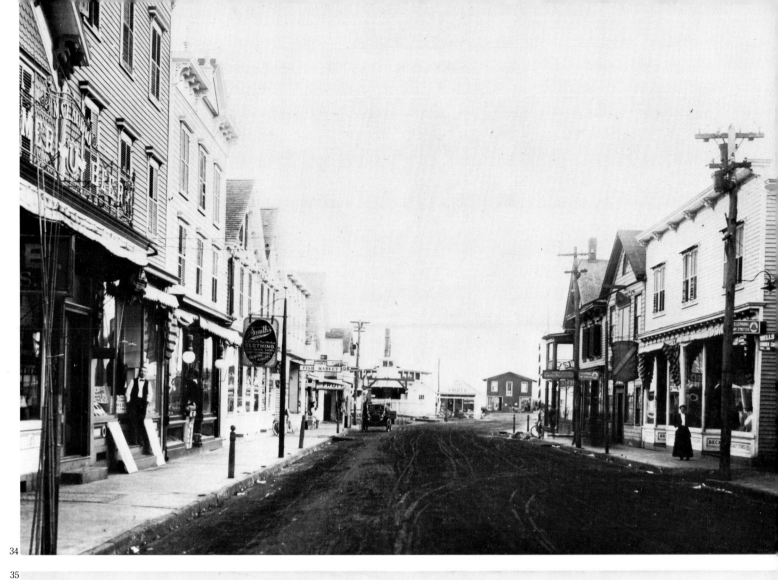

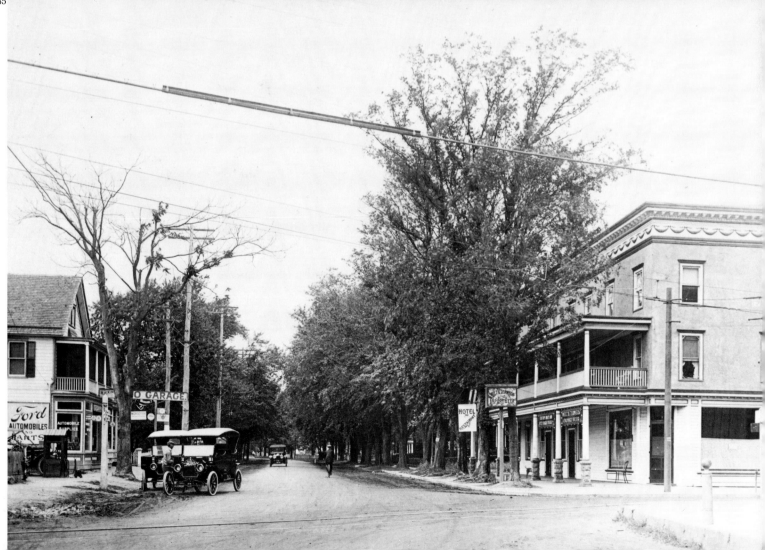

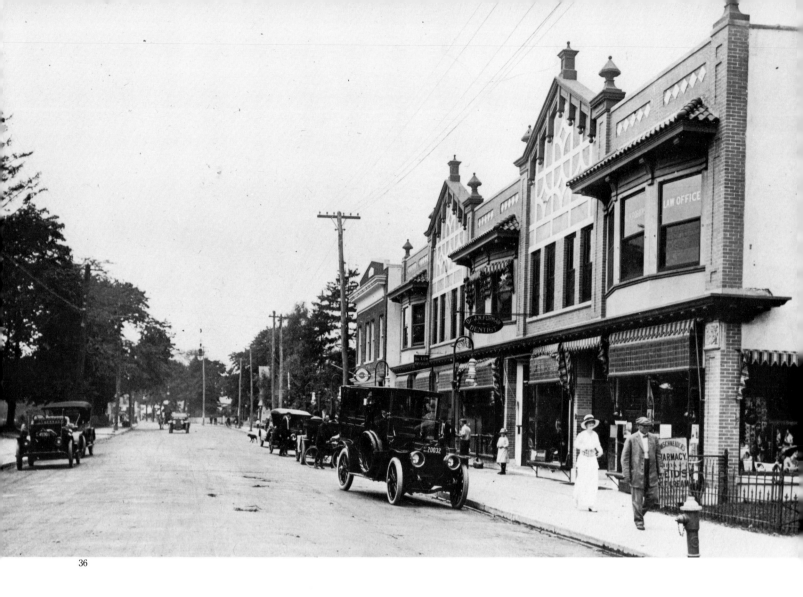

36

36. Main Street, Bay Shore, ca. 1914. Located on the western border of the town of Islip, Bayshore (in earlier times known as Mechanicsville and Penataquid) enjoyed the resources of Great South Bay for fishing, clamming, oystering and the fresh water of several streams for saw-, fulling- and gristmills. After the Civil War, the South Side Long Island Rail Road brought more summer visitors and the establishment of large estates. At this time, Amos Doxsee, whose name is still known in the clam-canning business, organized the First Methodist Episcopal Church, which competed for congregants with the Congregational Church and the Catholic Church, organized ten years later. In 1880, an African Methodist Episcopal Church was organized with 15 members. *(Photograph by Henry Otto Korten; Nassau County Museum.)*

37. A Babylon Street, ca. 1905. Babylon was formerly known as Huntington South. Located in the midst of a pine forest, the land was "purchased" in 1657 from the Indian sachem, Wyandanch, for a collection of coats, weapons, ammunition and stockings. Peaceful conveyances of land continued until 1705, as the colonists prized the salt hay in the marches to the south and wood. Later settlers also welcomed the town's proximity to the waterfront, useful for oystering, clamming and the hotel business. In the late nineteenth century, the country seats of August Belmont and Austin Corbin (President of the Long Island Rail Road) were located north of the village. At the time of this photograph, the population of Babylon was 2157. *(Lightfoot Collection.)*

38. Main Street, Babylon, ca. 1915. At the intersection of Main Street and Deer Park Avenue, the photographer focused his camera on the Heffley Brothers drugstore, intending to sell postcards made from the print to the pharmacists for display and sale in the store. The brick and frame structures on Main Street were built in the 1870s. Those that remain today are still admired for their mansard roofs and molded window caps. In the rear of the photograph is the clock tower of the Italianate First Presbyterian Church, built in 1783 and surrounded by a fine wooden fence with square posts topped by carved urns. *(Photograph by Henry Otto Korten; Nassau County Museum.)*

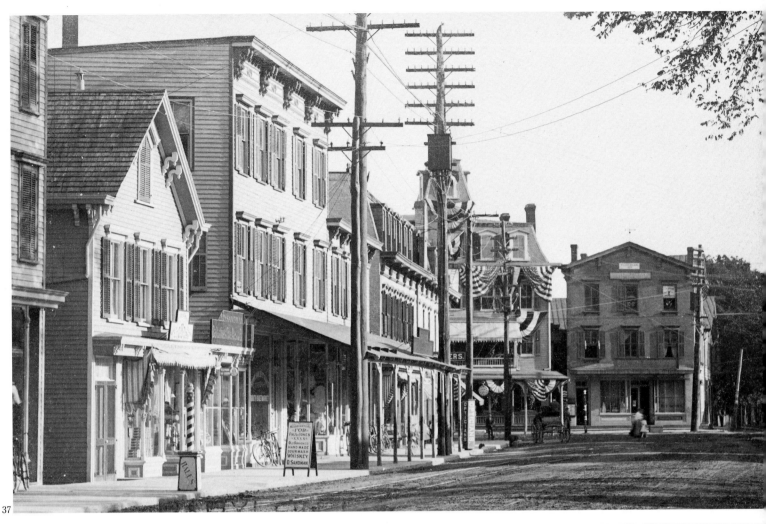

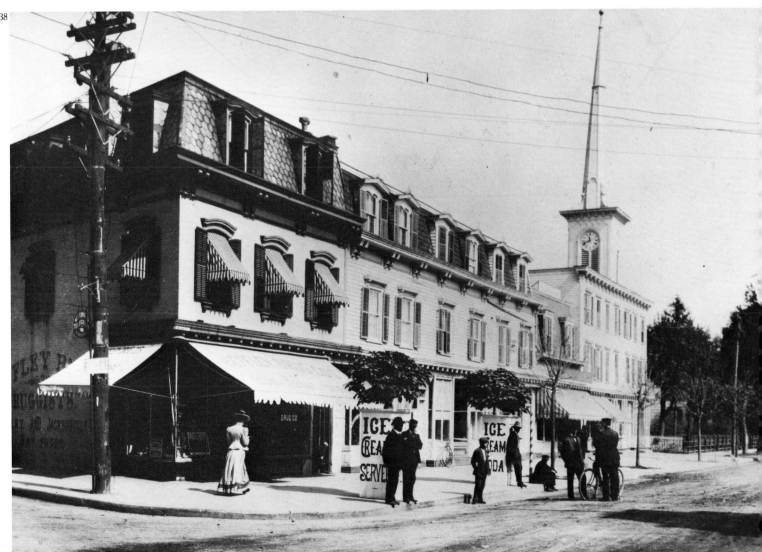

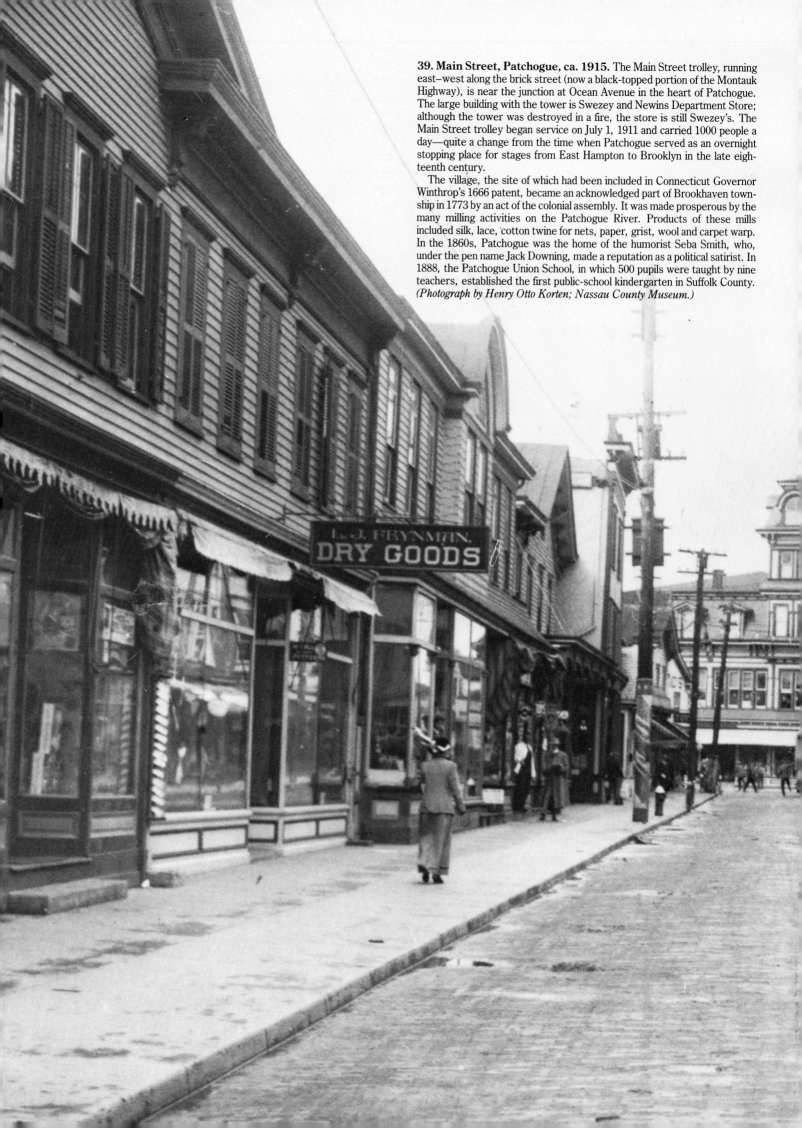

39. Main Street, Patchogue, ca. 1915. The Main Street trolley, running east–west along the brick street (now a black-topped portion of the Montauk Highway), is near the junction at Ocean Avenue in the heart of Patchogue. The large building with the tower is Swezey and Newins Department Store; although the tower was destroyed in a fire, the store is still Swezey's. The Main Street trolley began service on July 1, 1911 and carried 1000 people a day—quite a change from the time when Patchogue served as an overnight stopping place for stages from East Hampton to Brooklyn in the late eighteenth century.

The village, the site of which had been included in Connecticut Governor Winthrop's 1666 patent, became an acknowledged part of Brookhaven township in 1773 by an act of the colonial assembly. It was made prosperous by the many milling activities on the Patchogue River. Products of these mills included silk, lace, cotton twine for nets, paper, grist, wool and carpet warp. In the 1860s, Patchogue was the home of the humorist Seba Smith, who, under the pen name Jack Downing, made a reputation as a political satirist. In 1888, the Patchogue Union School, in which 500 pupils were taught by nine teachers, established the first public-school kindergarten in Suffolk County. *(Photograph by Henry Otto Korten; Nassau County Museum.)*

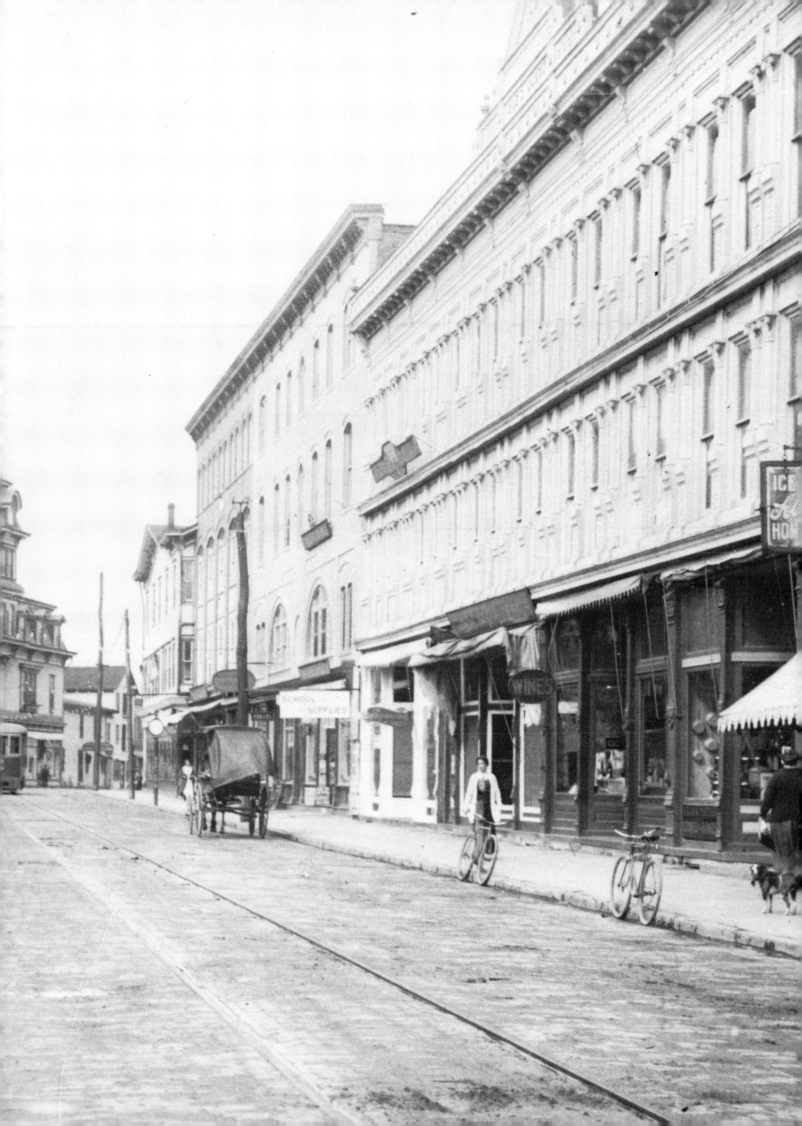

40

41

42

40. Main Street and Post Office, East Islip, ca. 1915. Sixteen streams flow into Great South Bay from sources in the town of Islip, and, until the intensive settlement of the post–Civil War period, the shoreline was a salt marsh 300 or 400 feet wide. This well-watered land was first deeded to Matthias Nicoll, secretary to Richard Nicoll, Governor of the Province of New York under the Duke of York (later James II), in the mid-seventeenth century. He left it, in turn, to his son, William. At his death in 1780, William Nicoll owned 60 square miles of Islip, which was named after the seat of the Nicoll family in Northamptonshire, England. William Nicoll represented Suffolk in the colonial assembly for 21 years at the beginning of the eighteenth century. His family's land monopoly was so strong that throughout the eighteenth century the land remained unsettled.

South Country Road (now also Montauk Highway), the Main Street of this photograph, was laid out in 1732, a mile from the bay. In 1765 the town meeting passed a law banning "furriners" from fishing in the bay at a penalty of 40 shillings. But strangers slowly established themselves until, by the late nineteenth century, there was a continuous line of settlement along the South Country Road. East Islip did not gain its post office until after the turn of the century, when it filled the space between Islip and the estate of William K. Vanderbilt, east of the village at Oakdale. *(Photograph by Henry Otto Korten; Nassau County Museum.)*

41. Sidewalk Scene, Main Street, Southampton, ca. 1915. On a summer afternoon, Korten recorded a peaceful, tree-shaded Main Street, with a mixture of automobiles and buggies drawn up before the handsome columns of the post office and the brick arches of the bank (left side of picture). A north–south road, Main Street in 1915 was quite a different place from its seventeenth-century counterpart. Stocks and a whipping post were established at the junction of Main Street and Academy Lane in 1648, and in

1653 a law was passed that anyone above the age of 14 convicted of lying must pay five shillings for each offense or sit in the "stox" for five hours. The last use of the Main Street whipping post occurred in 1820. Southampton's Main Street was also the site of dramatic activity during the Revolution, when the British general, William Erskine, established his headquarters there in 1778, using the home of a patriot forced to flee to Connecticut. *(Photograph by Henry Otto Korten; Nassau County Museum.)*

42. Main Street Business Section, East Hampton, ca. 1915. By the turn of the century, East Hampton was already a fashionable summer resort, with a thriving business district along its still unpaved Main Street. Note the brick alleys and chauffeur-driven autos at the curb. But the town has a long history as well. It was settled by a few Southampton families in 1651; in those years important revenues came from the dead whales cast up on its shores. The moral and religious fervor of Southampton was transplanted here, too. In 1653, one Goody Edwards was sentenced to stand with a split stick on her tongue for speaking slander, while Goody Garlick was transported to New Haven to be tried for witchcraft.

During the Revolution, East Hampton played a proud part, every inhabitant capable of bearing arms signing articles of association recommended by the Provincial Congress. On April 7, 1776, Captain John Dayton discouraged armed British vessels from landing by the subterfuge of marching his soldiers to the bay and then having them change their coats and march a second time, thus persuading the British that they were outnumbered. The ladies of East Hampton were also patriots. According to the tradition of Pudding Hill, a colonial dame living at the western end of Main Street prepared a pudding with fresh berries, but rather than allow the British soldiers to eat it, she threw it down the hill into the sand. *(Photograph by Henry Otto Korten; Nassau County Museum.)*

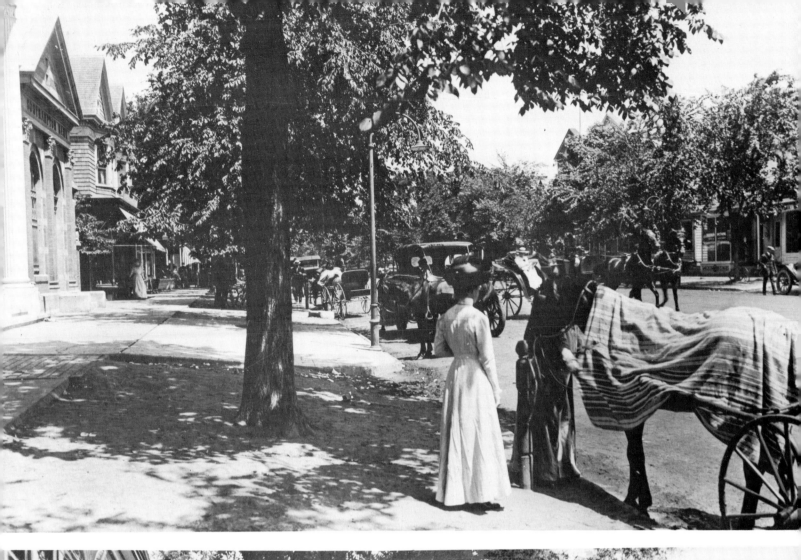

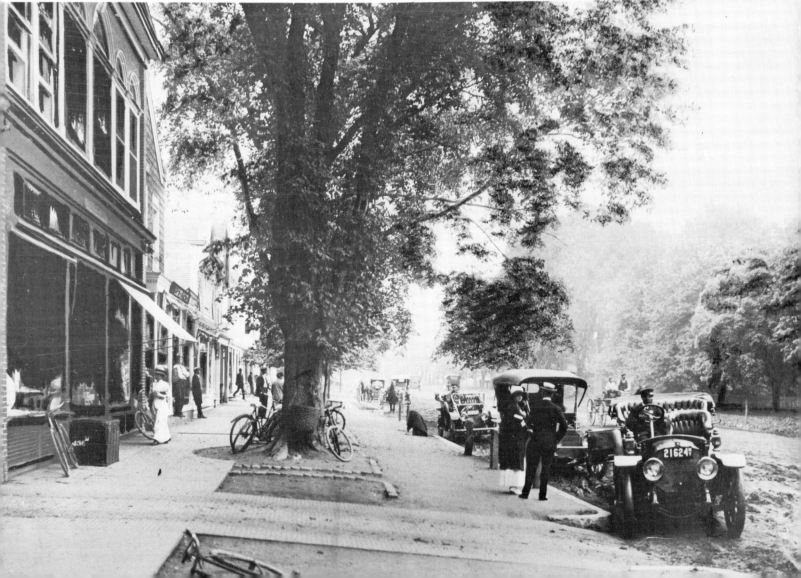

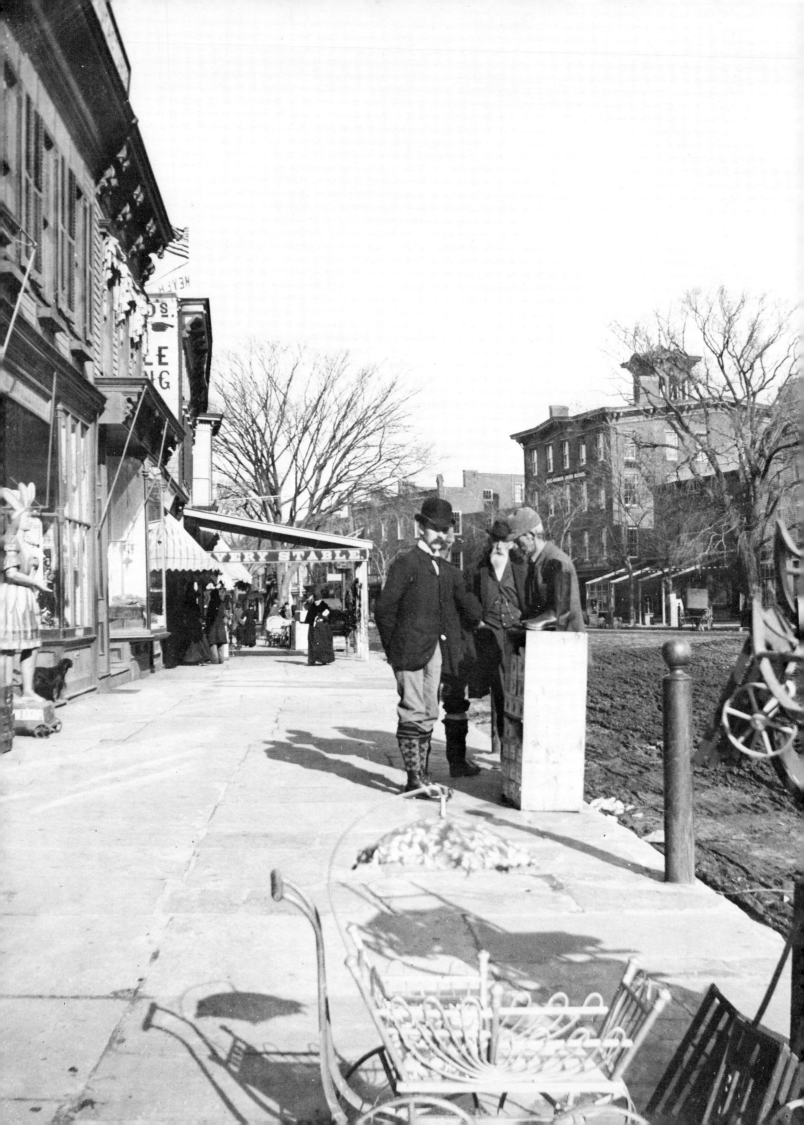

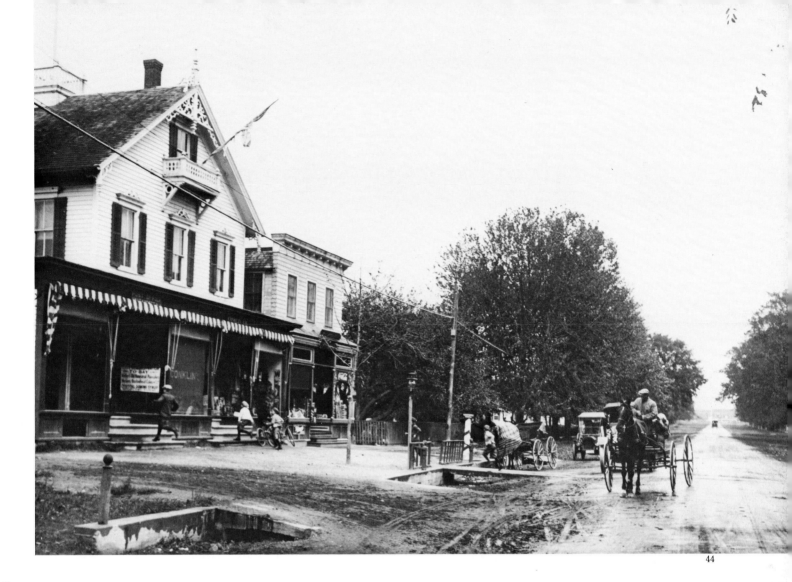

44

43

43. Main Street, Sag Harbor, ca. 1905. The brick building on the east side of Main Street (right rear) was built as a hotel at the cost of $17,000, but was purchased by the town to use as a school in 1870 for a mere $7000; the decline in the value of Sag Harbor real estate was caused by the loss of the whaling industry, a major contributor to prosperity in the town from 1760 to the Civil War. Reminders of whaling days can still be seen in the Main Street area at the handsome old Custom House (1790), the Whalers' Presbyterian Church (1844) and the structure that now houses the Whaling Museum (1845). Main Street itself was laid out in 1745 and was the main thoroughfare by which eastern Long Islanders approached the harbor in 1776, forced by their patriot sympathies to flee across the sound after the British won the Battle of Long Island.

In the following year, Sag Harbor was the site of a daring Revolutionary incident, when Lt. Colonel Jonathan Meigs, with 170 men in whaleboats, crossed the sound from Connecticut to attack the British occupiers; he returned after killing six and taking 90 prisoner, without the loss of any of his men. Sag Harbor was a vulnerable port during the War of 1812, when a brick arsenal was built and townspeople recorded the wreck of the British sloop-of-war *Sylph*. The big fire of 1845 destroyed the wharf and surrounding buildings, but as whaling declined new enterprises were founded, among them the Joseph Fahys Watch Case Manufacturing Company, which moved to Sag Harbor in 1879; the company brought 40 Jewish families from Ellis Island, who built the first synagogue in Suffolk. *(Lightfoot Collection.)*

44. Main Street, Amagansett, ca. 1915. Amagansett, where the earliest land deed is dated 1683, grew less rapidly than East Hampton, its neighbor on the west. Its population was 548 in 1880; by 1903, it had increased only to 550, while East Hampton, with 807 in 1880, had doubled in population by 1903. Amagansett did not need to build its own Presbyterian Church until 1860. The absence of sidewalks in this photograph emphasizes the country atmosphere of the town. The photographer, hoping to sell a postcard view to the proprietor, made this record of the sign in Conklin's window: "To-day—Hecker's Old Homestead Pancakes and Buckwheat Cakes with Crystal Domino Syrup. STOP! TRY THEM!" *(Photograph by Henry Otto Korten; Nassau County Museum.)*

FARMING AND MILLING

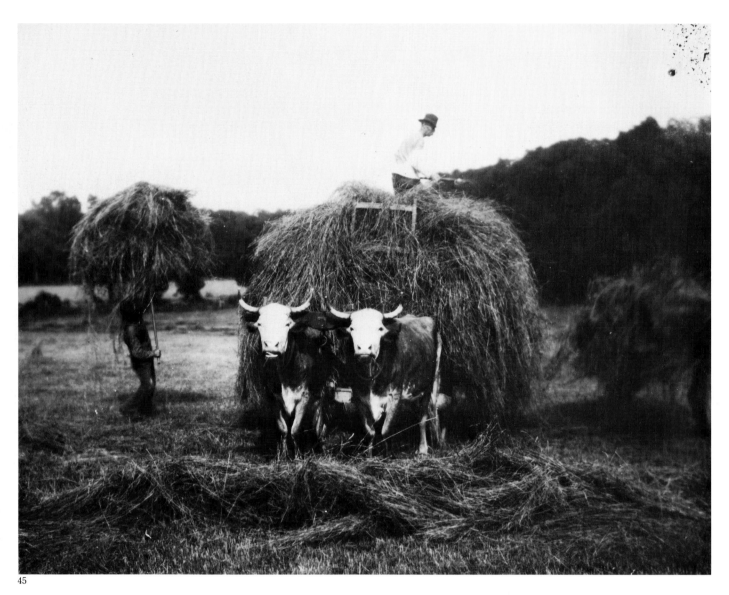

45. Hay Wagon with Yoke of Oxen, Cold Spring Harbor, 1903. At the northwest boundary of Suffolk County, Cold Spring Harbor, as the name implies, was long famous for saltwater- and freshwater-related industries: paper, grist- and woolen mills in the late seventeenth and eighteenth centuries; whaling in the first half of the nineteenth century. This photograph, taken when the town was also home to the Brooklyn Biological Laboratory (now the famous Cold Spring Harbor Laboratory for Biological Research) and the New York State Fish Hatchery, reminds us that industrial and scientific advances had not replaced time-honored methods in the slow but sure events of the agricultural year. This farmer raked his hay by hand, although horse-drawn hay rakes had been introduced on Long Island by the mid-nineteenth century. His field-grown hay, a valuable animal food, replaced salt hay, the natural product of Long Island's indented coastline and the colonial farmer's first fodder. If this farmer had a surplus of field hay beyond what he needed for his own stock, he probably sold it, as his Riverhead contemporaries did, to a neighbor who owned a power press. *(Photograph by Hal B. Fullerton; Suffolk County Historical Society, Fullerton Collection, #L1415.)*

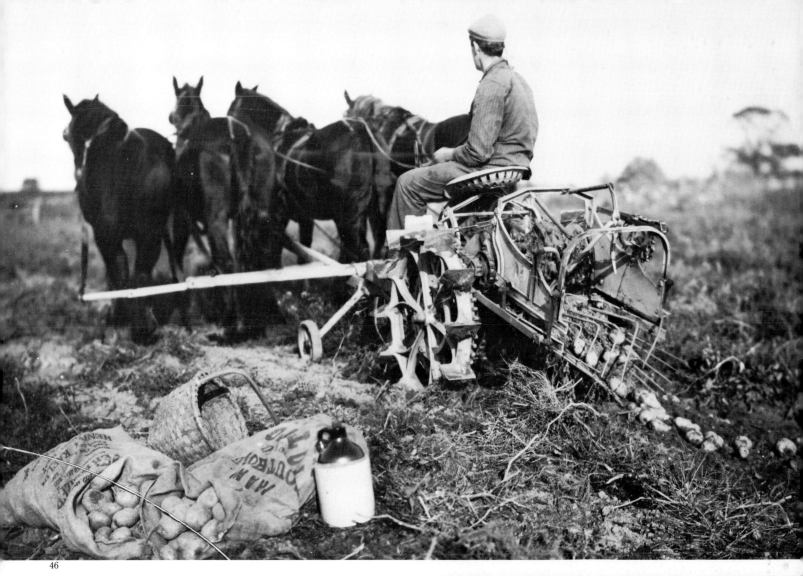

46

46. Horse-Drawn Potato Digger, Peconic, 1903. As competition from the Western states in the sale of corn, wheat and other grains increased in the nineteenth century, Long Island farmers turned to other crops—vegetables and fruits primarily—which could be sold to their nearby market, the growing population of New York City, or shipped across the sound to New London and Boston. The transition was not easy; in 1852, the *New York Times* scolded the farmers for their slowness in meeting the city's needs.

The soil and climate in Suffolk were congenial to the potato, tested by progressive farmers in the 1840s. By 1875, it had become a favored money crop for many farmers. Production was greatly encouraged by the late nineteenth-century development of machines for digging, planting, fertilizing and spraying the potatoes. This "apron-chain" type of potato digger left potatoes on top of the soil to be picked up by hand and packed into half-bushel baskets, two baskets to each burlap sack. Perhaps the jug contains "switchel," a temperance drink made of molasses, water, ginger and vinegar.

The immigration of Polish farmers, beginning around 1884, was another factor in the Long Island development of the potato; these farmers had European experience of the native American plant. Despite the 1917 potato blight and a lowering of the island water table caused by high evaporation in the potato fields, the famous Long Island potato is still Suffolk County's most important vegetable crop. *(Photograph by Hal B. Fullerton; Suffolk County Historical Society, Fullerton Collection, #L307B.)*

47. Cauliflower Auction, Riverhead, 1913. In 1872, the Riverhead Town Agricultural Society, founded nine years earlier, bought one pound of Algiers cauliflower seed for its members, beginning the period of almost 100 years during which Long Island farmers were the most important cauliflower growers in the United States. Fresh cauliflower was sent to the New York market and cauliflower-pickle plants were established for the fresh market overflow. The extraordinary development of this vegetable crop, along with the potato, led to further communal activity among farmers. As early as 1888 they called for a branch of the New York State Experimental Station to be established on Long Island (it was eventually founded in 1922) and held meetings to address the scientific problems of the farmer.

The economic problems were also significant, as individual farmers shipping barrels of cauliflower to commission merchants in New York were sometimes victimized by dishonest dealers. These problems were solved in

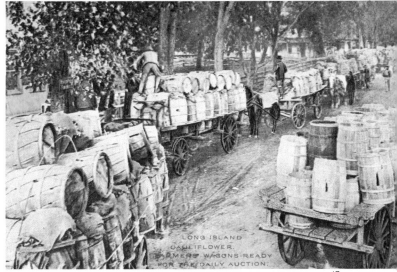

47

1900 by the establishment of the Long Island Cauliflower Association, which shipped whole carloads at lower rates and supervised unloading in New York. Later the association started the daily cauliflower auction to which the wagons seen here are going. The auctions were held first on Hallet Street, then at the fairgrounds entrance and continue now at the auction block on Mill Road.

In 1913 the Long Island Cauliflower Association shipped seven million heads of what they called "the luscious snowflake brand." In 1950, the volume of cauliflower shipped through the auction all over the Eastern United States (including cabbage and brussels sprouts) reached 1,383,192 crates. The success of the Cauliflower Association stimulated the development of the Long Island Potato Exchange in 1908 and other centralized farm co-op organizations, such as the Long Island Produce and Fertilizer Company (1921), now called LIPCO-AGWAY. *(Lightfoot Collection.)*

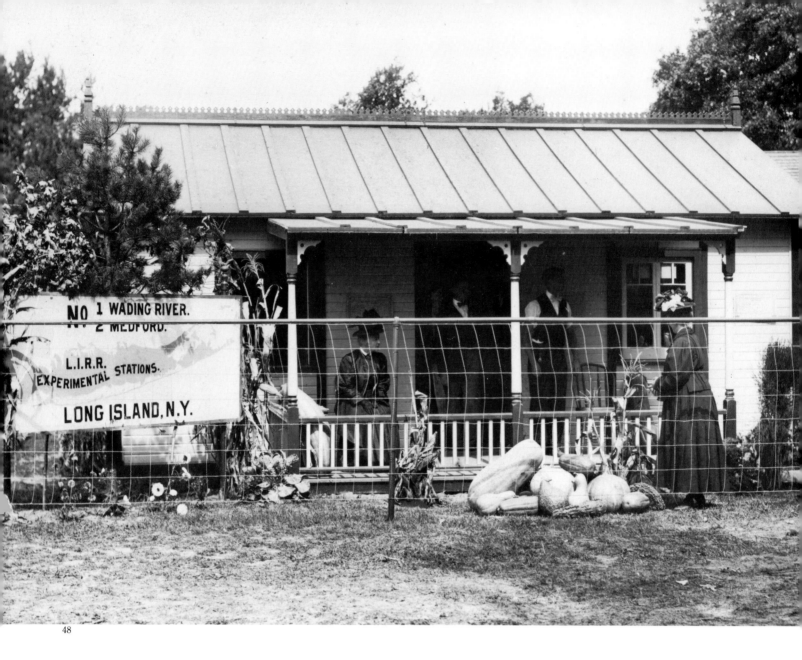

48

48. Farm Cottage, Riverhead Fair, 1908. Like the farmers' associations, the Long Island Rail Road also promoted regional agricultural development. To prove the fertility of lands for sale along its tracks, the railroad employed special agents Hal and Edith Loring Fullerton, who set up experimental farms at Wading River (1905) and Medford (1907). Buying the worst land they could find—all scrub pine and sand—the Fullertons set to work dynamiting, clearing, planting. Fighting insects, experimenting with seed types, developing irrigation systems, struggling with day labor, they proved that the common man with small financial resources could have a fine house and farm of his own if he had ambition and farming know-how. At the Riverhead Fair, the Fullertons displayed their giant radishes, exotic Japanese vegetables, perfect tomatoes and corn. They proved there was a market for their fine produce and cut out the middleman distributor by packing vegetable hampers for the Manhattan trade, including peas picked at dawn and delivered by railroad in time for dinner. Mrs. Fullerton, as much a dynamo as her photographer-husband, described the experimental stations in her book, *The Lure of the Land: A Call to Long Island* (1906, 1909, 1911). *(Photograph by Hal B. Fullerton; Suffolk County Historical Society, Fullerton Collection, #2081A.)*

49. Automobile Display, Riverhead Fair, 1908. Records of the Suffolk County Agricultural Society go back to 1818, when a constitution was written providing for biannual meetings and an annual fair. But the size of the county interfered with the development of these plans; a western fair was held as early as 1843 in Commack, the East End following with a Greenport Fair in

1849. In 1865, the Suffolk County Agricultural Society was reorganized with plans to hold its annual fair at Riverhead. An exhibition hall was built in 1867, and in subsequent years attracted such speakers as Horace Greeley, P. T. Barnum and Teddy Roosevelt. To stimulate attendance the society diversified its displays, including Indian relics, horse races, schoolwork (for which the Long Island Rail Road offered gold medals), and later the automotive products shown in this photograph. School buildings are now located on the site of the former fairgrounds. *(Photograph by Hal B. Fullerton; Suffolk County Historical Society, Fullerton Collection #254.)*

50. Trotter at the Judges' Stand, Riverhead Fair, 1897. Long Island farmers were even prouder of their horses than they were of cattle or sheep. From the period of earliest settlement, racing was a popular sport colonists brought with them from England. A number of racing champions were foaled in Suffolk County in the nineteenth century. One was the famous Lady Suffolk of Commack that raced from 1838 to 1853 and was the first to trot a mile in single harness in less than 2:30. Another outstanding performer was Rarus. Foaled in 1867 and raised by R. B. Conklin at Sound View Stock Farm, Greenport, he proved to be the world's fastest trotter of his time. Other top-notch trotters were raised by Carll S. Burr, Jr. at his Indian Head Farm in Commack. President Ulysses S. Grant, who sometimes stayed at Burr's home, was one of the prominent citizens who purchased Burr's trotters. Such horses raced at the Burr's own one-mile trotting racetrack or at innumerable smaller tracks, including this one at the Riverhead Fair. *(Photograph by Hal B. Fullerton; Suffolk County Historical Society, Fullerton Collection, #2036.)*

49

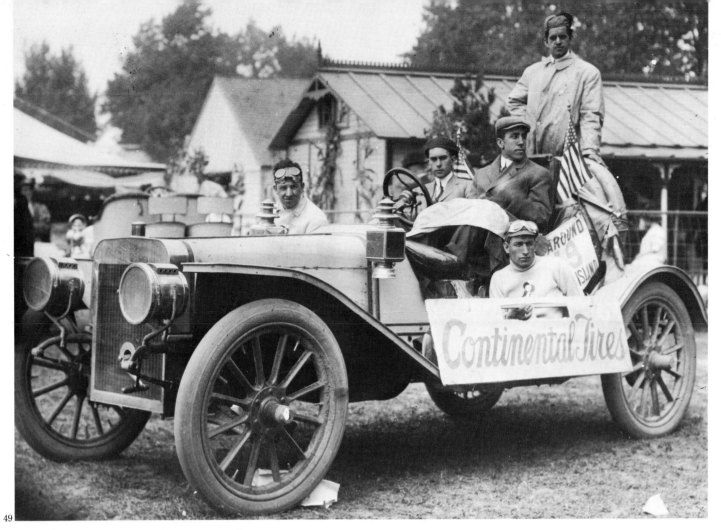

50

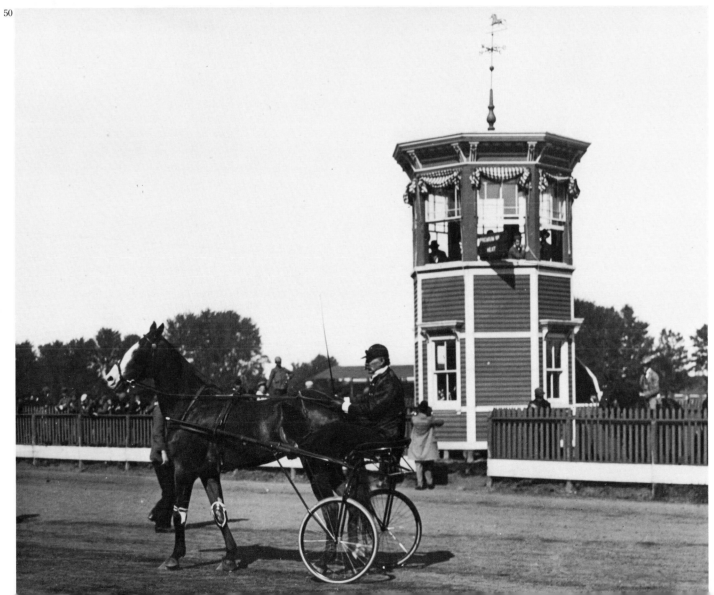

37

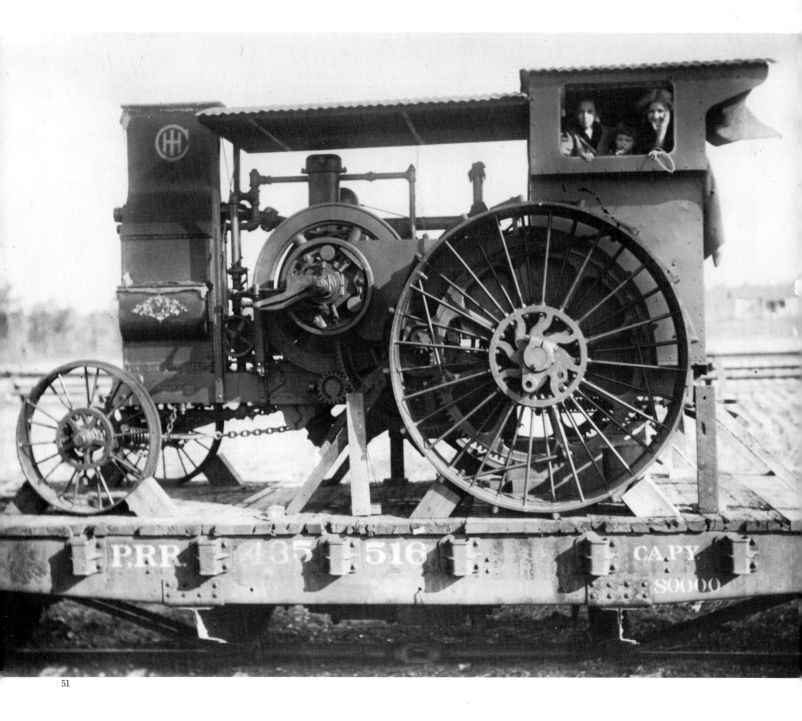

51

51. Steam Reaper at Medford, ca. 1912. The Long Island Rail Road tested new equipment at its experimental farm stations, including this steam reaper. Journalists and visitors were welcome at the stations and were likely to be amazed to see nearly 1000 plant varieties under cultivation, including the Japanese walnut, bamboo, almonds and pecans. Mrs. Fullerton took over supervision of the Medford Farm after her husband retired in 1927, but the Pennsylvania Railroad, which controlled the Long Island Rail Road, decided to discontinue the farm soon after. One permanent outgrowth of the Fullerton's experimental demonstrations was the establishment in 1912 of the New York State Institute of Applied Agriculture of Long Island at East Farmingdale, now part of the State University. *(Photograph by Hal B. Fullerton; Suffolk County Historical Society, Fullerton Collection, #6091.)*

52. Bringing the Grain to the Mill, Bridgehampton, 1899. This four-story windmill, known as the Beebe Mill, was built in Sag Harbor in 1820, where it was also used as a signal station for whaleships entering the bay. In 1837 it was purchased by Judge Abraham T. Rose and Richard Gelston and moved to Bridgehampton. Moved again by James A. Sandford, it was renovated with steam power and sold to Prospect Park, in Brooklyn. When this last move was regarded as impractical, it was resold, operated until 1911 and then was sold again in 1935. Today it still stands as a landmark in

Bridgehampton. Significant for its composite wood and cast-iron gearing, the Beebe Mill, 41 feet and 5¼ inches from the first floor to the top of the cap, is representative of American technology in a transitional period, standing on the border between America's wooden age and the beginning of the iron and steam era. *(Photograph by Hal. B. Fullerton; Suffolk County Historical Society, Fullerton Collection, #144.)*

53. Daniel Hildreth Wind Sawmill, Seven Ponds, ca. 1890. The old mills were not restricted to producing flour and meal. Water mills sometimes drove fulling equipment—water-driven mallets that pounded woolen cloth in a mixture of water, fuller's earth and soap to remove dirt and grease. Both water mills and windmills were geared to saw native timber in the days when the local supply met immediate needs. One of the most striking survivors of this era was the wind sawmill at Seven Ponds, which had sails of board instead of cloth. The wheel powered a huge ripsaw that cut lumber at high speed. The mill was also unusual in that, to catch the wind, the whole structure turned on a post sunk into the ground, instead of the conventional arrangement of having only the bonnet turn. Yet another unusual example of Long Island mill technology was the Great Western Mill at Southold, which had iron sails that could be reefed; it burned in 1870. *(Queens Borough Public Library, Long Island Division.)*

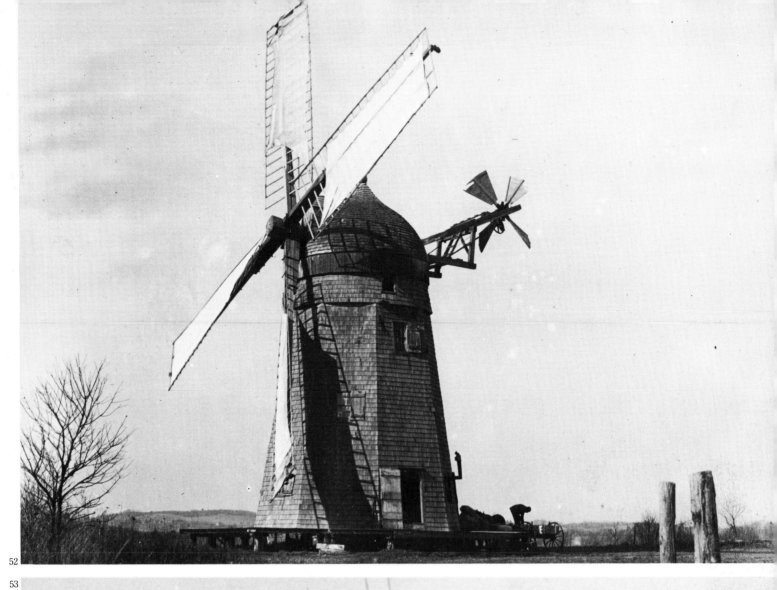

52

53

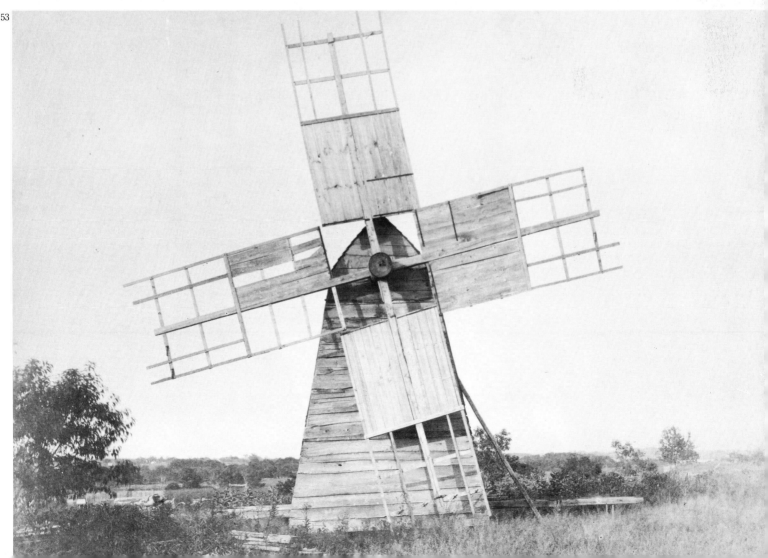

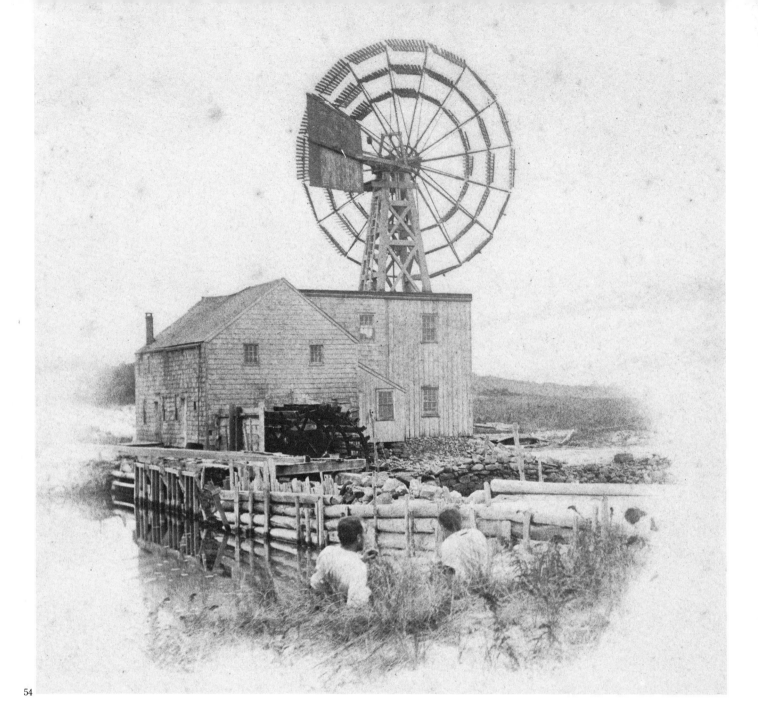

54

54. Peconic Mill, ca. 1895. Mills that harnessed the tides of the sea for power had to be built as part of a dam, usually at the mouth of a creek. The sea water would be allowed to enter the creek through a gate in the dam until high tide. Then the gate was closed. As the tide fell outside the dam, there would be a difference of level between the water inside the dam and that outside. This head of water was used to turn the mill wheel.

Since the towns controlled the creeks, the building of a mill and dam required official approval, which often involved a grant of land alongside the dam site and sometimes town involvement in building the dam. The arrangement was much like a modern franchise for a utility, as conditions and rates for the miller's services could be stipulated, including days in the week for operation and a requirement for free grinding for ministers.

This unique mill operated on a stream that entered the sound at Peconic. It was a conventional tide mill until its owners decided to add wind power to allow grinding when the water wheel was idle or the water was frozen. The mill was able to handle up to 300 bushels of grain a day. Because the need for the mill decreased as fewer farmers grew grain on the North Fork, the wind wheel was not repaired after it was wrecked by a blizzard in November 1898. The channel for the tidal wheel, known as the gutter, was allowed to fill up with sand, seaweed and mussels. Abandoned, the mill slowly broke apart. *(Lightfoot Collection.)*

55. Great Tidal Mill, Huntington, ca. 1905. Many tidal mills had docks so that sailing vessels could deliver grain and take away flour. The huge mill at Huntington had this feature. It was built in 1752 by Zophar Platt and operated until 1919. By the early 1900s it was known as Smith's Mill. Its mill dam was wide enough for a road to let wagons cross the water from the east side of the harbor. The mill building was destroyed by fire in 1930. The nearby home of the miller still stands on West Shore Road. The Surfside Delicatessen now stands on the site of the mill; part of the pond has been filled to make a baseball diamond. *(Lightfoot Collection.)*

56. Mill, Cold Spring Harbor, ca. 1910. This unusual mill was built in 1791 by Hewlett, Jones and Company. It was not a tidal mill, but received its water through the quarter-mile flume from an elevated freshwater pond south of the harbor. Before 1700, there were 25 or more water mills in Nassau and Suffolk, the grants important enough to be made in town meetings that provided farm and pastureland for the miller's use.

The mill in the photograph originally had a large wheel, but silting of the harbor made it difficult to keep the wheel free. To solve this problem, a turbine was placed in the mill, providing power for the grinding of 200 bushels of wheat a week. The dock was one of the main landing places for great quantities of manure shipped from New York's stables and streets aboard sloops or schooners and intended as fertilizer for Long Island farms. The mill burned down in 1921. *(Lightfoot Collection.)*

57. Mill, Southaven, ca. 1910. The few well-settled areas in the center of the island, such as Yaphank, clustered around small streams, some rather grandly called rivers. These waterways nourished attractive trees and were harnessed to drive mills. This mill was built in 1745. Its millpond is the place where Daniel Webster caught the famous 14½-pound trout which he carried on the afternoon stage to New York; it was served for dinner at Delmonico's that night. *(Lightfoot Collection.)*

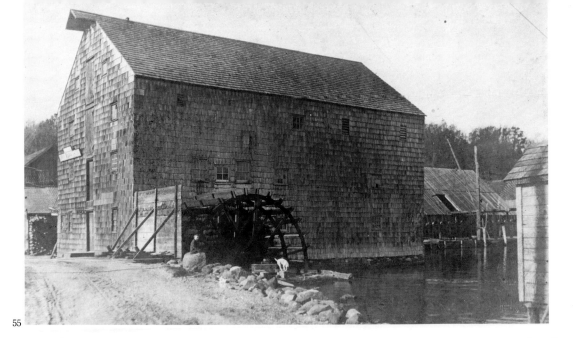

55

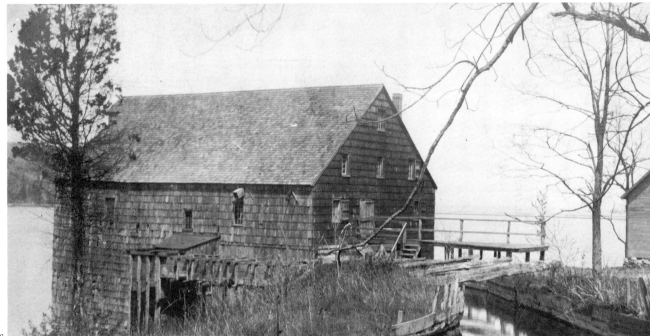

56

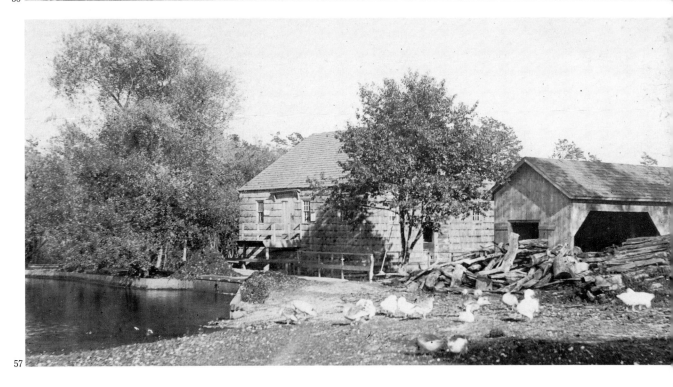

57

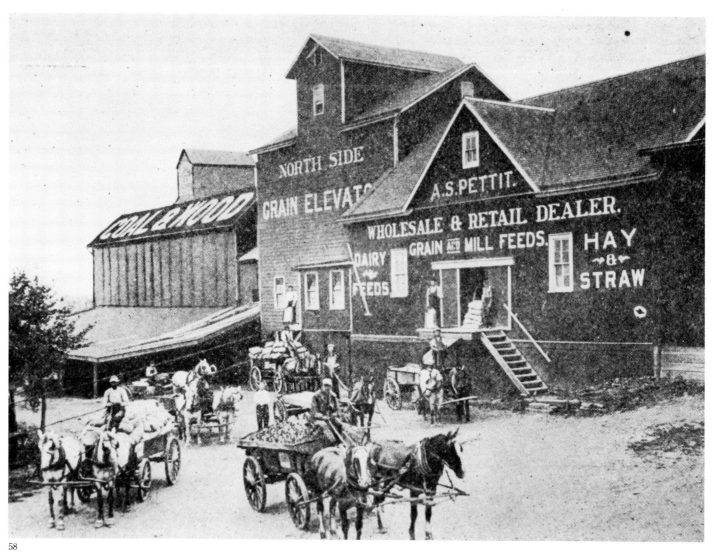

58

58. A. S. Pettit's Grain, Coal and Wood Depot, Huntington Station, ca. 1900. The merchant in grains was an important agent for farmers. Since he usually had his warehouse next to the railroad tracks, he often also dealt in coal and other fuels delivered by train. Fertilizer and various other farm supplies were natural additions to his stock. A. S. Pettit started out as the station agent and postmaster at Fairground, once the name of Huntington Station because of a nearby racetrack. Pettit soon built up a large business at the station site. For a time, the post office was located in the building, with Mrs. Pettit as postmistress. *(Huntington Historical Society.)*

59. Golden Pickle Works, Greenlawn, ca. 1880. Introduced as early as 1848, the cucumber was once a major Long Island specialty. Beginning in the 1860s, many pickle factories sprang up, especially along the extension of the railroad through the town of Huntington. These factories used millions of cucumbers, which schoolchildren were hired to pick at three cents a row. The "Pickle King," Samuel Ballton of Greenlawn, had been a slave in the South, but fled to the Union lines during the Civil War and fought for the North. After the war, he and his wife moved to Long Island, where he earned his title by growing one million cucumbers in one season. The pickle industry began to fade in the 1920s when the cucumber crop was destroyed by pests. However, sauerkraut, which was prepared in the pickle factories, was produced into the 1930s. *(Greenlawn-Centerport Historical Society.)*

60. Cattle Tent, Riverhead Fair, September 1898. In colonial days, thousands of cattle were shipped annually by boat from Wading River to New York. Special shows featuring cattle were held at Bridgehampton in the 1880s. The introduction of refrigerated railroad cars, which brought in cheap beef, lamb and hogs from the West, had much to do with the decline of meat herds in Suffolk, although dairy herds were maintained long afterwards and some farmers still raised pigs. *(Photograph by Hal B. Fullerton; Suffolk County Historical Society, Fullerton Collection, #1105C.)*

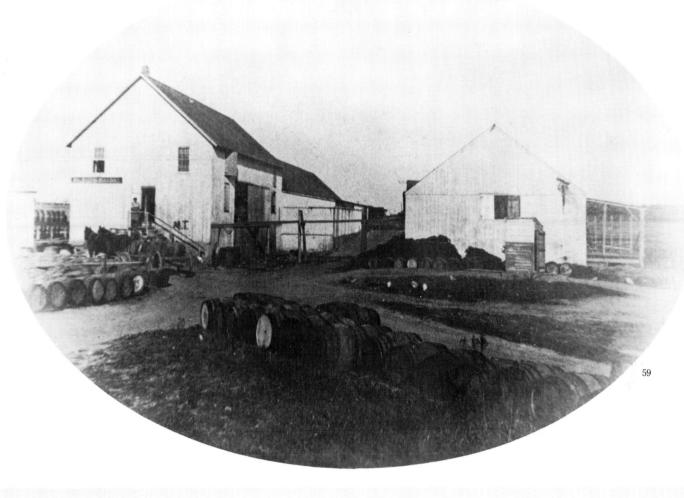

59

60

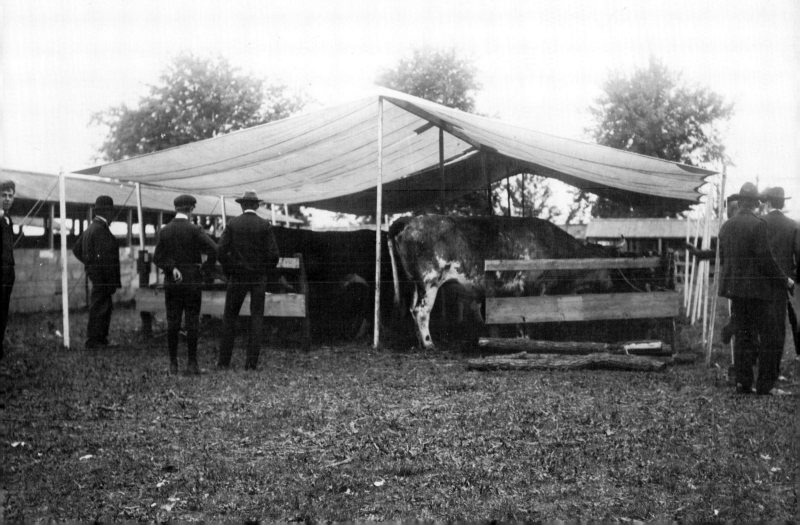

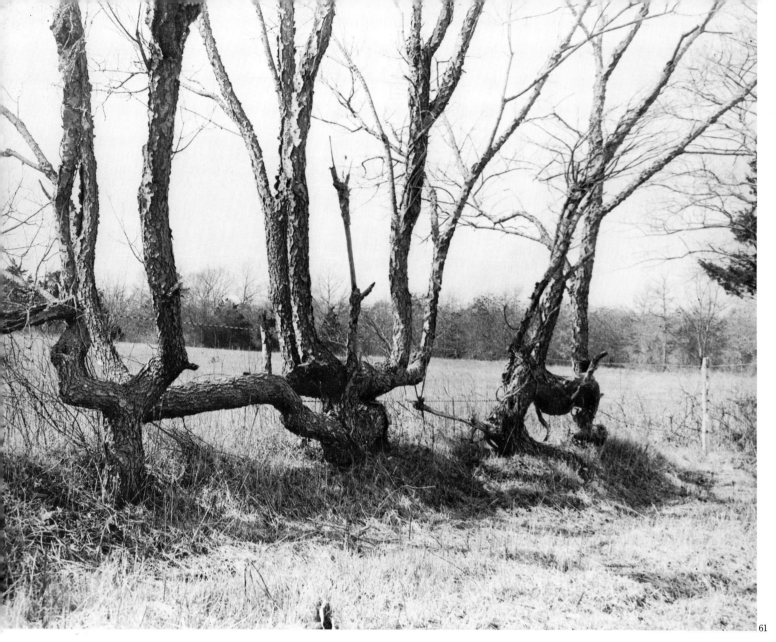

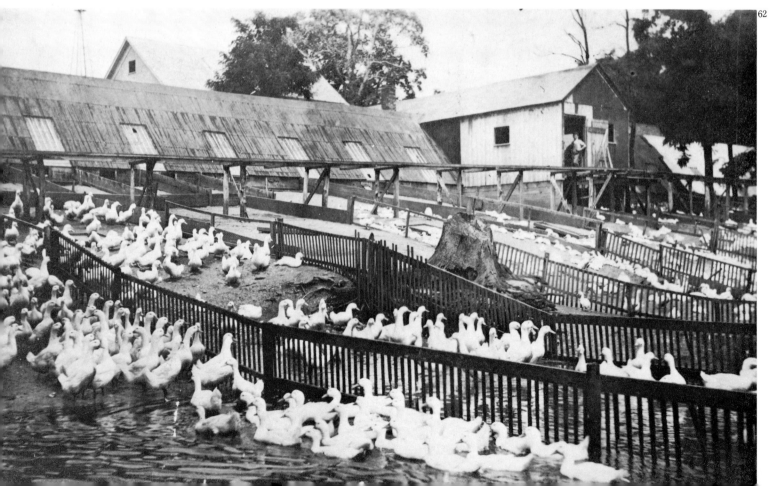

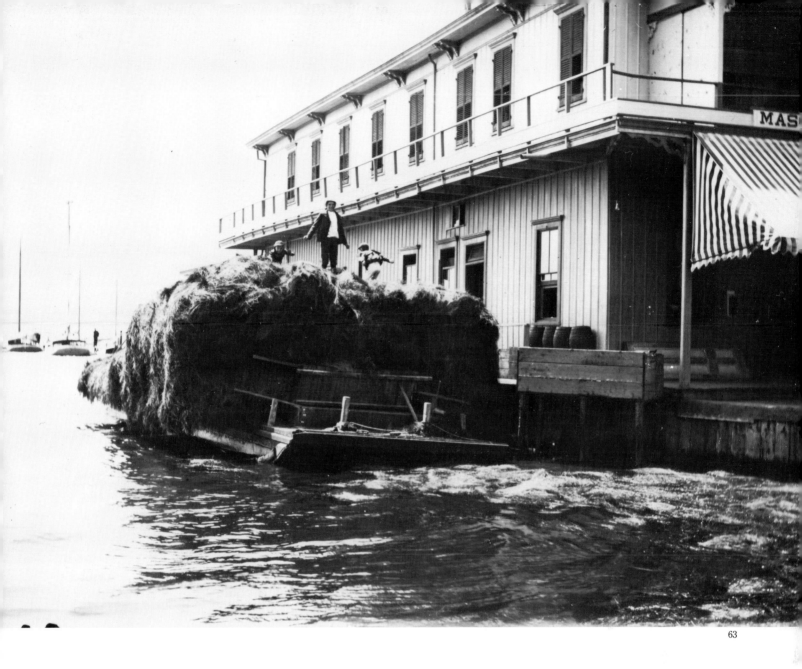

63

61. Lopped Trees, Lyman's Path, Bellport, March 25, 1903. "Lopped trees" were trees which had been cut down two-thirds of their height when young so that spring scions formed which were bent down to either side to grow horizontally. With adjacent trees, they formed a living fence that restricted movement of horses and cattle. Only oak, hickory and wild-cherry trees could stand the injury done by lopping and continue to thrive. *(Photograph by Howard Conklin; Queens Borough Public Library, Long Island Division.)*

62. Duck Ranch, Moriches, ca. 1910. The gourmet's delight, Long Island duckling had its beginnings in 1873, when a New York merchant named McGrath, visiting China, was impressed by the size of some white ducks he saw near Peking. He arranged to have 25 of the ducks transported to the United States. Sixteen died en route, and the recipients of the live ones ate five more. Four were kept by the agent who delivered them; they were brought to Connecticut, where they multiplied rapidly. A few ducks were taken to Long Island, where they thrived so well that duck dinners were standard fare by the 1890s.

Speonk had a large producer, A. J. Hallock's Atlantic Farm, which raised a quarter of a million ducks a year; Hollis Warner, on Riverside Drive in Riverhead, produced half a million ducks a year. Local women, paid five dollars a day to pluck duck feathers, were once among the best-paid workers of the East End, but gradually they were replaced by machines. The problem of controlling the wastes from the ducks, which polluted local streams, led to a drastic reduction of the number of farms. Duck production remains high on Long Island because of the expansion of a few farms, notably Corwin's, where freezing and eviscerating plants allow for the production of a million indoor-grown birds a year.

Chicken and fancy poultry were also raised for profit and pleasure on some Long Island farms, and poultry shows were held at Huntington. Chicken farming reached its peak after World War I; at one time, the Lone Oak Poultry Farm at West Islip, with 30,000 laying hens, was one of the largest in the country. *(Lightfoot Collection.)*

63. Salt-Hay Barge at the Mascot Dock, Patchogue, 1899. In addition to cultivating crops, the people of Long Island harvested various wild plants. One of the most important was the salt hay that covered the islands of Great South Bay and land along creeks. This hay was very useful for bedding cattle, mulching plants and insulating houses. It could also be sold in New York as the filling for cheap mattresses or cushions. In some locations, the old families shared the salt hay on common meadowlands and divided the lands into lots held by different individuals. Elsewhere, the towns retained the title to meadowlands and auctioned off sections of them each year to local residents for harvesting. A crew of three men usually sailed out to a lot to cut the hay. In some cases, flat-bottomed barges, powered by sail or motor, would be used to transport the load. The cutting of salt hay was very strenuous work, but was welcomed as a change from farm routines. *(Photograph by Hal B. Fullerton; Suffolk County Historical Society, Fullerton Collection, #1485A.)*

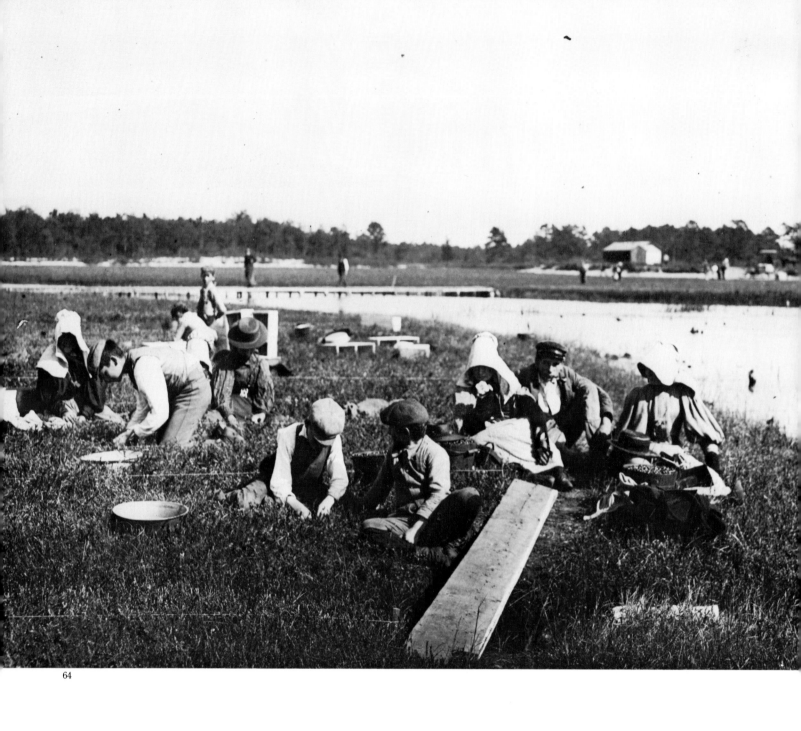

64

64. Cranberry Bog, Calverton, 1918. The cranberry was a natural crop that grew wild in the freshwater bogs of Suffolk County. Commercial cultivation increased production in Manorville, Calverton and Riverhead. Dams were used in Riverhead to flood the cranberry bogs in winter, protecting the vines from frost. Berries were picked with a special scoop with rows of long, closely spaced prongs. The vines slipped between the prongs; the berries were retained. Cranberry production began in the 1870s and decreased after 1930, when mechanical pickers were introduced to replace human labor; it turned out that the machines would not work well unless the bogs were carefully weeded and maintained. The cost for this attention made production unprofitable in view of competition from Massachusetts and Wisconsin. The Davis Marsh, located between Calverton and Manorville, stopped operating in 1976. Blackberries and wintergreen berries were once harvested commercially in Suffolk; the annual strawberry crop still reminds Long Islanders of the berry-growing capacities of their land. *(Photograph by Hal B. Fullerton; Suffolk County Historical Society, Fullerton Collection, #1997.)*

65. Bunker Boats, Greenport, ca. 1947. The menhaden, or mossbunker ("bunker" for short), an oily fish that spawned by the millions in Long Island's bays, was originally caught commercially for use as fertilizer, but methods of cooking it and pressing it to yield oil were eventually developed. In the pre–Civil War period, single hauls of 40,000 fish were taken by hand-held seines made of cotton twine. After the war, steamers owned by large companies took over the business. At the height of the steamer fishery, in 1881, 211 million mossbunkers were caught, producing more than a million gallons of oil. The steamers used large purse nets, then brought the catch to shoreline factories where the fish were processed.

The oil was used as a base for paint; the solid part, called guano, was used for fertilizer, especially in the cotton fields of the South and in the vineyards of Italy. In September 1899, fire destroyed three large businesses at Promised Land, a village of fish-oil and fertilizer factories that had grown up along the beach between Montauk and East Hampton in the 1870s. This disaster reduced the extent of the menhaden fishery, which, in 1898, had employed 9348 Long Island men working 601 vessels. The increase in tourist business on the East End and a decline in the abundance of the overfished bunker led to the closing of the last factory, Smith Meal Company, in 1969. *(Photograph by Frederick S. Lightfoot; Lightfoot Collection.)*

FISHING AND SHELLFISHING

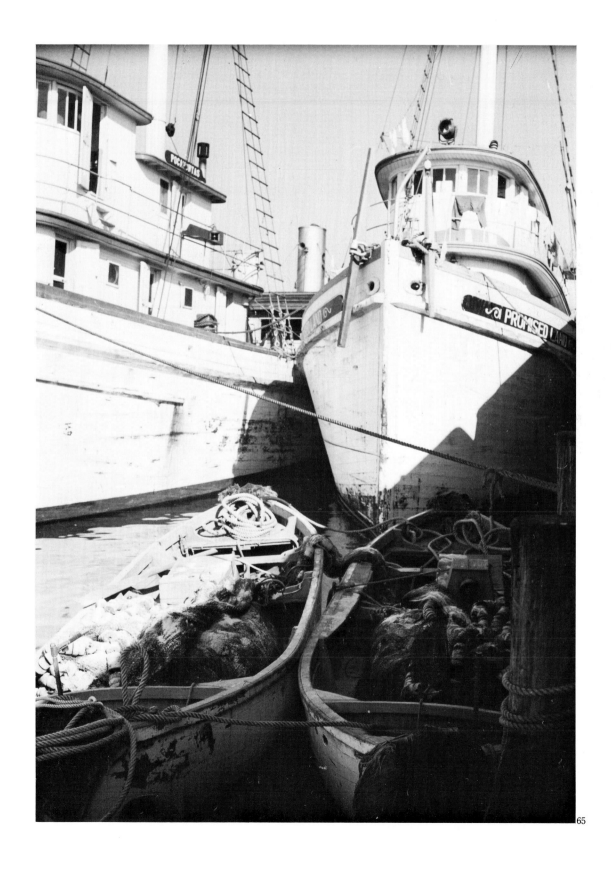

65

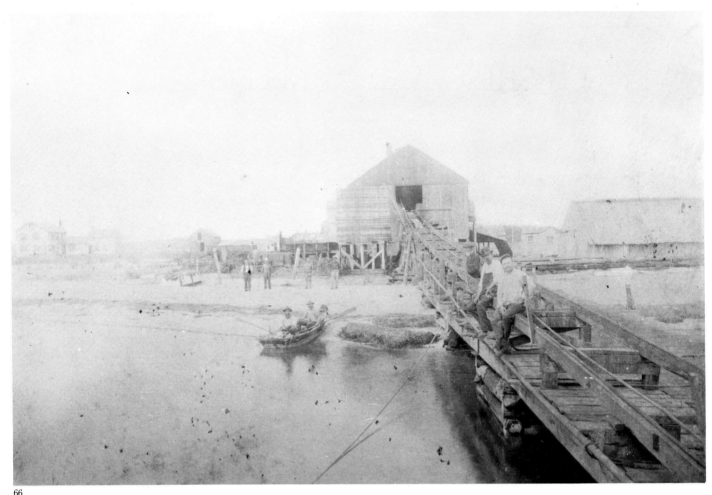

66

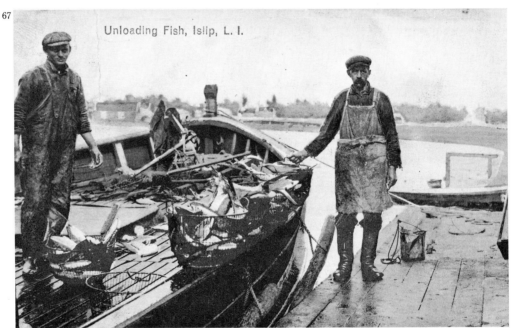

67

Unloading Fish, Islip, L. I.

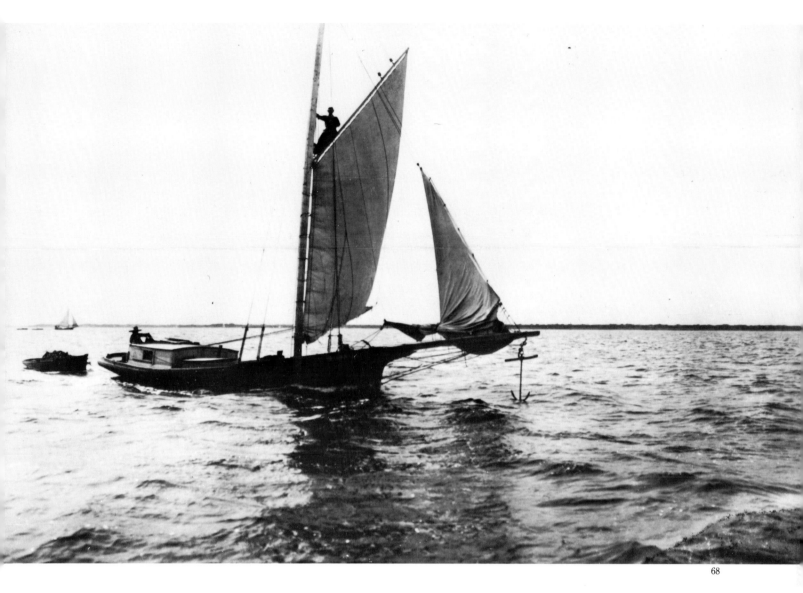

66. Deep Hole Fish Factory, Gardiners Bay, ca. 1890. This fish factory, one of the best of its time, used steam power to drive its equipment and a conveyor to bring the fish from the boats to the plant. The boat crews were often made up of Nova Scotians who traveled annually to Long Island for work. When immigration laws ended this practice, some of them settled on Montauk. Factories of this type developed after Marcus Osborn of Southampton introduced new techniques for catching and processing the fish at Jessup's Neck in 1847. The oil could be sold for about a dollar a gallon in the 1860s, but the price dropped below 30 cents once mass production was achieved. *(Collection of Mrs. Max Reutershan.)*

67. Unloading Fish, Islip, ca. 1915. Catching the fish is only one part of the fisherman's work. He has to stow the catch carefully in the hold of his boat, spreading ice over it. At dock, the catch has to be unloaded and sorted, weighed and sold. Boats and fishing gear have to be repaired, cleaned and made orderly; supplies and fuel must be replenished before the fisherman can catch his short night's sleep, casting off again in the morning. The wire-frame fish baskets in this photograph are still in use at some island harbors. *(Lightfoot Collection.)*

68. Fishing Sloop with Look-Out, Great South Bay, ca. 1902. One way men learned about handling boats and nets was to work on one of the many small boats that fished the bays, ocean and sound, going out early in the morning and coming back in the afternoon with the day's catch. These boats were often only sail-powered, but the manufacturing of small inexpensive engines led to the use of auxiliary sailboats and finally entirely engine-driven boats. Skilled fishermen could set drift nets, run a purse seine smartly if surface-feeding fish were around, drag a trawl net and tend fish traps. They had a rich resource in the 95 square miles of Great South Bay, which stretches for 24 miles across the Nassau-Suffolk border and has an average width of three miles. *(Photograph by Hal B. Fullerton; Suffolk County Historical Society, Fullerton Collection, #1324A.)*

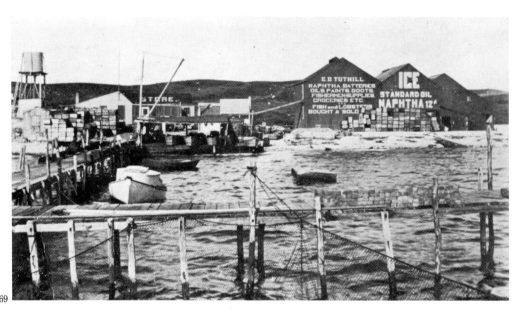

69

70

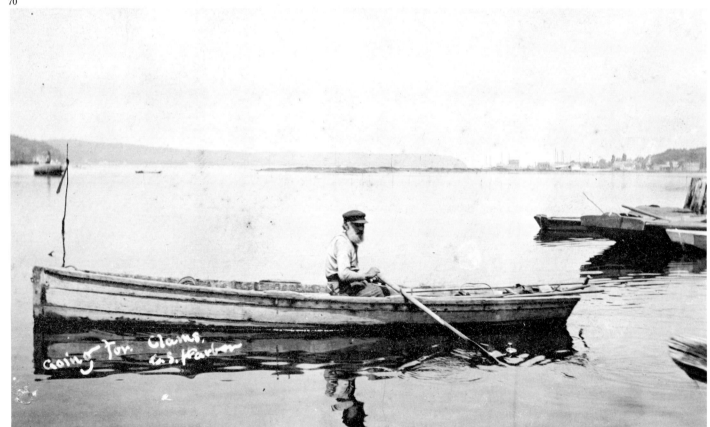

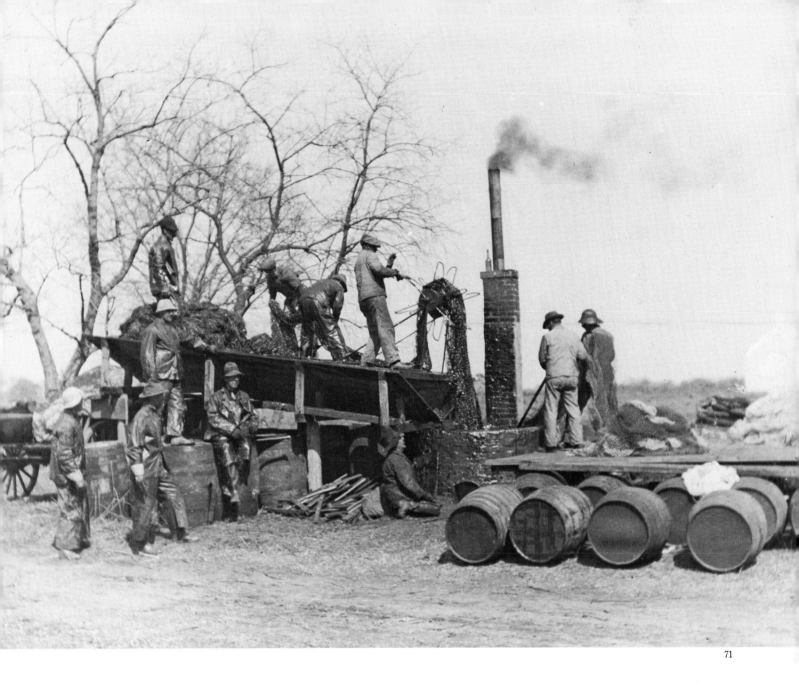

69. Montauk Fish Dealers, ca. 1910. The waters around Montauk Point have long been recognized as a rich resource for fishermen. All migrating fish that travel up the coast in spring and in the reverse direction in fall, pass through the Montauk waters. After spring spawning, many species congregate near Montauk to feed. Lobsters are year-round residents of the rocky bottom areas there, and codfish, with other cold-water fish, move down toward Montauk in the winter. Before the railroad reached the point, fishermen brought their hauls to wharves at Sag Harbor and Greenport. A 700-foot iron pier and plant were built at Napeague in 1880 to pack fish for shipment, but the pier was wrecked by winter storms.

In 1882, "Cap'n Ed" Tuthill, an East Marion man who fished at Montauk, erected a house on the beach at Fort Pond Bay. Once Montauk had rail service, Tuthill and others became prosperous shippers of fish. Tuthill was a customer of the railroad valuable enough to merit a special train from New York to get him to Montauk in a hurry. In later years, he entered a partnership with Perry B. Duryea, who took over the business in 1931. *(Lightfoot Collection.)*

70. Going for Clams, Cold Spring Harbor, ca. 1910. In addition to fish and lobsters, shellfish have been a valuable part of the Long Island fisheries. The simplest to catch and the most popular is the clam, which comes in two varieties: hardshell and softshell. Not counting "treading" for clams with your toes, the only equipment you need is a clam rake. Every year hundreds of

men and women go out on Great South Bay and on other bay waters of the North and South Shores to harvest clams with rakes having handles about 20 feet long. Pictures of old-time "baymen," who knew the ins and outs of Long Island's sheltered waters, are hard to find; the original bayman, reputed to have been a far wilder and solitary individual than his modern counterpart, had vanished from the scene by the time photography documented the shoreline. By the turn of the century the bayman must have become a romantic image, for this picture was sent as a New Year's postcard greeting from a mother to her son, pent in a Wall Street insurance office. *(Photograph by Greene of Port Jefferson; Lightfoot Collection.)*

71. Tarring the Seine, North Fork, 1916. The first fishnets used on Long Island were made of linen thread and were too small for capturing the great schools of menhaden that entered Long Island's bays for spawning. The development of cotton twine made it possible to make nets of larger size, including seines that could cover half a mile of creek or shoreline. During the winters, sailors and their women worked on knitting pounds of twine with meshes of an inch and a quarter. The last step in the process was to soak the net in tar, a preservative that prevented mildew. During the Civil War, cotton twine became scarce and costly, a blow to the small companies of "longshore" sailors in the menhaden fishery. *(Photograph by L. Vinton Richard; Oysterponds Historical Society.)*

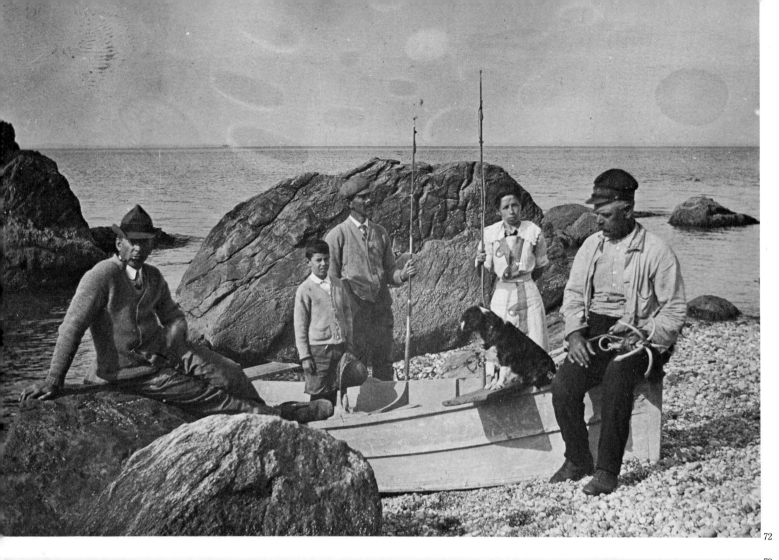

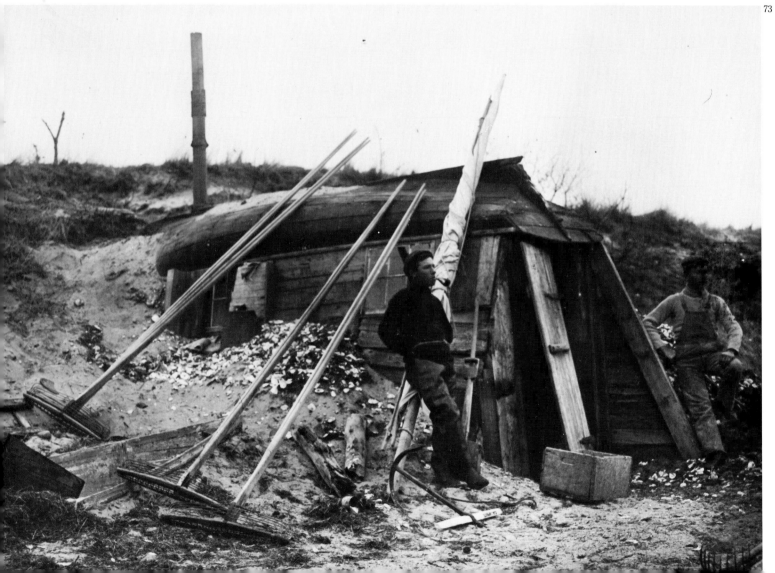

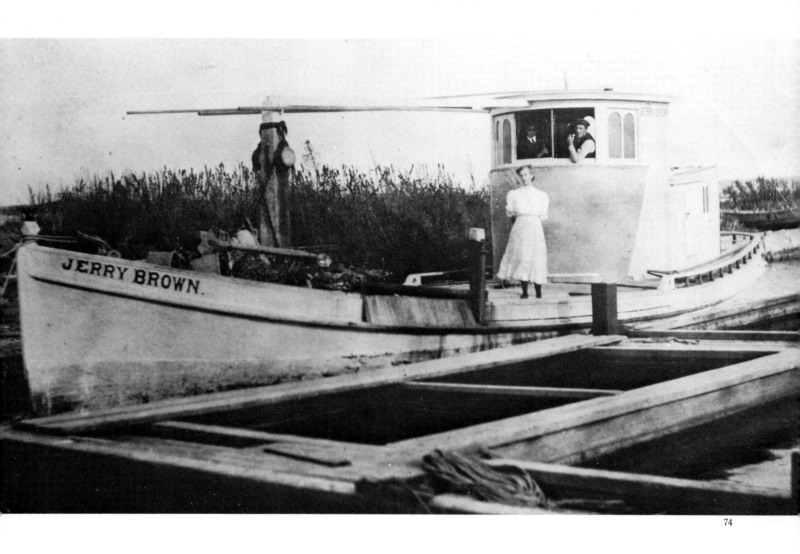

72. Blackfishing, East Marion, ca. 1905. Fishing was recreation as well as business, as these neatly dressed anglers on the beach near Rocky Point prove. The town of East Marion, formerly called Oysterponds Upper Neck, was known for its building of fishing smacks, vessels built with wells in which to carry live or iced fish. These deep-keel boats could carry over 1000 codfish; other fish in these waters included sea and striped bass, eels, flounders, mackerel, porgies and the blackfish the people in the photograph caught in Long Island Sound. The name East Marion was given to the village in the 1850s, when local residents were denied a post office called "Rocky Point" because a town of that name already existed in the state. A local resident, Warren Griffing, suggested East Marion, after the famous Revolutionary War general Francis Marion, a South Carolinian known as "the swamp fox" for his daring ventures against the English. East Marion is adjacent to some of the most beautiful wetlands on Long Island. *(Lightfoot Collection.)*

73. Oystermen's Shack with Boat Roof, ca. 1900. The irregular coast of Suffolk County, with about 600 miles of indented shoreline, provided some fine breeding grounds for oysters. Early settlers learned about oyster beds from the Indians, whose middens contain oyster shells. The oyster industry established itself early. Oysters from Virginia were seeded in Great South Bay in 1815, and they were very popular in New York restaurants throughout the nineteenth century, some observers noting that they were served more frequently than meat.

Although the supply must have seemed inexhaustible, by the late nineteenth century some of the most famous beds were cleaned out, disappointing gourmets who could distinguish the flavors of oysters from different locales. By the time of this photograph, thanks to oyster farming, 12 million pounds of oysters were harvested in a year. Problems of sewage and industrial waste reduced the volume by half in 1942, although the million-dollar business of 1901 was worth two million by World War II. As long as the water remained unpolluted, harvesters like those in the photograph could expect some good luck, for a single female oyster may discharge 100–500 million eggs a season. Adult oysters filter water at a rate of 26 quarts a day, however, and will not long survive pollution. *(Photograph by Hal B. Fullerton; Suffolk County Historical Society, Fullerton Collection, #2010.)*

74. Jerry Brown, ca. 1915. The oyster companies built special boats for dredging or converted older vessels. At first engines were used only to travel to and from the beds, and crew members hauled the dredges up from the bottom. Powered winches were installed later to save this labor, and the crew only tipped the dredges to empty the oysters out onto the deck. The large deck space on the *Jerry Brown* was used for storing oysters and doing rough sorting. Many such enterprises were defeated by natural and man-made disasters. The hurricane of 1938 damaged the oyster beds and growing pollution harmed the production of spat (baby oysters) in Connecticut. *(Suffolk County Marine Museum.)*

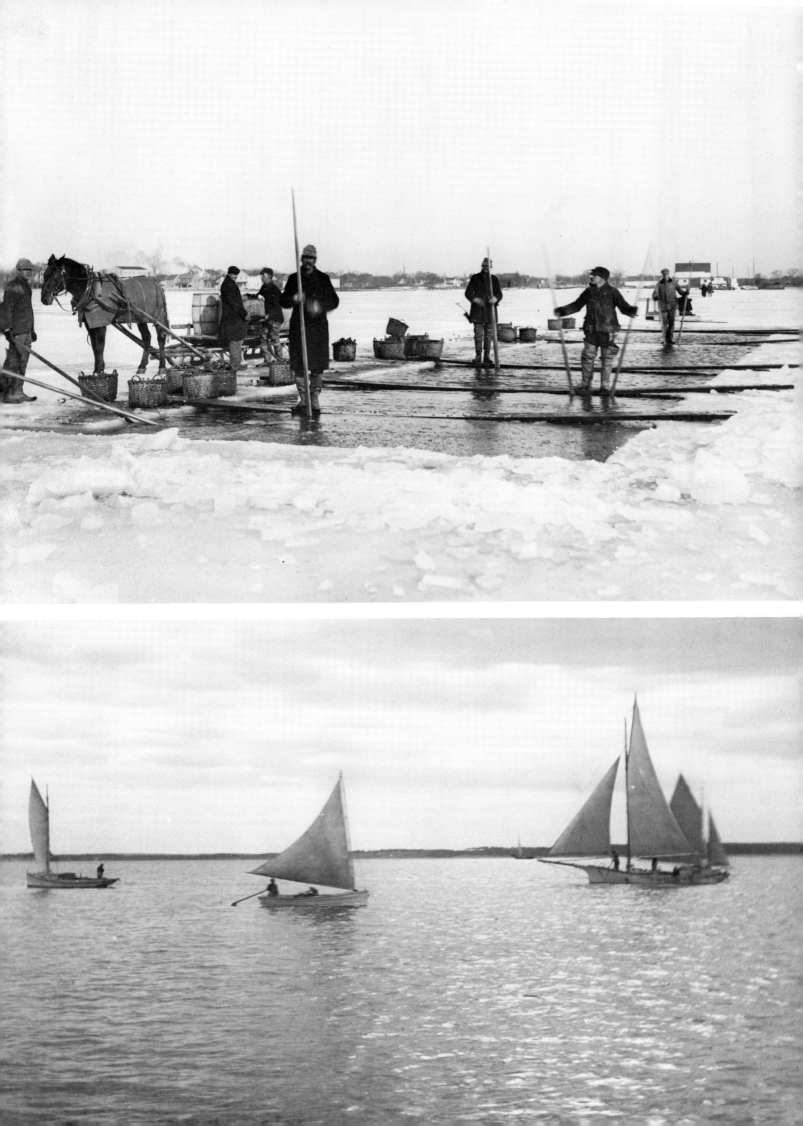

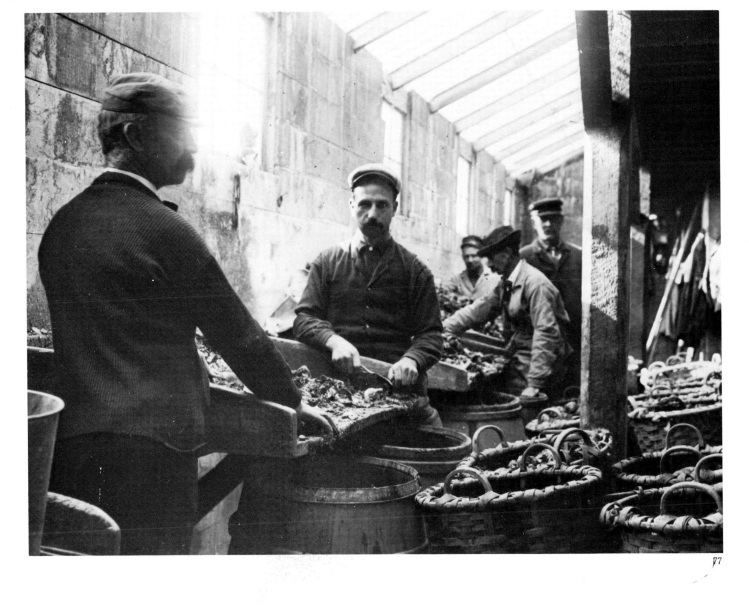

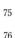

77

75. Tonging Through the Ice Near Patchogue, 1905. Toward the end of the nineteenth century, the baymen on Great South Bay who tonged natural oysters were not happy when immigrants from Holland, who had worked with oysters in their native land, organized companies to grow oysters with man's aid. These companies persuaded the towns to sell or lease to them acreages of the bay bottoms. They brought in baby oysters, called spat, from successful Connecticut beds, and spread them on Long Island bay bottoms.

Baymen not in on the arrangement argued that some of the companies' bottoms unjustly incorporated areas where oysters thrived naturally. They often poached on the companies' beds, with public sentiment on their side. There is no doubt, however, that only the companies' efforts maintained oystering as a significant industry after years of over-gathering and rising pollution. In the photograph, employees of one of the oyster companies are tonging oysters, which had been moved to shallow waters before the ice froze to permit easy harvesting during the winter. *(Photograph by Howard Conklin; Queens Borough Public Library, Long Island Division.)*

76. Dredging Scallops Off East Marion, 1915. The bay scallop, or "escallop," as the old-timers called it, is different from the clam and oyster in that, among other things, it can swim about in its adult form by quickly relaxing and contracting the muscle that holds the two halves of its shell together, causing the shell to open and close. This expels water in a strong jet that propels the scallop. The muscle is considered a great delicacy, especially the variety that thrives in Peconic Bay. Unfortunately, it takes a great many scallops to fill a quart container, and there are never enough in the bays to supply a large-scale fishery.

As a result, the scallop business has been regulated by law to conserve the scallop by limiting baymen to a certain number of bushels of two-year-old scallops a day. In the years before 1915, fishermen were even forbidden to use any power other than sail or oar. The harvesting of scallops seems to have been unknown on Long Island until some Connecticut fishermen explained their merits in the 1860s. Soon afterwards, the fishery developed so quickly that the stench of large piles of discarded shells became a problem for tourist resorts. New Suffolk was the foremost port for bay scallops, furnishing the empty shells to the oyster industry for use in collecting spat. *(Photograph by L. Vinton Richard; Oysterponds Historical Society.)*

77. Cleaning and Sorting Oysters Near Great South Bay, ca. 1900. When the oysters arrived at the dock, they had to be unloaded, cleaned and sorted for size. Many oysters were sold live in the shell and were packed in barrels. Others were shucked, the meats going into small cans, the shells being saved for use as a covering for dirt roads or as collecting material for the harbor bottoms in Connecticut, where baby oysters were set. The people who worked at shucking, a poorly paid job, included Portuguese from New England and blacks from Virginia, who migrated to Long Island during months with an "r" in their names. Local shuckers included the Polish immigrants who farmed during the summer and shucked in the winter. Some growers used to "drink" their oysters, putting them in fresh or brackish water. This made the oysters whiter and plumper, improved the flavor, but was also a good way to sell water at the price of oysters. *(Photograph by Hal B. Fullerton; Suffolk County Historical Society, Fullerton Collection, #1028A.)*

Fishing and Shellfishing 55

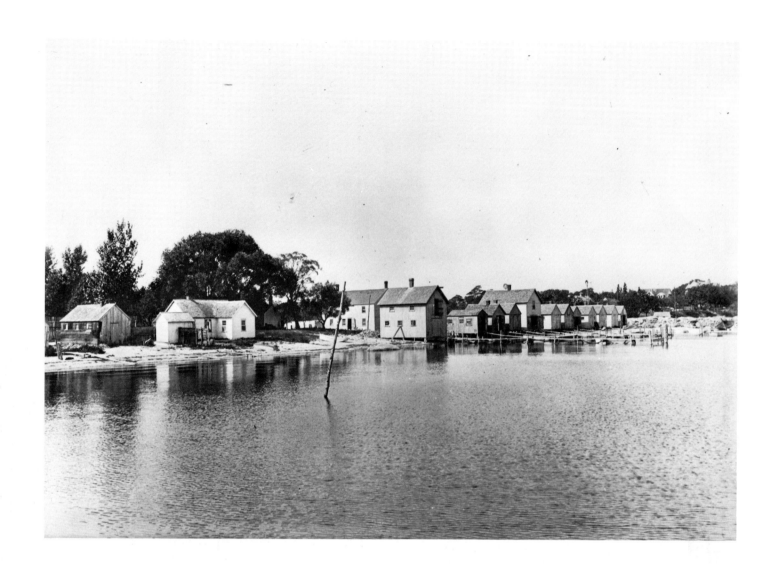

78. Waterfront with Scallop Shops, New Suffolk, 1914. Once called Robins Island Neck (possibly after *robben*, the Dutch word for seals), New Suffolk was laid out and developed as a community of 80 acres by Ira Tuthill—farmer, shopkeeper, fisherman, blacksmith, brickyard owner and deacon! Tuthill promoted New Suffolk as a summer resort, advertising in a New York newspaper, in 1840, that he had opened his house for the accommodation of boarders. Steamboats brought passengers from New York to Port Jefferson, from which stages carried them to Riverhead and New Suffolk—a day's journey. For those in less of a hurry, four packet sloops ran between New York and New Suffolk. While Tuthill proclaimed the beauty and healthfulness of his location, others saw it as a convenient center for shellfish processing, as indicated by this line of scallop shops, where scallops were opened, processed and packed for sale. *(Photograph by Henry Otto Korten; Nassau County Museum.)*

INDUSTRIES

79. Storehouse and Horse-Powered Boat Winch, Port Jefferson, 1897. From earliest records until about 1885, a major part of Suffolk County's shipbuilding industry was centered in Port Jefferson. With the decline of whaling, the use of freight and passenger trains and the introduction of steam-powered vessels, the industry shifted to the building of pleasure boats. By the time this photograph was taken, craftsmen had turned from the construction of oceangoing sailing ships to painting, repairing and storing smaller craft. The horse-powered winch seen here was still being used for hauling the boats. *(Photograph by Hal B. Fullerton; Suffolk County Historical Society, Fullerton Collection, #1450A.)*

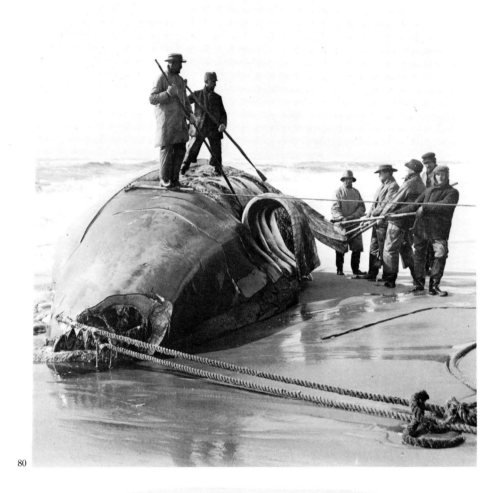

80

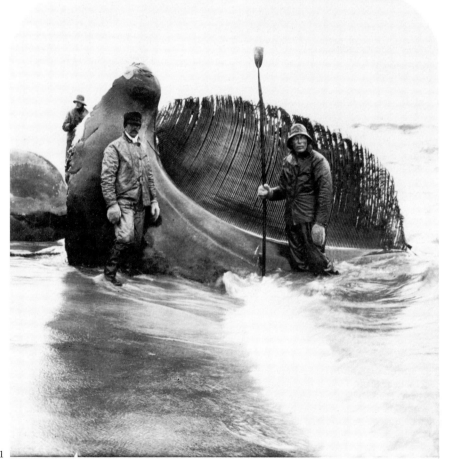

81

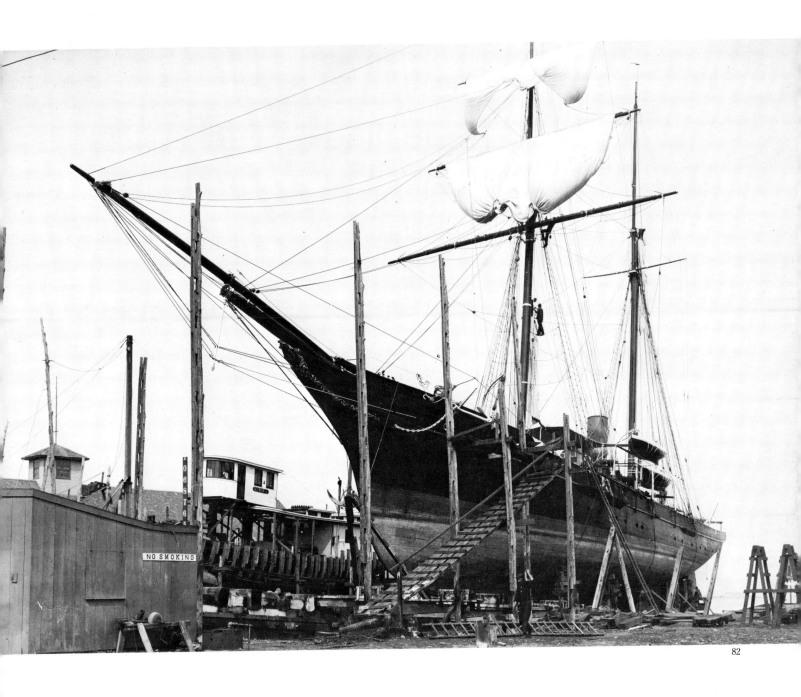

82

80. Cutting a Whale Near Amagansett, ca. 1907. From the time of colonial settlement until the mid-nineteenth century, whaling was a flourishing industry on Long Island. When whales were still plentiful, it was customary to go along the shore in open boats and, once a whale was killed, to tow it to shore where it was "tried" into oil. As whales became scarcer, it became necessary for whaling ships to take ten- or 11-month voyages—or longer— sometimes as far away as the Pacific or Arctic, but shore whaling continued into the early twentieth century. At the height of the industry in 1847, 70 Sag Harbor vessels were engaged in whaling and the port netted $996,500 from whale oil and bone. This whale has been beached (whales which drifted to shore were considered gifts of Providence in the seventeenth century). The men are cutting or "flensing" the whale to remove its blubber, from which oil will be extracted. *(Negative by Underwood & Underwood, published by The Keystone View Company; Lightfoot Collection.)*

81. Head of a Whale, Near Amagansett, ca. 1907. Before explosives were used, harpooning whales was a dangerous undertaking. A life-insurance policy dated October 5, 1847, shows that two Sag Harbor whalemen (both of whom died at sea) were each insured for $200 with an annual premium of $12.80. The large right whale seen here, a native of the Arctic region, was taken off the coast of Long Island. The right whale had a large strainer in its mouth that held back the edible contents of the water it swallowed and expelled. This strainer yielded the strong and flexible whalebone once used to reinforce corsets. Shore whale fishing dwindled by the twentieth century. In 1907, two of the last Long Island whales were struck, one at Wainscott and one at Amagansett. *(Negative by Underwood & Underwood, published by The Keystone View Company; Lightfoot Collection.)*

82. Yacht, Port Jefferson, ca. 1905. Shipyards increasingly catered to the demands of the wealthy for extravagant pleasure yachts. Some of these oversize yachts frequented the waters of the sound and the Peconics. This one, hauled out at Port Jefferson, had sail as well as engine power. Millionaire sportsmen, such as William K. Vanderbilt, Jr. and Howard Gould, commissioned elaborate vessels for their private use as well as for steam-yachting competitions. As the *Port Jefferson Echo* observed in 1907, "None but the wealthy can hope to own the floating palaces beside whose immense cost the finest of automobiles is in comparison as cheap as a bicycle." *(Lightfoot Collection.)*

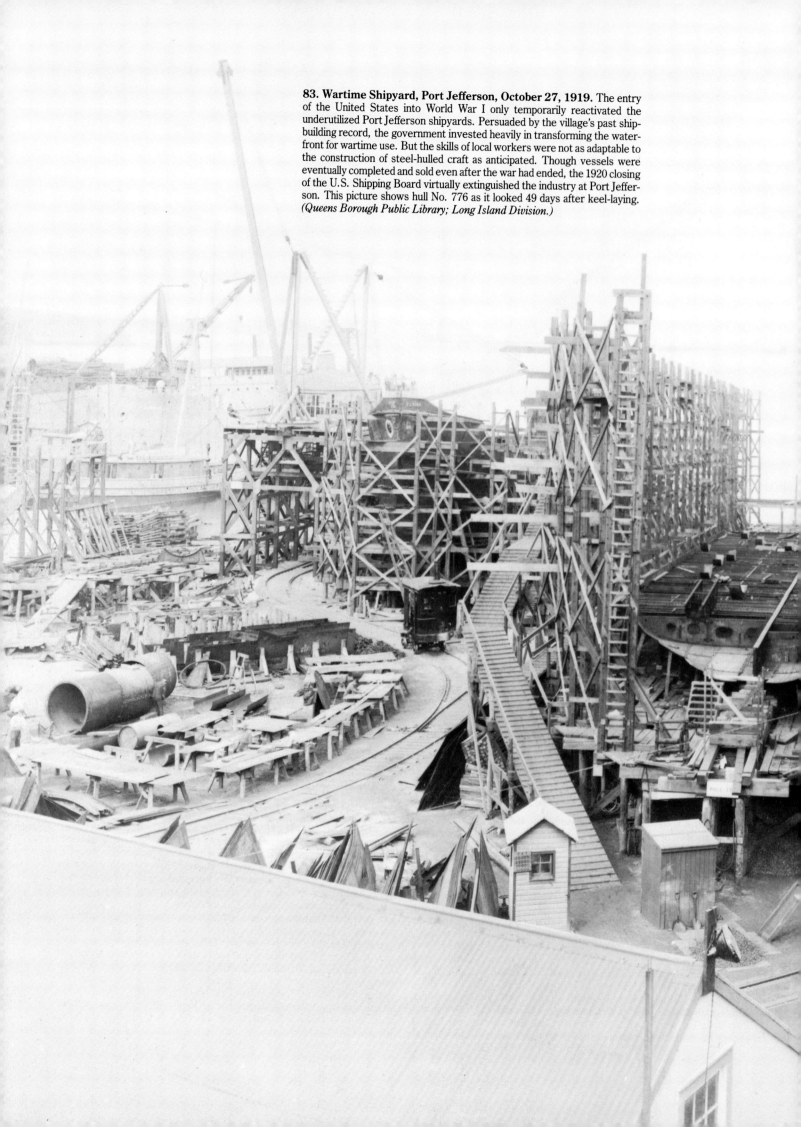

83. Wartime Shipyard, Port Jefferson, October 27, 1919. The entry of the United States into World War I only temporarily reactivated the underutilized Port Jefferson shipyards. Persuaded by the village's past ship-building record, the government invested heavily in transforming the waterfront for wartime use. But the skills of local workers were not as adaptable to the construction of steel-hulled craft as anticipated. Though vessels were eventually completed and sold even after the war had ended, the 1920 closing of the U.S. Shipping Board virtually extinguished the industry at Port Jefferson. This picture shows hull No. 776 as it looked 49 days after keel-laying. *(Queens Borough Public Library; Long Island Division.)*

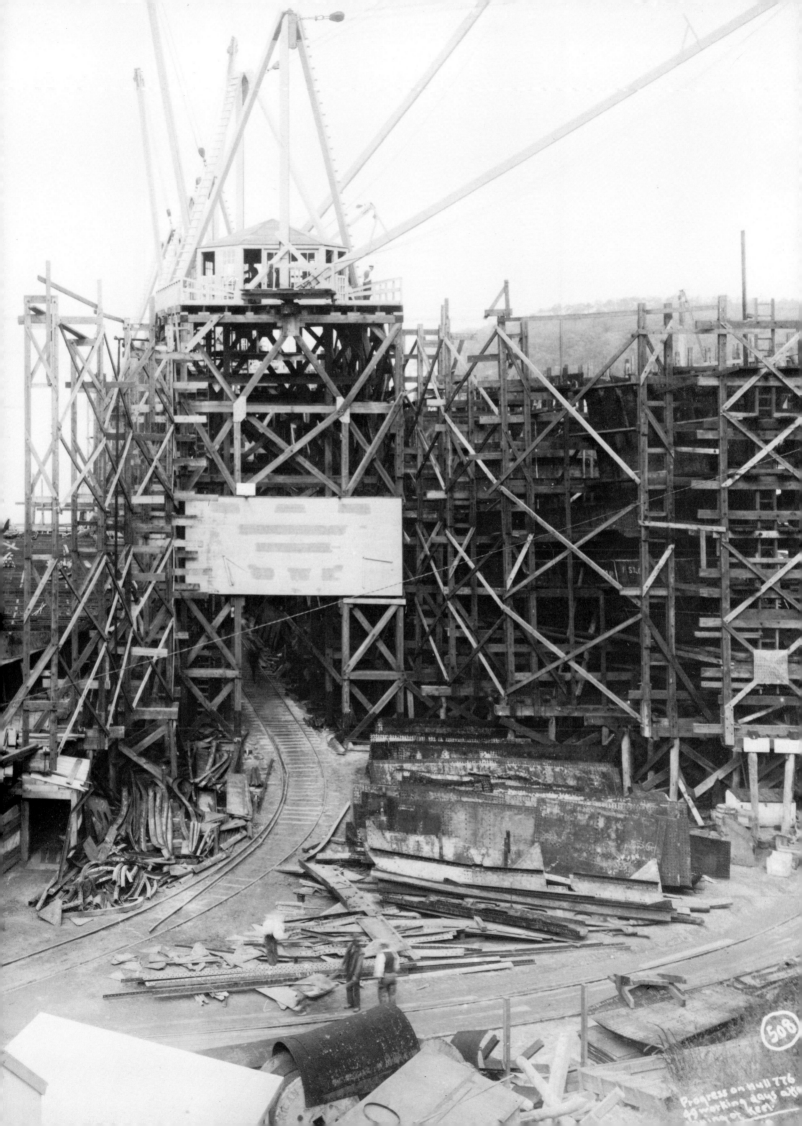

Progress on Hull 776
99 working days after
laying of keel
508

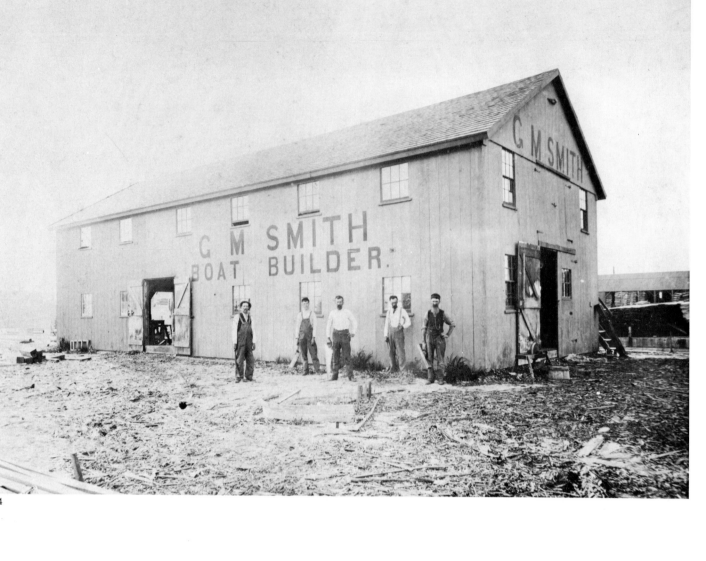

84. G. M. Smith's Boatshop, Patchogue, 1892. It was estimated that by 1885, nearly one-third of Suffolk's male population worked in the county's 25 shipyards. On the South Shore, the shallow depth of the Great South Bay precluded the construction of large vessels. In the 1890s, Patchogue had several small yards specializing in boats of up to a 40-foot keel. G. M. Smith's yard, which operated from 1876 to 1938, was noted for the excellent design and workmanship of its boats. All work was done by hand, with the exception of a sewing machine used on the sails. Standing in this picture are, from left to right: boatbuilder Gil Smith, holding an ax; Asa Smith (Gil's son) with a hatchet; Jim Wicks with a saw; Lew Wicks with a hammer; Mr. Post with a block plane. *(Queens Borough Public Library, Long Island Division.)*

85. Cutting Up Lumber in Greenport's "Industrial" Center, ca. 1888. During the 1880s, Greenport's main sources of revenue came from menhaden fisheries, boatbuilding and summer tourism. But, as in many other developing villages, small-scale industries and professions also thrived: carriage shops, livery stables, blacksmiths, veterinarians, hay dealers, tanners, shoemakers. The men seen in this picture (George Preston at right) are cutting heavy lumber. Behind them, from left to right, are the buildings of L. F. Bersenger, carriage maker, and W. E. Shipman, blacksmith and horseshoer. *(Stirling Historical Society.)*

86. Hygeia Ice Company, Greenport, ca. 1910. Without ice to chill fish in boat holds or during shipment, East End fishermen were hampered in supplying markets with fish in prime condition. For many years, their only source of ice came from blocks cut from the freshwater rivers and ponds during winter and stored for use in summer. The ice was kept from excessive melting by covering it with salt hay or sawdust in insulated icehouses. It was a great blessing when mechanical refrigeration at last allowed ice to be made in quantity all year. One of the first ice plants was built in Greenport in 1899. Besides supplying the local fishing fleet, the ice was sold to restaurants and homes throughout the North Fork. *(Stirling Historical Society.)*

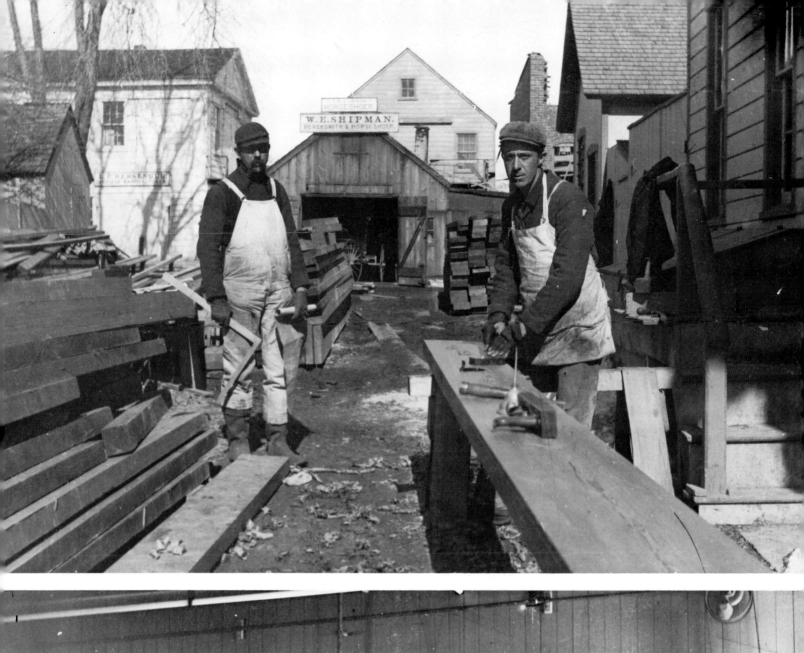

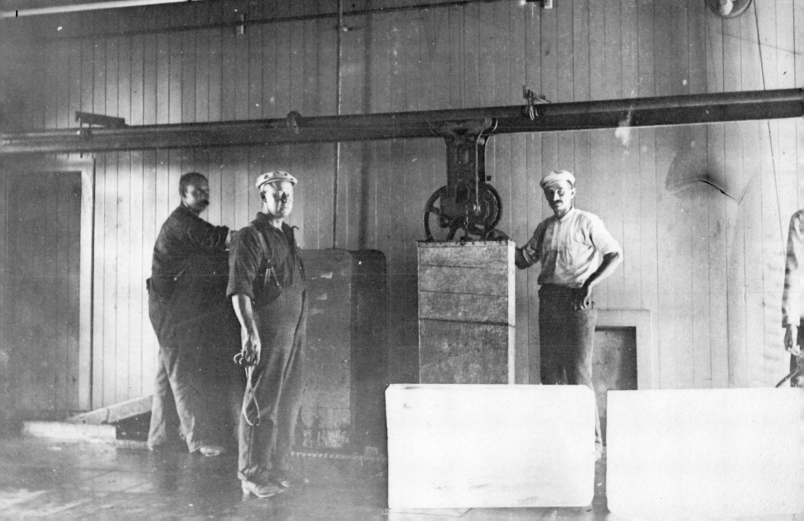

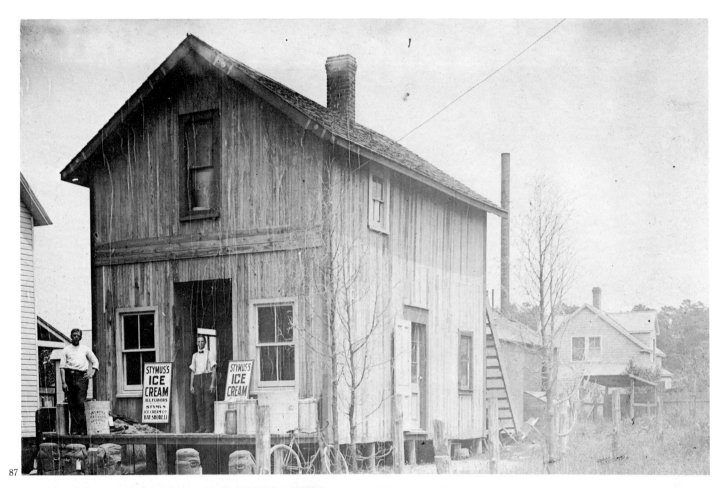

87

88

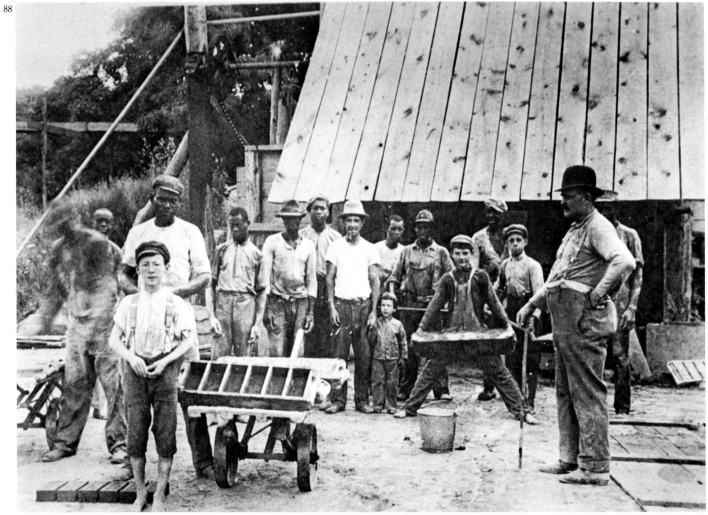

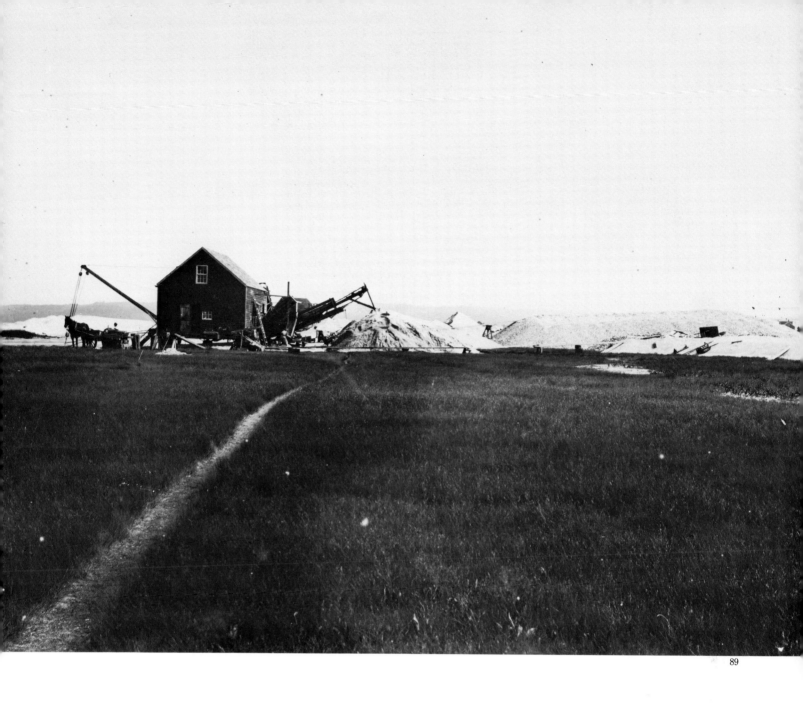

89

87. Stymus's Ice-Cream Factory, Bay Shore, ca. 1905. The swelling population on Long Island created a surplus of labor. Manufacturers installed "factories" in old mill buildings, using the plentiful manpower to make such products as organs, rubber, cigars, buttons, drumheads and pickles. The summer tourist trade also stimulated local production of such delicacies as ice cream. Commercial preparation of ice cream had grown with the discovery that salt mixed with ice produced a lower temperature than ice alone, as well as with the introduction, late in the nineteenth century, of mechanical refrigeration. *(Lightfoot Collection.)*

88. Old West Neck Brickyard, Lloyd Harbor, ca. 1900. Beneath Long Island's topsoil lie varied clay deposits—white for pottery and pipes, ocherous for yellow pigment, red and brown for stoneware, coarse pottery and bricks. Indians had used this clay for making simple vessels. Settlers later produced brown ware and stoneware chimney pots and pipes, drain tiles and brick. Suffolk County's greatest concentration of brickyards was near Huntington. In the 1870s, the two West Neck yards of Charles H. Jones and Frank M. Crossman produced 15 to 20 million bricks annually. Rarely photographed, these brickyard workers pose under the watchful eye of a derbied foreman.

Most workers were Irishmen, picked up by representatives of the yards as they emerged from the immigrant station at Castle Garden (later at Ellis Island) in New York. As this picture shows, blacks were also employed. In the days before industrial safety, the child laborers do not even wear shoes to protect their feet. *(Huntington Historical Society.)*

89. Sand City, Huntington, August 1900. Tremendous hills of sand and gravel, left by glacial deposits, provided the materials for a lucrative industry on Long Island. Gangs of Nova Scotians and European immigrants were hired at nominal wages to do seasonal work in the sand pits. One deposit of sharp, gritty sand near Northport was found to be ideal for stonecutters, who used it in sawing, dressing and polishing marble. At Eaton's Neck, another type suited the molding sand required in metal casting. By the 1870s, sands were commercially handled, as were the 15 to 20 thousand tons of gravel shipped to New York and elsewhere. Before environmental control was instituted, entire areas were leveled and defaced. Eventually, most of the waterfront land and hills near the sound were considered more valuable for residences than for sand mining. *(Photograph by Hal B. Fullerton; Suffolk County Historical Society, Fullerton Collection, #L25A.)*

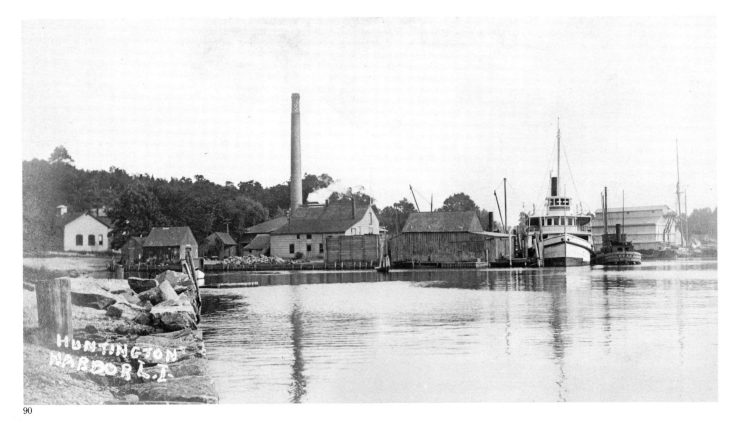

90. Huntington Light and Power Station, ca. 1905. Providing gas and electric power for a growing population was a new form of industry at the turn of the century. Before 1869, only five "gas-light" companies had existed at Astoria, Brooklyn, Flushing, Jamaica and Hempstead (the last-named was absorbed by the Nassau and Suffolk Lighting Company). The age of electricity created new demands for energy. At first, power companies were local affairs, with individual generating plants in the most progressive villages. Incorporated in 1902, the Huntington Light and Power Company operated until 1919, when it was acquired by the expanding Long Island Lighting Company. *(Lightfoot Collection.)*

91. Lace Mill, Patchogue, 1899. Patchogue's river and streams provided waterpower for many kinds of mills and factories. Since the eighteenth century, Patchogue had been home to the Union twine mill, the third cotton mill built in the United States and the first to make carpet warp from cotton. When the Nottingham Lace Works came to Patchogue, it became a major employer. Leased in 1880 to the Scottish firm of Carlslow Henderson and Company, the mill manufactured crinolines and imported lace curtains for bleaching and finishing. The business was sold in 1890 to the Patchogue Lace Manufacturing Company, seen in this idyllic view. *(Photograph by Hal B. Fullerton; Suffolk County Historical Society, Fullerton Collection, #L23B.)*

92. Lace Mill, Patchogue, ca. 1905. After looms were installed in the Patchogue mill for direct manufacturing of lace curtains, the business grew into a major industry. During the 1890s, for example, it produced about 900 pairs of curtains weekly. By the time this picture was taken, it had become one of the largest lace-curtain mills in the country. Postcard photographer Korten, who chose to immortalize these straw-hatted employees as they cycled home from the mill, achieved a more realistic, documentary image of the mill than Fullerton did. *(Photograph by Henry Otto Korten; Nassau County Museum.)*

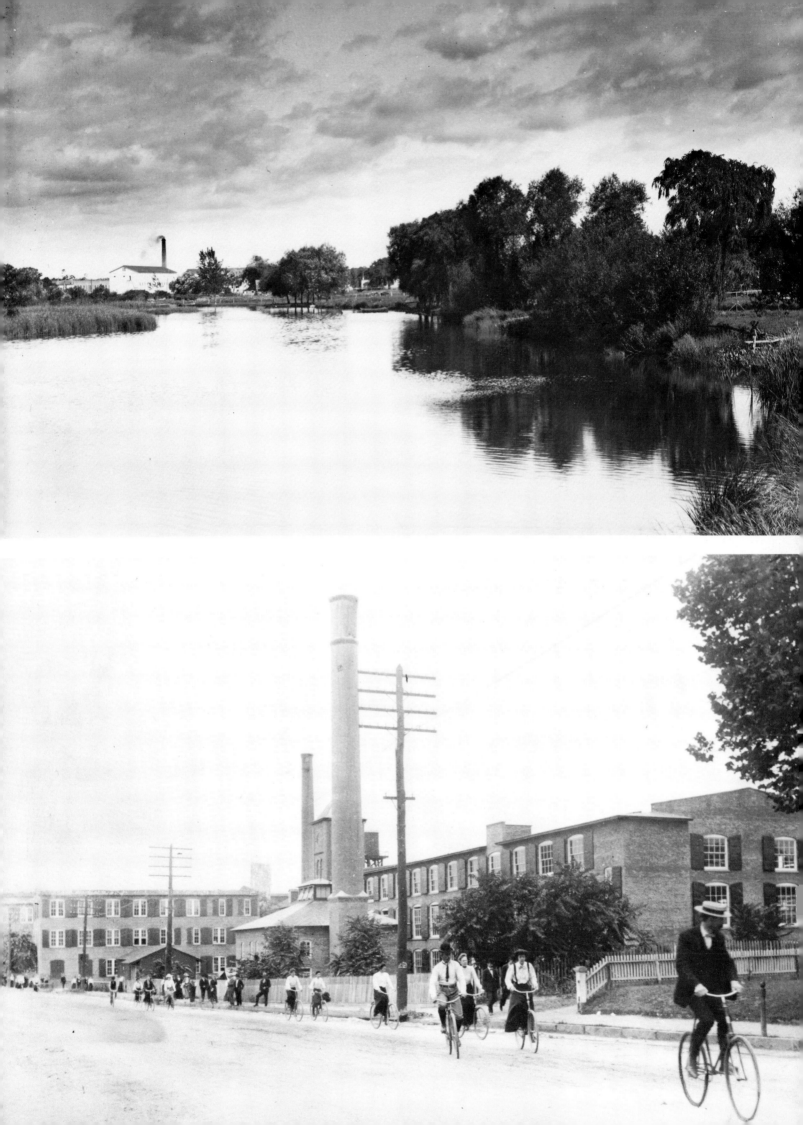

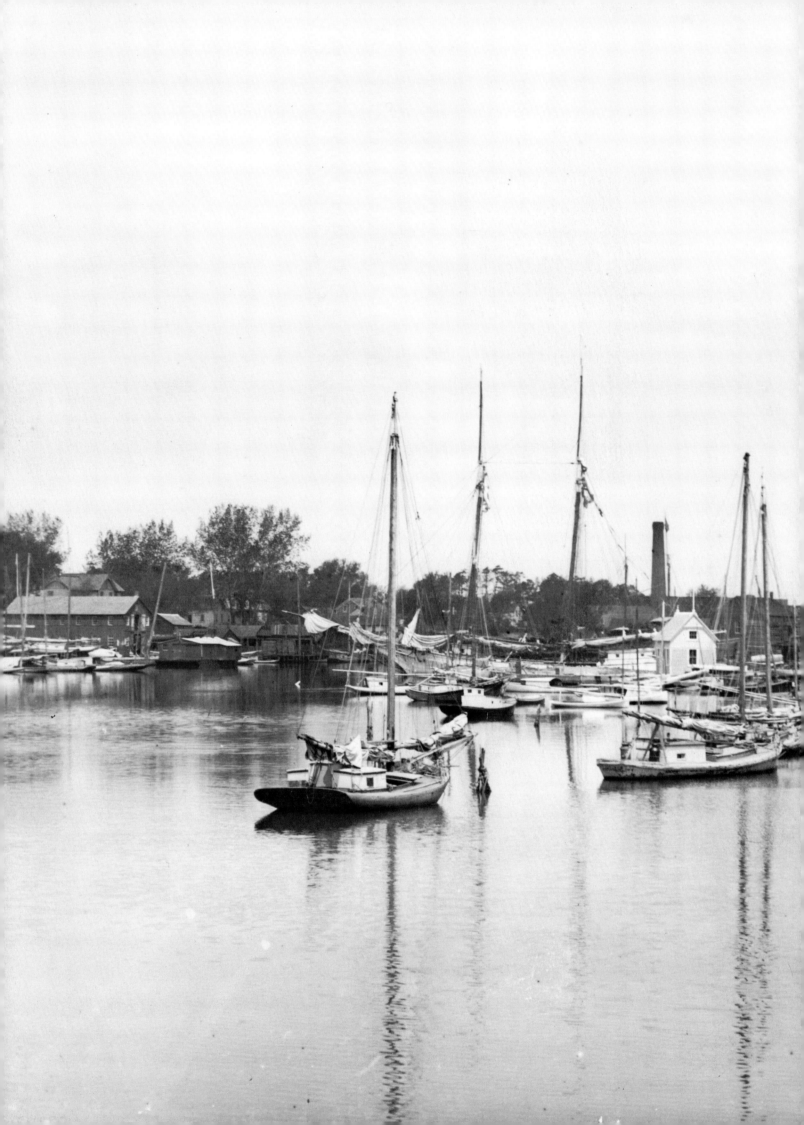

93. Lumber Mill, Patchogue, May 21, 1904. Use of the sawmill was a major factor in developing America's lumber industry. On Long Island, steam-powered mills processed raw lumber into planks, doors, sashes, blinds and furniture. The Bailey yard at Patchogue, the largest manufacturer of blinds, sashes and doors in Queens and Suffolk Counties, possessed enormous stocks of lumber and many work buildings. It was located directly on the Patchogue River, so that raw lumber and finished goods could travel by water. Eventually, lumber was transported by railroad. *(Photograph by Howard Conklin; Queens Borough Public Library, Long Island Division.)*

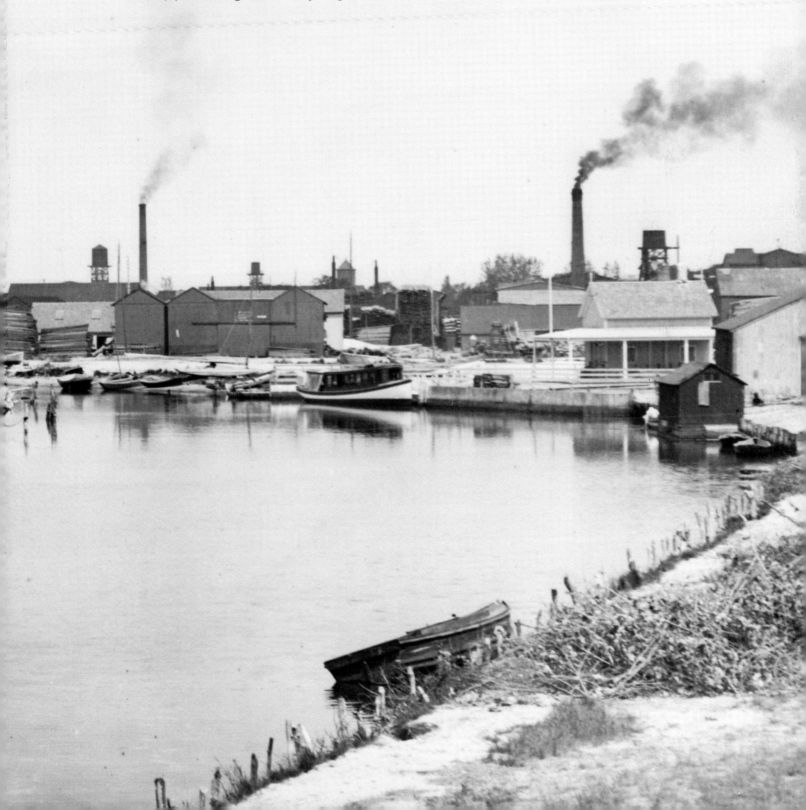

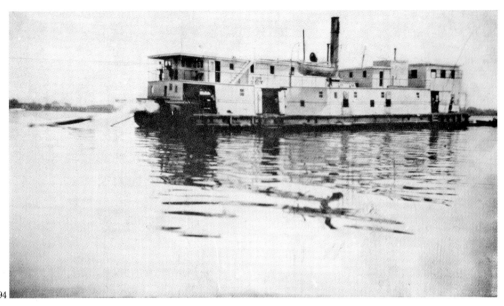

94

95

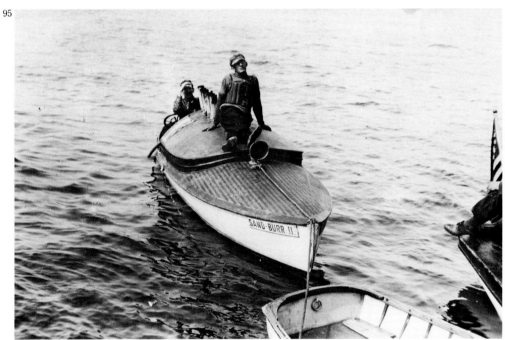

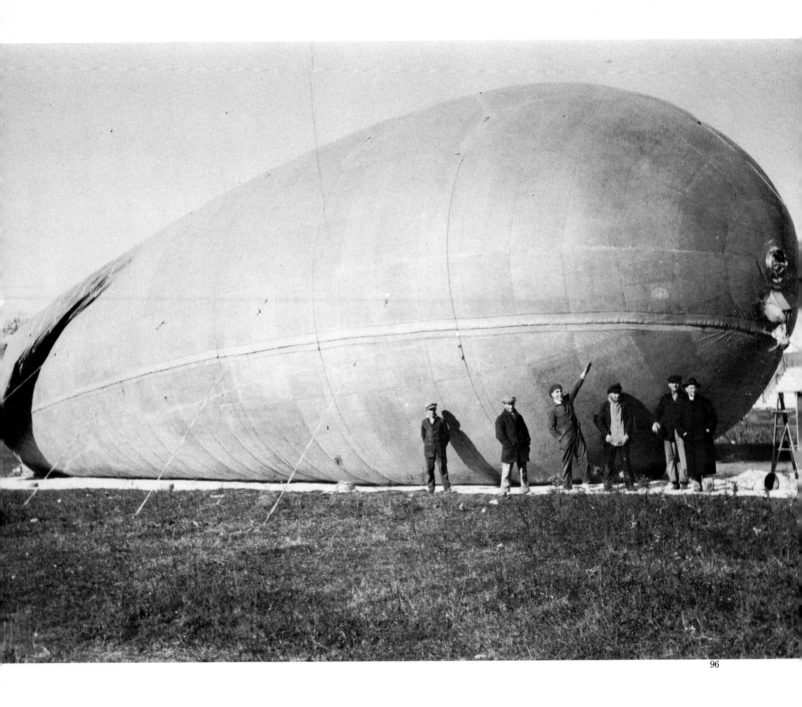

96

94. Torpedo Practice of E. W. Bliss Co., Sag Harbor, ca. 1910. Long Island's protected harbors and surrounding waters were especially suitable for the manufacture and testing of military vessels. In Suffolk County, the defense industry appeared with the Holland Company submarine project at New Suffolk. In 1906–07, the Hawkins yard at Port Jefferson was used to outfit a secret Navy torpedo boat, the *Lake*. Soon afterwards, Sag Harbor became the base for the Bliss manufacturing company, which turned out torpedoes for the Navy and tested them in local waters. *(Lightfoot Collection.)*

95. *Sand-Burr II*, 1911. Following the lead of Navy torpedo boats, sportsmen interested in racing wanted boats built with high-horsepower engines. Several Long Island boat yards specialized in designing and building these high-speed hulls, packing in the powerful engines so tightly that the operators had little room in which to move. When Prohibition brought on rum-running, some of the larger boats were overhauled and put to work evading the Coast Guard with their precious cargo. *(Lightfoot Collection.)*

96. World War I Balloon Manufactured on Long Island, ca. 1918. By the twentieth century, the technology of balloon flight had advanced well beyond the first ascent in France of a craft inflated by heated air produced by burning straw and wool. Ballooning was gradually improved through experiment and trial. Balloons were used to observe enemy maneuvers during the Civil War. During World War I, research carried out on Long Island was used to produce large barrage-type balloons. The plant that made them is believed to have been in the area of Northport. *(Huntington Historical Society.)*

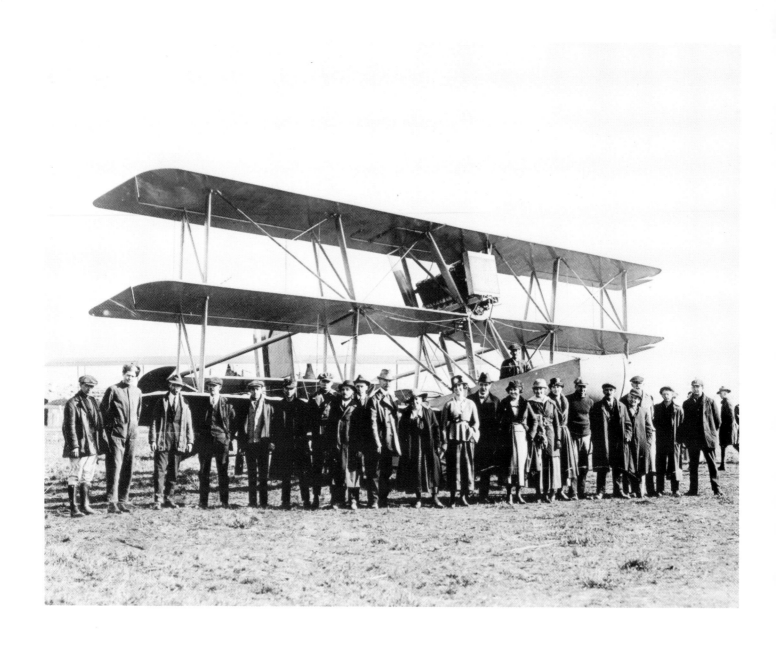

97. Lawrence Sperry's First Seaplane, Built at Farmingdale, 1918–20. As a result of World War I, Suffolk County was involved in military aviation. At Bayshore, a base was set up for testing such hydro-aeroplanes as the Curtiss No. 9 Tractor. Lawrence Sperry, the noted aviation pioneer, joined Curtiss in developing the aerial torpedo, a secret guided missile tested at Copiague. A secret test field also existed on the edge of Great South Bay near Amityville. Here, during 1918, many of the world's first guided missiles were tested. To ensure that expensive planes used as missiles would not be lost during testing, Sperry would ride as a passenger on the missile until it reached its target, then take over the plane's controls and fly it back. During 1918–20, Sperry also constructed the large seaplane seen here, which was built at Farmingdale and tested at Amityville. *(Amityville Historical Society.)*

SHIPPING AND LIFESAVING

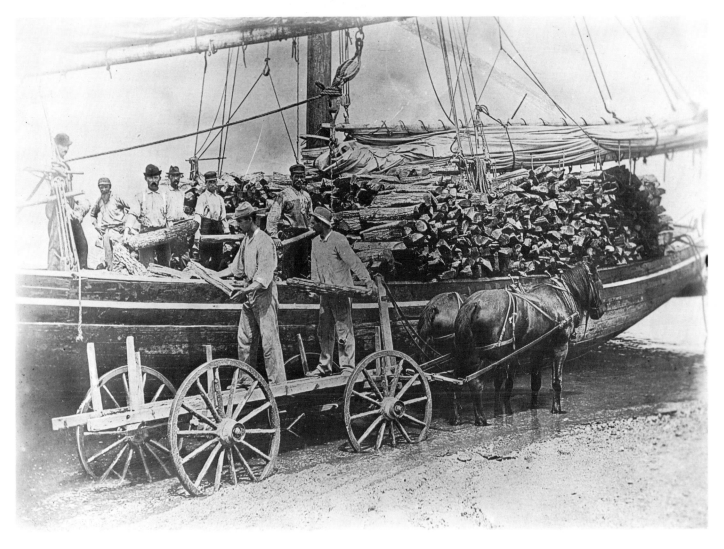

98. Sloop *Emma Southard* **Loading Cordwood on the Sound, Miller's Landing, 1890.** In terms of volume, cordwood was probably the largest cargo for Long Island sailing vessels. Thousands of acres of woodlands in the pine barrens were cut to the ground in winter by groups of workers who were paid 65 cents a cord for pine and 75 cents a cord for oak. Most of the wood was hauled to the sound shore and shipped in the spring, some of it going to New York for firewood, but the bulk of it heading for the brick-making kilns up the Hudson River at Haverstraw. This trade continued until 1915 at Halesite. Cordwood was also freighted in quantity from some Great South Bay and Peconic Bay landings. Cutting was very active near Flanders to supply brick kilns in the Greenport area, until a devastating fire swept the woods. Before conversion to coal, every local two-stove house required 40 cords of wood a year. Other island forest products included dunnage wood, used to wedge barrels of kerosene tightly in ship holds, black-locust fence posts and treenails, and charcoal produced in the pine barrens. *(Lightfoot Collection.)*

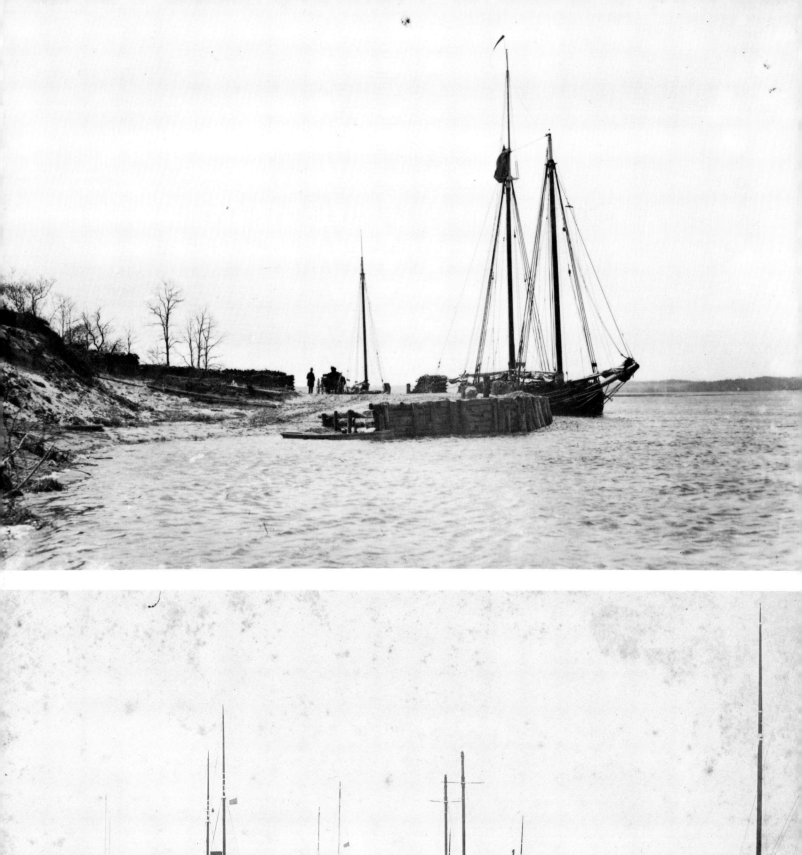

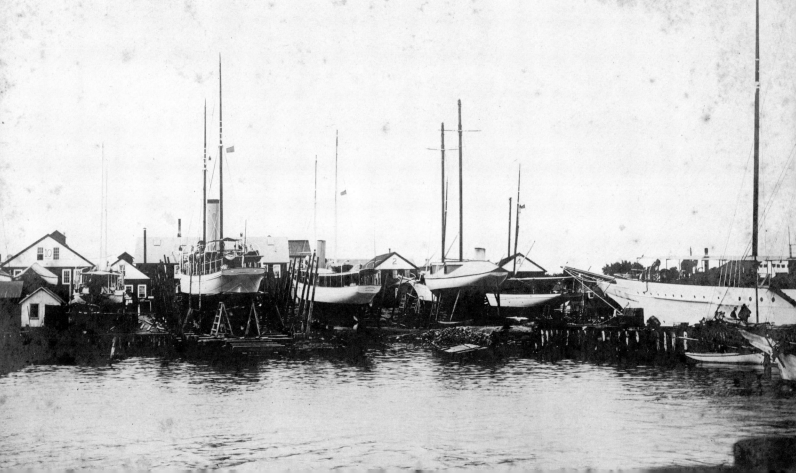

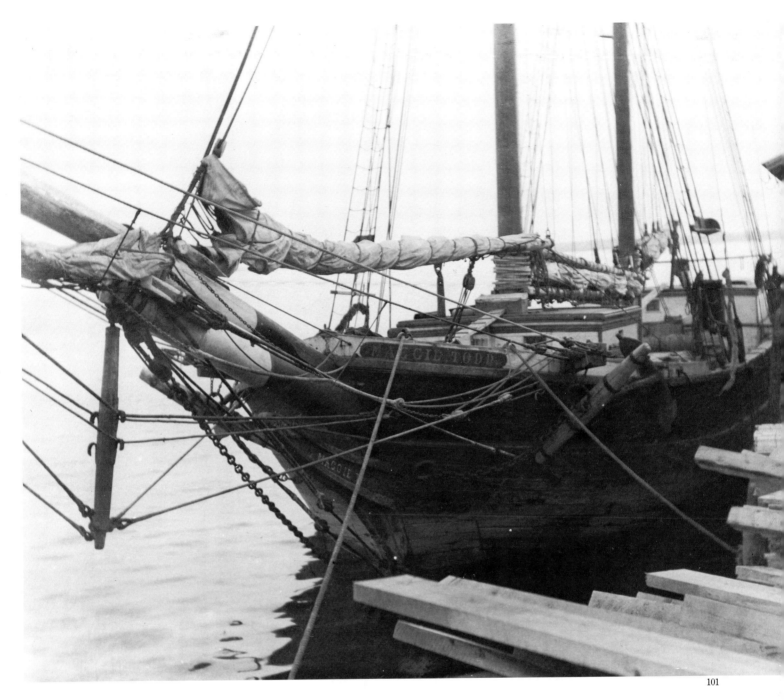

101

99. Stony Brook Harbor, 1899. To earn a living on the water, one did not necessarily have to be a fisherman. The waters surrounding the island were used as a huge system of highways for commercial transportation. Before the railroads were constructed, it took three days for a few passengers, their baggage and the mail to make the grueling journey between East Hampton and Brooklyn. The only practical way to ship a sizable volume of freight was to bring it to a harbor and load it on a sloop or schooner. In good weather, a sailing packet from Sag Harbor to New York was a faster and more comfortable way to travel than by stagecoach. When the railroad came, its speed was decisive for most travelers, but it was expensive, it could not handle a great deal of freight at first and, worst of all, it ran down the center of the island instead of along the shoreline where population was concentrated.

Consequently, steamboats were more highly valued by many North Shore and Peconic communities; even sailing vessels continued to prosper, especially with low-cost, bulky cargoes. A sloop packet ran between Huntington and New York as late as 1892, and cargo sailing vessels survived well into the twentieth century. The photograph shows a typical North Shore landing. From 1868 to 1873, 86 different sailing vessels, one steamer and six canal boats visited Stony Brook, a town filled with the solid, imposing homes of ship captains and a center of the cordwood shipping industry. *(Photograph by Hal B. Fullerton: Suffolk County Historical Society, Fullerton Collection, #261A.)*

100. Greenport Basin and Construction Co. Shipyard, 1916. For men less wealthy than the Morgans and Vanderbilts, the pleasure of yachting could be enjoyed on steam yachts large enough for comfortable living aboard.

A captain, engineer, one or two deckhands and a cook made up the ship's company. The Greenport Basin and Construction Co., which built and repaired yachts, could accommodate 150 yachts in its winter quarters. This group of yachts is being readied for summer. The yard overflowed with work during World War I when it launched a high-speed torpedo boat for the Navy, distribution boats for the War Department and subchasers for Russia. *(Photograph by Leander Chute; Stirling Historical Society.)*

101. *Maggie Todd*, Lumber Schooner, Greenport, 1916. Despite the tremendous quantity of cordwood cut on Long Island, there was a lack of high-grade timber for lumber. Stands of chestnut, oak, locust, spruce and planted white pine were thoroughly depleted by the Civil War; some of the best trees had been cut by the British during their seven-year-long occupation of Long Island during the Revolution. Shipbuilding took a huge toll: Robert Cushman Murphy estimated that it took 2200 trees to provide the lumber for a 74-gun frigate in 1770; construction of this kind of ship denuded 40 acres of first-growth timber. The wood-burning locomotive took over, in the nineteenth century, as a prime consumer of wood. It not only burned wood for fuel, but it started many fires along the route of the rails. As the trees diminished, so did the sawmills, creating the need to import lumber. There are records of deliveries by boat to Indian Island (now called Aquebogue) as early as the 1860s. Most of the lumber was shipped from Maine, the English-speaking provinces of Canada and the South. *(Photograph by L. Vinton Richard; Oysterponds Historical Society.)*

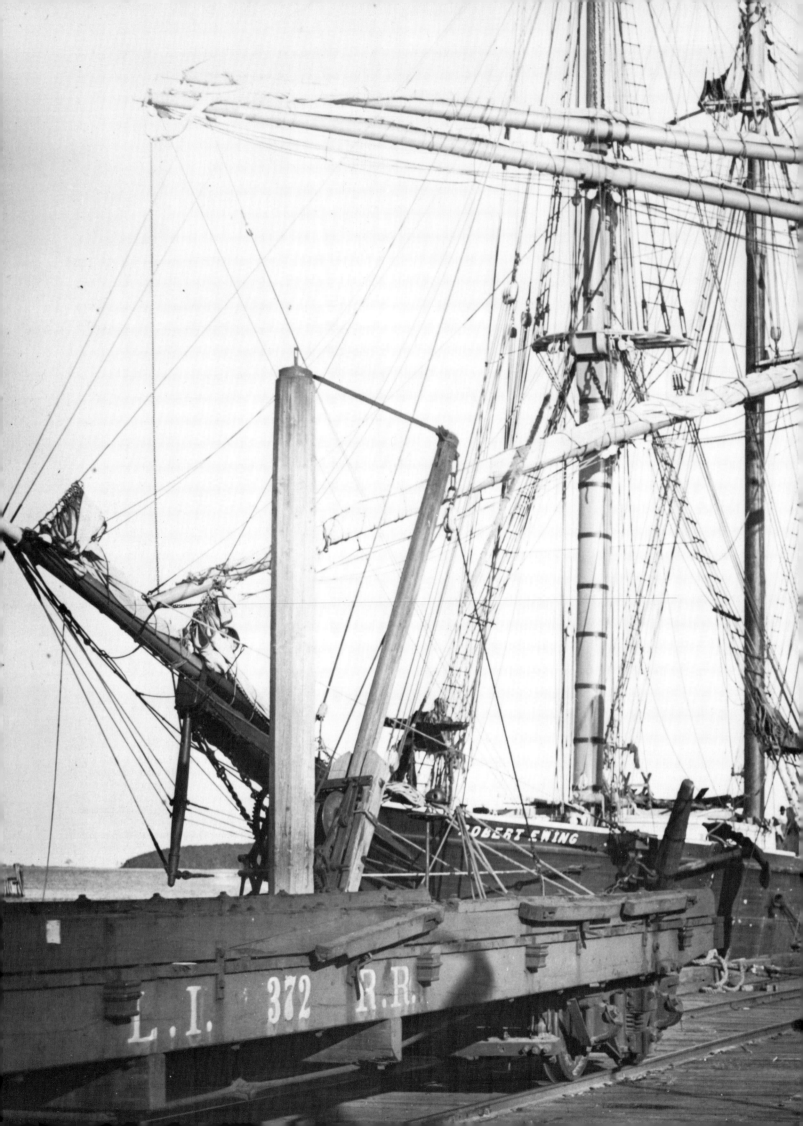

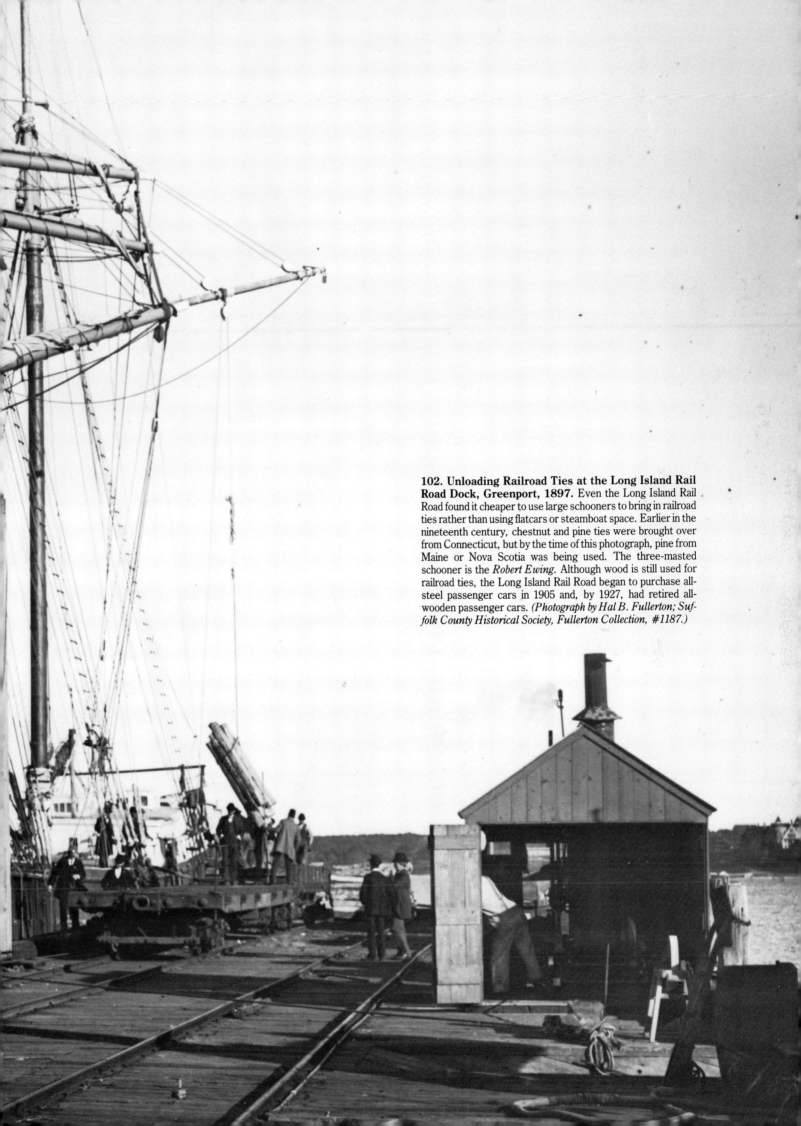

102. Unloading Railroad Ties at the Long Island Rail Road Dock, Greenport, 1897. Even the Long Island Rail Road found it cheaper to use large schooners to bring in railroad ties rather than using flatcars or steamboat space. Earlier in the nineteenth century, chestnut and pine ties were brought over from Connecticut, but by the time of this photograph, pine from Maine or Nova Scotia was being used. The three-masted schooner is the *Robert Ewing*. Although wood is still used for railroad ties, the Long Island Rail Road began to purchase all-steel passenger cars in 1905 and, by 1927, had retired all-wooden passenger cars. *(Photograph by Hal B. Fullerton; Suffolk County Historical Society, Fullerton Collection, #1187.)*

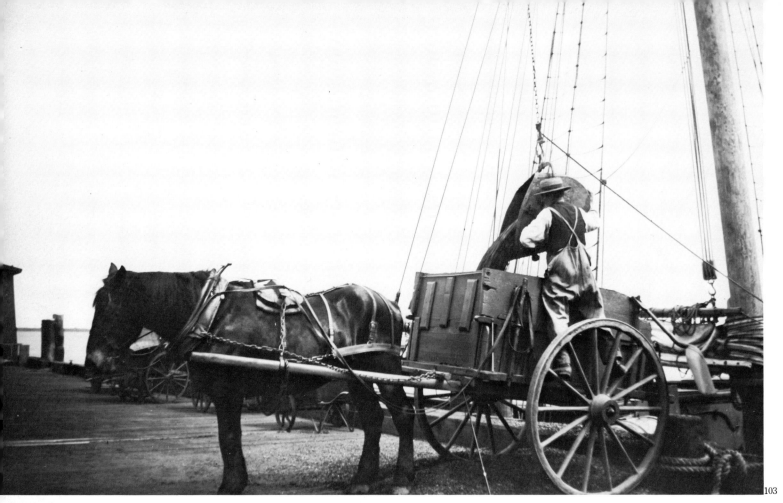

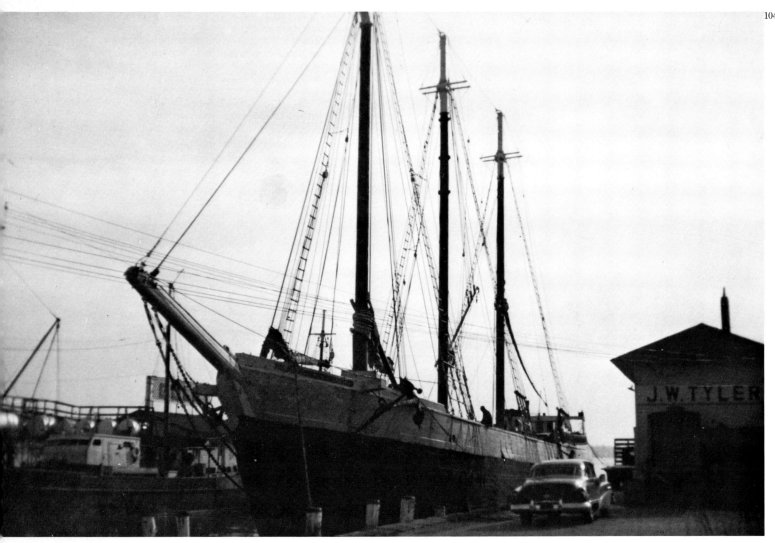

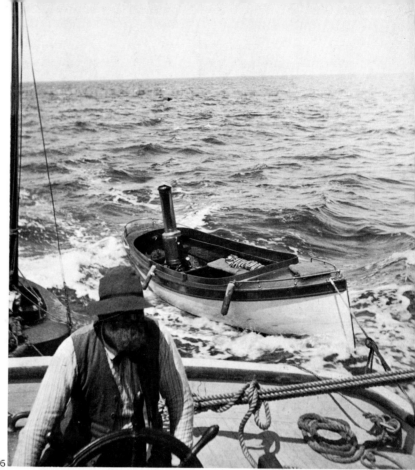

105

106

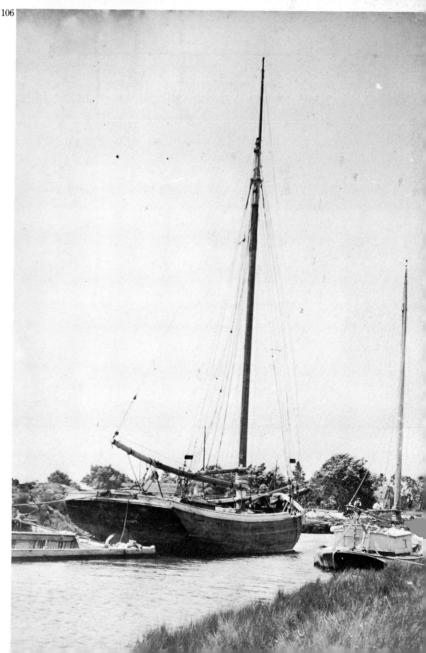

103. Unloading Coal, Sag Harbor, ca. 1900. Coal, used to fuel steamboats and locomotives as well as stoves and furnaces, was another heavy, bulky cargo delivered inexpensively by sailboats. The schooner in the photograph is unloading at the Long Island Rail Road's dock. Sag Harbor was named after the adjacent town of Saggaponack, in the eastern part of the town of Southampton, which, by 1694, was feeling the need for a port closer than the then-used North Sea, in the western portion of town. The first mention of the name Sag Harbor occurs in town records of 1707. By the end of the eighteenth century, Sag Harbor was achieving fame as a whaling port; it was at the height of its glory in 1846, when 63 ships sailed from its docks. *(Lightfoot Collection.)*

104. *City of New York,* **Greenport, 1951.** In a poignant picture, Admiral Byrd's Antarctic exploration flagship is seen tied up with her sailing rig trimmed down. The once grand *City of New York* ended her days ingloriously by ferrying seed potatoes between Prince Edward Island and Greenport. On an ill-fated trip, she snapped a towline and grounded on Chebogue Ledge. When the tide fell, she keeled over, toppling a stove, and was destroyed by flames. *(Photograph by Vincent Quatroche.)*

105. Towing a Motorboat, ca. 1905. This unusual picture was taken aboard a steam-powered launch towing two smaller vessels. The photographer, perched above the bearded helmsman, used a stereoscopic camera to take this view. *(Lightfoot Collection.)*

106. *Mabel A. Jarvis* **of Blue Point, 1905.** This large sloop carried cargoes of brick down the Hudson River to the South Shore of Long Island. At other times, she delivered oyster spat, traveling from Connecticut to the Blue Point oyster grounds. Active in the years between 1880 and the World War I, the boat was like the modern tramp steamer, following no regular route, but picking up cargo wherever it was available. *(Lightfoot Collection.)*

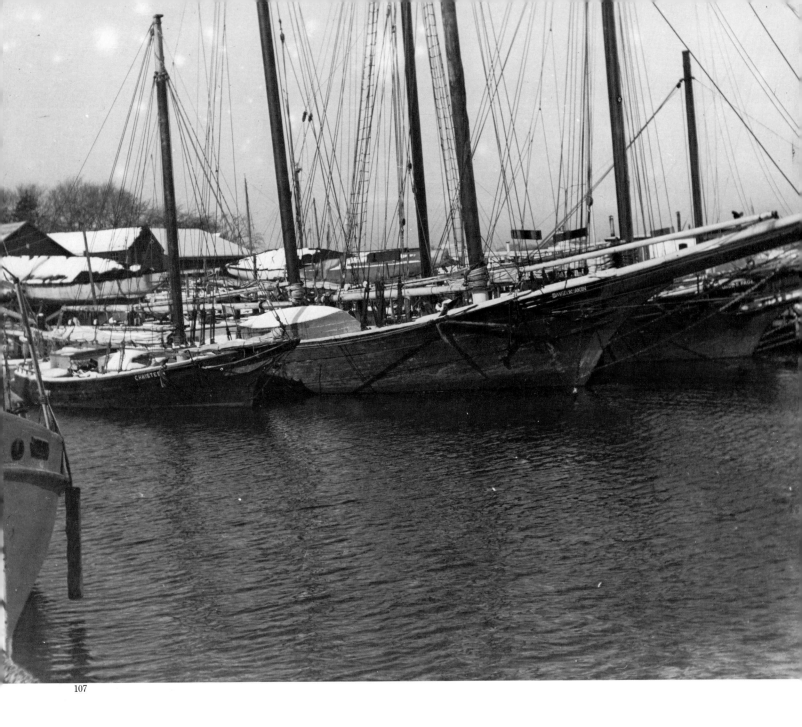

107

107. Shipyard at Greenport, 1916. These typical two-masted schooners are tied up for the winter. Such vessels largely superseded sloops after the Civil War and generally ranged from six to ten feet in draft and from 50 to 100 tons. A three-man crew could handle one of these boats comfortably on freight-carrying journeys, but on fishing trips extra berths had to be added. The hulls were often painted in bright colors—red, blue, yellow and green. The boats were used for interchangeable cargoes, including stone, oyster spat, lumber and cordwood; in fishing season, they were sent out after codfish, mackerel, bluefish and blackfish. One old-timer who engaged in this varied trade recalled it as a good life, telling how, in the early days of World War I, boats fishing out of Greenport sometimes exchanged friendly greetings with the crews of German submarines that surfaced off Montauk to recharge their batteries. *(Photograph by L. Vinton Richard; Oysterponds Historical Society.)*

108. Shipbuilding at Northport, 1899. Shipbuilding was one of the chief sources of employment in practically every Long Island port. Northport, for example, had five marine railways by the 1860s; the yard of boss Jesse Carll built many large vessels, the biggest of which was the 1100-ton bark *Mary A. Greenwood.* Even the shipyards in such a minor port as Setauket–East Setauket turned out almost 80 vessels from 1835 to 1868, most of them schooners. In 1869, the David Bayles yard at East Setauket produced the largest sailing vessel ever built in Suffolk, the 1460-ton full-rigged *Adorna.* The major shipbuilding center was Port Jefferson, which had seven yards. *(Photograph by Hal B. Fullerton; Suffolk County Historical Society, Fullerton Collection, #1473B.)*

109. Holland Torpedo Boat Company Submarine, New Suffolk, ca. 1905. Long Island has strong ties with the United States Navy, especially at the major West End location, the Brooklyn Navy Yard. In an earlier period, when they were not so large, naval vessels often came into Suffolk bays to anchor. One of the less well-known relationships between the Navy and Long Island was the use of New Suffolk as a naval base for the testing of seven Holland Company submarines, from 1899 to 1905. The torpedo-boat destroyer *Winslow,* active in the Spanish-American War, joined in maneuvers with the submarines. *(Collection of Ron Ziel.)*

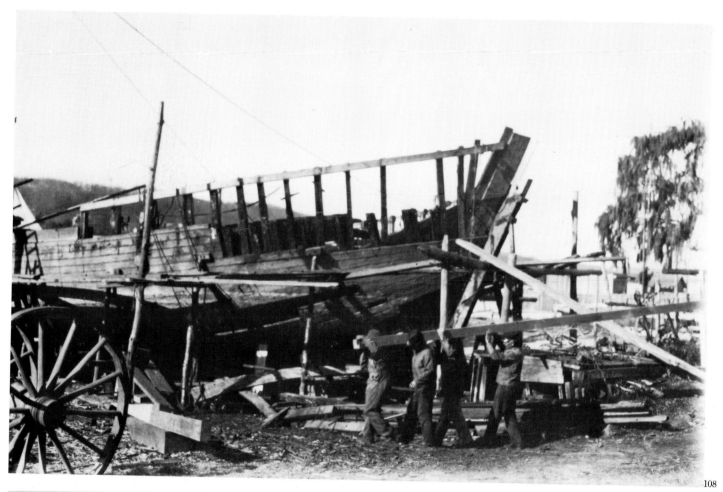

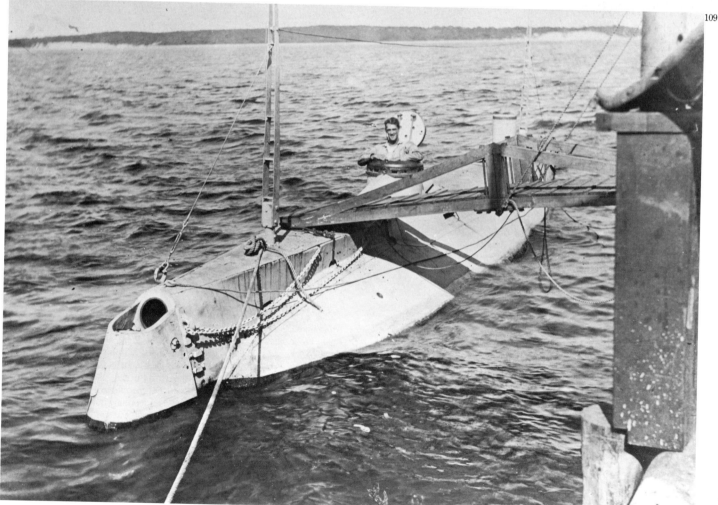

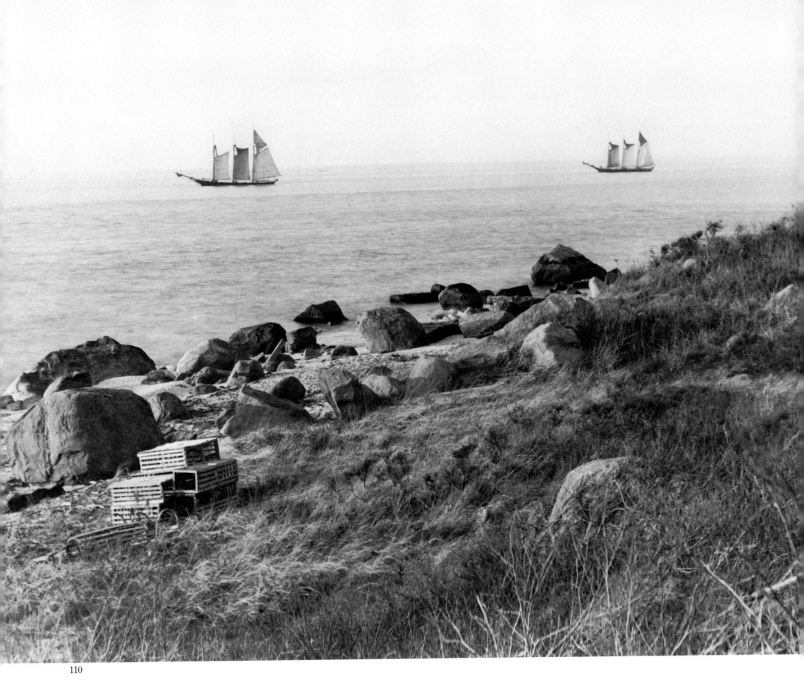

110

110. Three-Masters Off Munn Bight, North Fork, 1915. Large schooners with three to five masts came to Long Island as late as the 1950s, hauling bulk cargo such as fertilizer from the South. Handling big schooners was tricky in the strong currents of Long Island Sound. Here two three-masters are waiting for the tide to turn. Lobster traps in the foreground are reminders of another maritime activity. Munn Bight, off the town of Orient, preserves, in its name, part of the heritage of England; "bight" is derived from the Old English "byht," meaning bend or angle, and refers to a wide bay in a curved shoreline. *(Photograph by L. Vinton Richard; Oysterponds Historical Society.)*

111. Fire Island Life-Saving Service Crew, 1908. Although Wreck Masters, appointed by the state governor from 1787 on, were required to help victims and protect property belonging to wrecked ships, rescue service on Long Island relied on volunteers until the founding of the Life-Saving Service, a federal agency, in 1871. When Margaret Fuller, the famous Boston writer, returned to the United States from Rome in 1850 with her Italian husband and young son, her ship was wrecked in the surf off Fire Island; all three perished and the manuscript of her long-awaited firsthand history of the Roman Revolution was lost. But all vessels were endangered; the coastwise schooners and large sloops carrying cargoes of coal, bluestone and other heavy materials constantly ran through the Fire Island inlet, risking shipwreck in the shifting channels.

When these vessels were grounded, the lifesaving crew had to jettison cargo, hoping to free boats by lightening them. Captain J. Sim Baker, who was assigned to this Fire Island station around 1911, recalled having to wait on board stranded vessels until the turn of the tide and crawling into the rigging for a nap in the midst of a January storm. Twenty-eight lifesaving stations were established on the South Shore, each with a captain, crew of six or seven surfmen, breeches-buoy equipment and a lifeboat. *(Queens Borough Public Library, Long Island Division.)*

112. Stranding of the S.S. *Gowanburn*, 1907. Today, with radio direction finders and radar aboard seagoing vessels of all sizes, it is rare for a large ship to be cast up on beaches like those along the South Shore. For that reason, the government's original lifesaving stations on the coast were abandoned and a smaller number of stations belonging to the Coast Guard (created in 1915 by a merger of the Life-Saving Service and the Revenue Cutter Service) have been maintained. But before modern electronics simplified navigation in fog, storm and darkness, a surprising number of large ships ran into the sand despite lightships and lighthouse warning beacons. One of these ships was the S.S. *Gowanburn*, which made its unscheduled arrival at Blue Point in 1907. Thanks to the development of powerful sea tugs, some of these ships were towed off the beach and survived, but others were hopelessly stuck. Over the years, their superstructures rusted and were blown away, and their ruins became havens for fish—choice spots for sports fishermen. *(Lightfoot Collection.)*

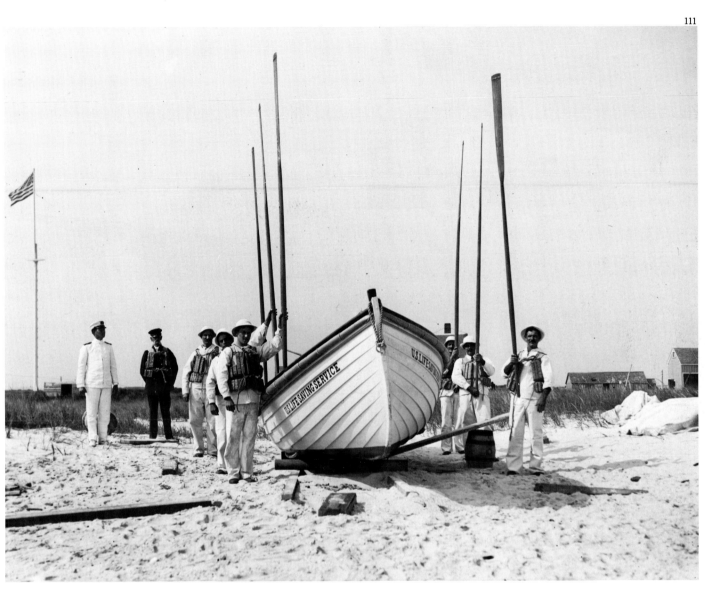

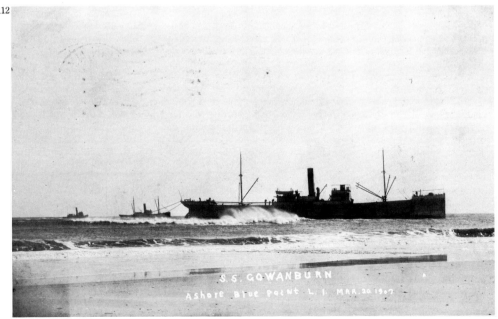

Shipping and Lifesaving 83

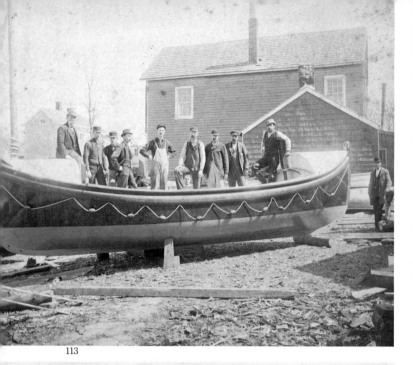

113

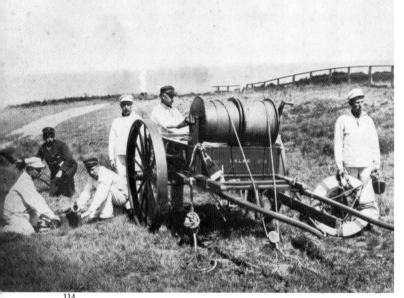

114

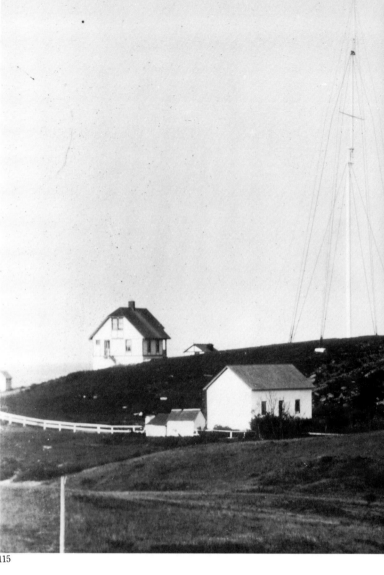

115

113. Beebe-McClellan Lifeboat and Its Builders, Greenport, 1893.
Large-scale production of a single boat design richly rewarded Frederick
Beebe of Greenport. He collaborated with Captain C. H. McClellan of the
U.S. Life-Saving Service in designing a self-bailing lifeboat. It was judged the
best boat available for the service in a competition held at the Mecox Life-
Saving Station, and became the standard boat of the service. Over 500 were
built, with some design modification and motorization, until World War I. The
boats were delivered to other parts of the United States; some were sold
abroad. The boat in the photograph was built for display at the 1893 World's
Columbian Exposition in Chicago. *(Stirling Historical Society.)*

**114. Breeches-Buoy Equipment and Crew, East Marion Station, ca.
1900.** The last Life-Saving Service station was established on Long Island in
1896 on the sound at East Marion. The crew is shown with its complete
breeches-buoy equipment. The cannon, a Lyle gun, was used to shoot a
weight as far as 700 yards to a stranded vessel. A light line attached to the
weight was to be picked up by someone on the ship and hauled in. Heavier
lines were attached to the end of the line, one of which was finally fastened to
the ship. On this line, a pulley and line ran from the ship to the shore;
suspended from it was the breeches buoy, much like a life-preserver ring. The
breeches buoy was hauled back and forth, carrying a person from the ship
safely over the breakers to shore on each round trip. *(Collection of the* Suffolk
Times.*)*

**115. Montauk Point Lighthouse and Marconi Company Radio
Tower, ca. 1910.** Ships traveling to or from New York City skirted the sandy
South Shore beaches closely—often too closely! Records show, for example,
that from November 1, 1854 to June 28, 1857, a period of less than three

years, 64 vessels were wrecked or in distress on the South Shore. Light-
houses were important among the safety arrangements for vessels at sea.
Montauk Light was the first to be built on the oceanfront; authorized by
George Washington in 1796, it was completed in 1797 according to designs by
John McComb.

Rebuilt in 1860, the octagonal tower stands 108 feet high; it is constructed
of cut stone, with walls three feet in thickness, widening to 12 feet at the
base. The light has a stationary beam of 200,000 candlepower. Its lantern had
been a gift of the French government. The Montauk Light is endangered by
erosion of the cliff on which it stands; originally more than 250 feet from the
edge of the cliff, the tower is now about 100 feet away. *(Photograph by Hal B.
Fullerton; Suffolk County Historical Society, Fullerton Collection, #L714.)*

116. Wreck of the *Penobscot*, Eaton's Neck, December 1902. The
Penobscot was one of the large schooners that could not survive the perils of
Long Island Sound, called "The Devil's Belt" by colonists, who well appreci-
ated its dangers. Sailing ships anchored at the Connecticut shore to weather
out a storm sometimes dragged their anchors, ending up on the North Shore
of Long Island with frozen sails. Eaton's Neck, at the end of a long narrow
beach, forms a claw enclosing Northport Harbor opposite Lloyd's Neck. A
natural barrier for ships in trouble, it now has a coast-guard station and
lighthouse at its northern tip. Eaton's Neck was named for Theophilus Eaton,
colonial governor of the New Haven colony, who held title under a gift he
claimed was given him by a Matinecock chief, Raseocon, in 1646. *(Photograph
by Hal B. Fullerton; Suffolk County Historical Society, Fullerton Collection,
#L269.)*

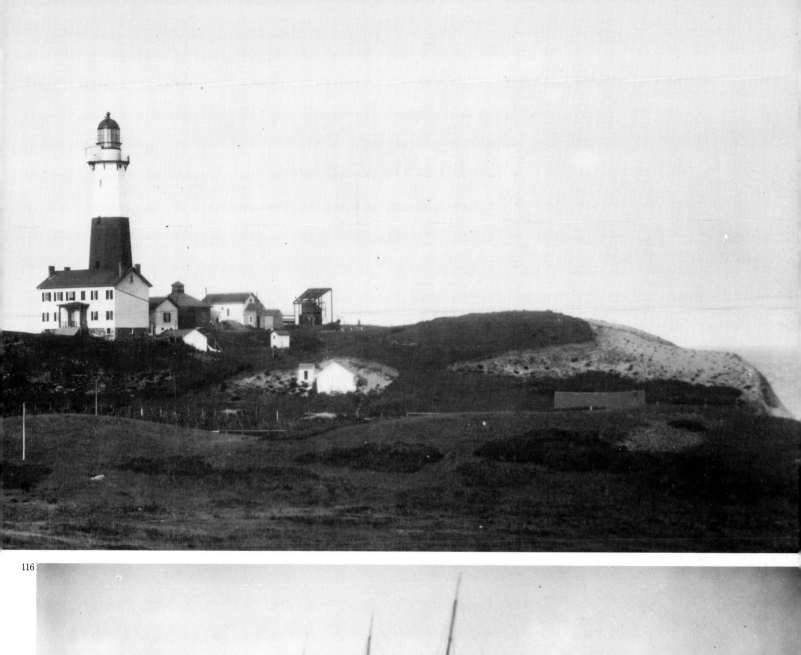

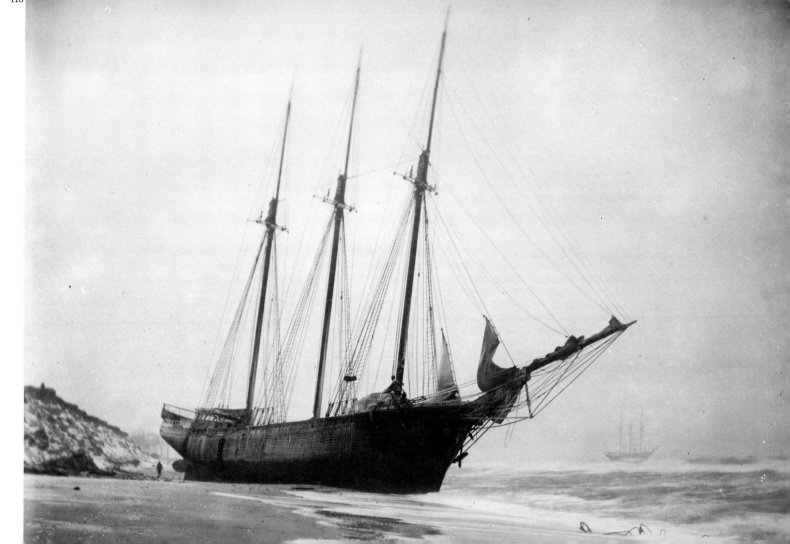

116

GETTING AROUND

117

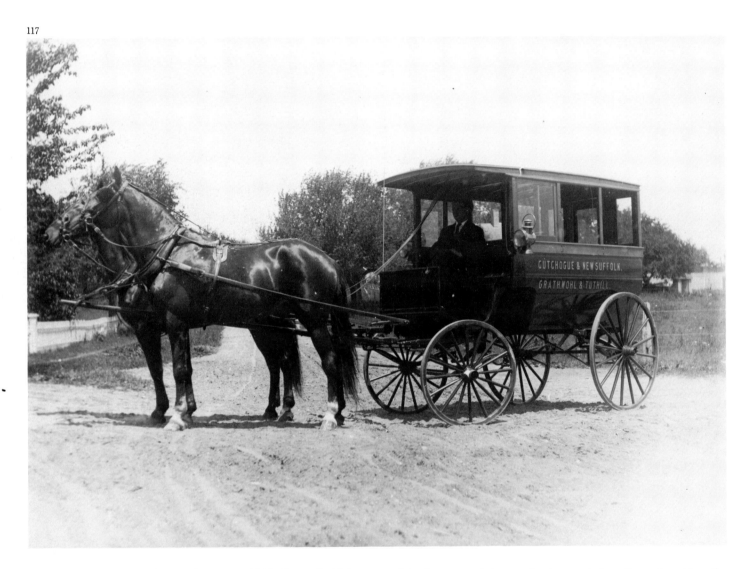

117. Cutchogue & New Suffolk Stage, ca. 1905. From colonial days until the turn of the century, horse-drawn coaches were one means of transportation between villages. Journeys were jolting, often tiring and uncomfortable, with frequent stops needed for both passengers and horses. The Long Island Rail Road made traveling easier, but early stations were sometimes far apart and trains ran infrequently and at awkward times. Since the lines were mostly east–west in Suffolk, railroad management welcomed the establishment of stages that carried passengers north or south. Grathwohl & Tuthill offered such convenient hamlet-to-hamlet service between Cutchogue and New Suffolk. *(Stirling Historical Society.)*

118. Beach Stage, Quogue, ca. 1905. Famous for its beaches, duck hunting and "excellent eels," Quogue had been a popular summer resort as early as the 1840s. With the extension of the Long Island Rail Road to Sag Harbor, Quogue became even more accessible and was host to an influx of summer visitors. So many private residences took in guests that Quogue Street was known as "boardinghouse row." One enterprising gentleman, Harmon P. Payne, ran a stage and livery company. His fleet of 15 horses and a

variety of wagons and stagecoaches transported vacationers to and from the beach. In 1908, Payne operated a gas-powered "Rapid Bus," the first such commercial vehicle in Suffolk County. *(Photograph by Henry Otto Korten; Nassau County Museum.)*

119. Old Tollgate between Sag Harbor and Bridgehampton, ca. 1905. Early dirt roads were variable in quality, often muddy in spring and fall, dusty in summer and frozen in winter. Incorporated in 1833, the Sag Harbor and Bull's Head Turnpike Company built and supervised a toll road from Sag Harbor to the Hamptons. For many years, the Sag Harbor–Bridgehampton gate, located on the main road going west (now Bridgehampton Road) was operated by Daniel McCullin and his wife. Tolls ran from three cents for a horse and rider to ten cents for a stagecoach with two horses (two cents for each additional horse). The Bridgehampton toll was abolished by a court order on August 12, 1905 because of the road's poor condition and the demand for a cycle path that could not be made on private property. The following year, the road was taken over by the government. Its tollhouse, seen here, burned down in 1909. *(Lightfoot Collection.)*

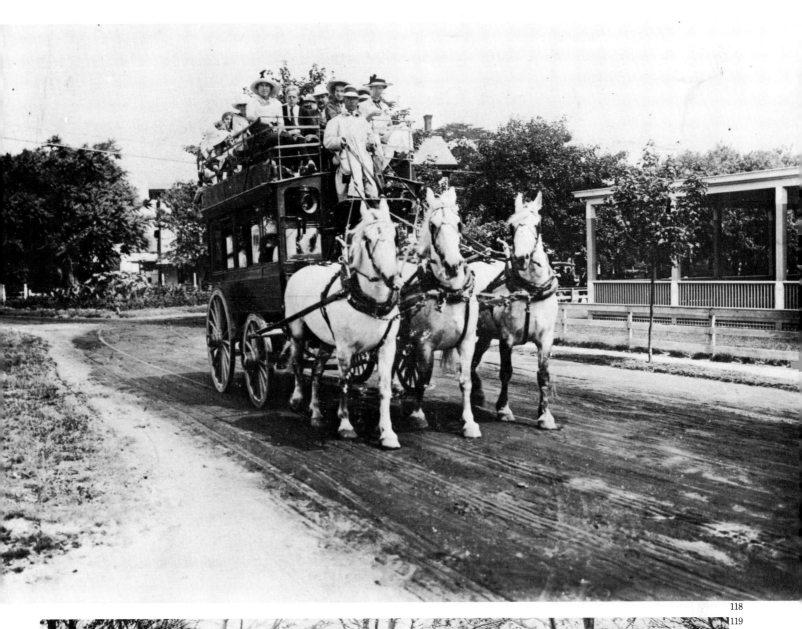

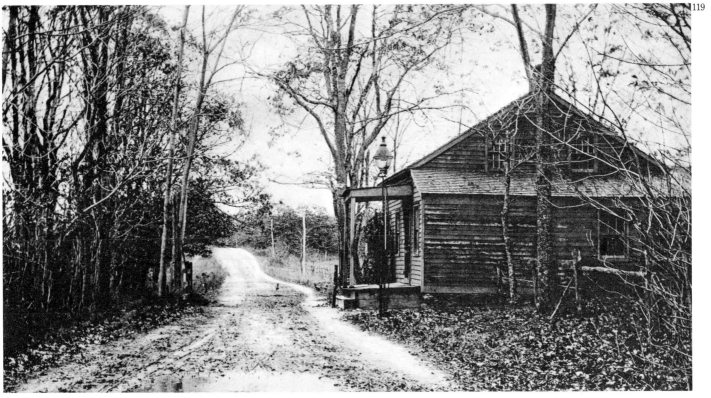

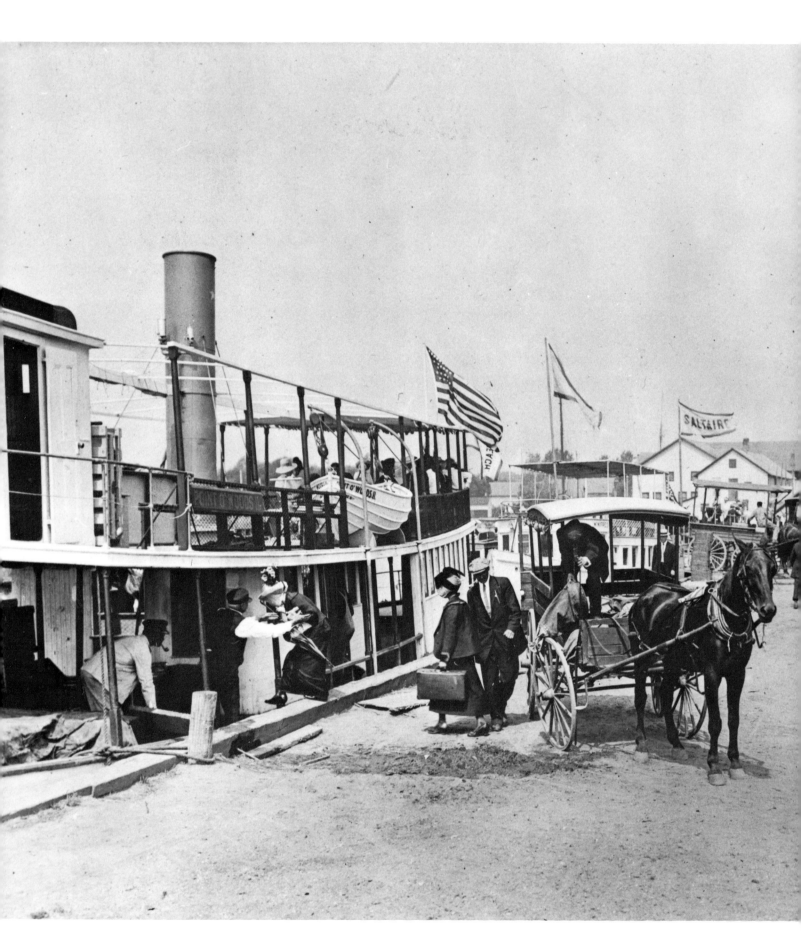

120. Dock, Bay Shore, ca. 1908. Fully clothed despite the summer heat, these vacationers are leaving their horse-drawn carriage just in time to catch the Point O'Woods ferry that will take them across Great South Bay. At the rear center of the photograph is a banner marking the departure spot for Saltaire, a popular resort at the turn of the century. Along with Brightwaters and Ocean Beach, Saltaire was one of three unincorporated Islip villages, easily accessible by boat from the Bay Shore dock, frequented by summer tourists. *(Photograph by Henry Otto Korten; Nassau County Museum.)*

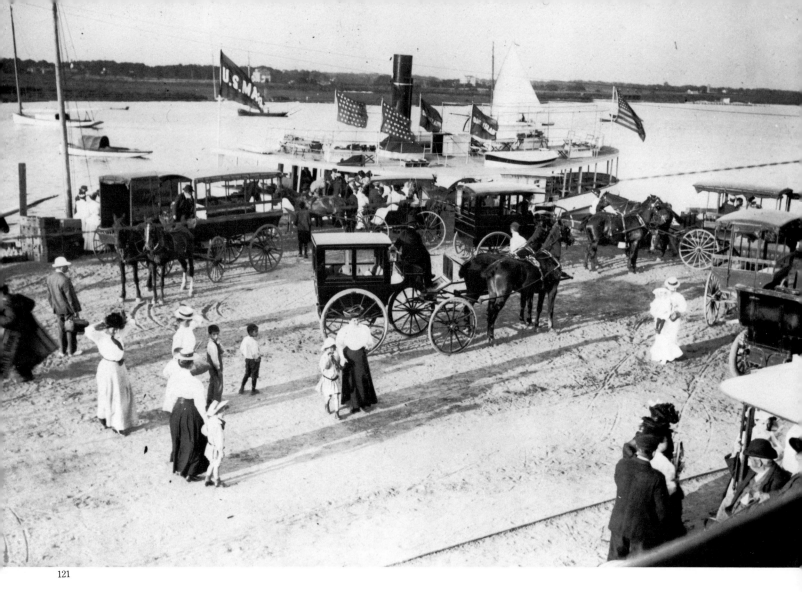

121

121. **Oak Island Steamer at the Dock, Babylon, ca. 1908.** A flurry of activity in summer, the Babylon dock was the point where vacationers could cross the bay to Oak Beach, Cedar Beach, Gilgo Beach and Fire Island. In 1856, David S. S. Sammis of Babylon opened the first successful ferry season when he chartered the steam yacht *Bonita* to bring travelers to his famous Surf Hotel on Fire Island. Oak Island, where the steamer pictured here is heading, had no permanent dwellings before 1879, when Henry Livingston, editor of the *South Side Signal*, became its pioneer summer resident. Located opposite Babylon, the beach at Oak Island soon became a popular spot for summer cottages and regular ferry service was inaugurated in 1886. *(Photograph by Henry Otto Korten; Nassau County Museum.)*

122. **Locomotive No. 92 Stopped at the Cross-Island Cycle Path, Patchogue, 1897.** The bicycle craze of the Gay Nineties, with its explosion of local and national "wheeling clubs," necessitated major changes in existing roads. Farmers considered bicycles a nuisance and menace. So many cyclists threatened to clog traffic on roads that the government built parallel cycle paths, four feet wide, for which a seasonal fee of 50 cents was charged. On Long Island, an extensive network of these paths was constructed. During one Sunday in 1897, 12,000 bikes were counted passing through Jamaica on a "Century Run" to Roe's Hotel in Patchogue. Catering to riders—especially

dropouts and mechanical failures—the Long Island Rail Road carried 176,000 bikes in 1898 on its "Bike Train" from Patchogue. Because of this heavy traffic, the railroad posted warnings at its crossings, such as the sign seen here. Locomotive No. 92 is a passenger train (4-4-0), D-52 Rogers type of 1883. *(Photograph by Hal B. Fullerton; Suffolk County Historical Society, Fullerton Collection, #356.)*

123. **"Mile-a-Minute" Murphy and His Train, 1899.** The Long Island Rail Road helped the bicycle revolution by installing racks in some of its baggage cars to transport the bikes of cyclists who traveled to the island by train. Photographer Hal Fullerton, also a Long Island Rail Road Special Agent, met bike champion Charles M. Murphy at a meeting of the League of American Wheelmen. Fullerton got permission from the railroad to test Murphy's claim that he could pedal his bicycle at a mile a minute. Planking was laid between the rails on a level section of track between Farmingdale and Babylon and a special hood was added to the coach to lessen wind resistance. The great run occurred on June 30, with Murphy's official time clocked at a mile in 57.8 seconds. In later years, "Mile-a-Minute" Murphy became the first motorcycle policeman in Nassau County. *(Photograph by Hal B. Fullerton; Suffolk County Historical Society, Fullerton Collection, #1405B.)*

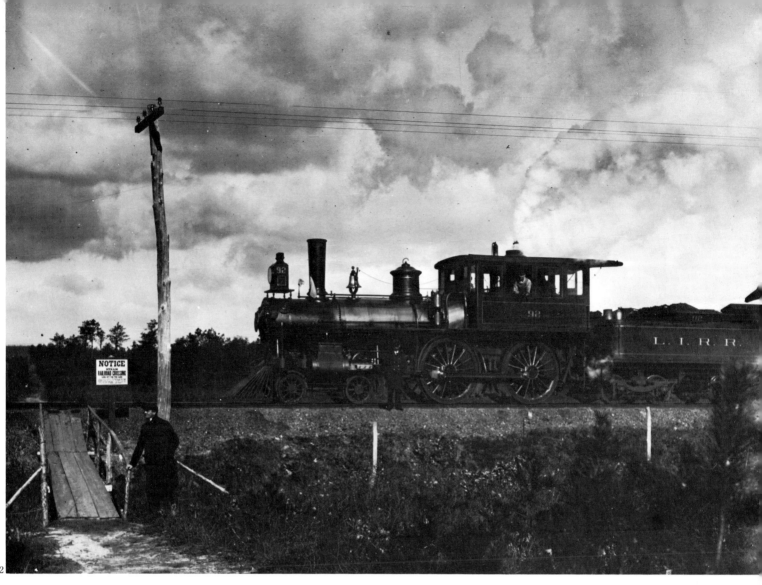

122

123

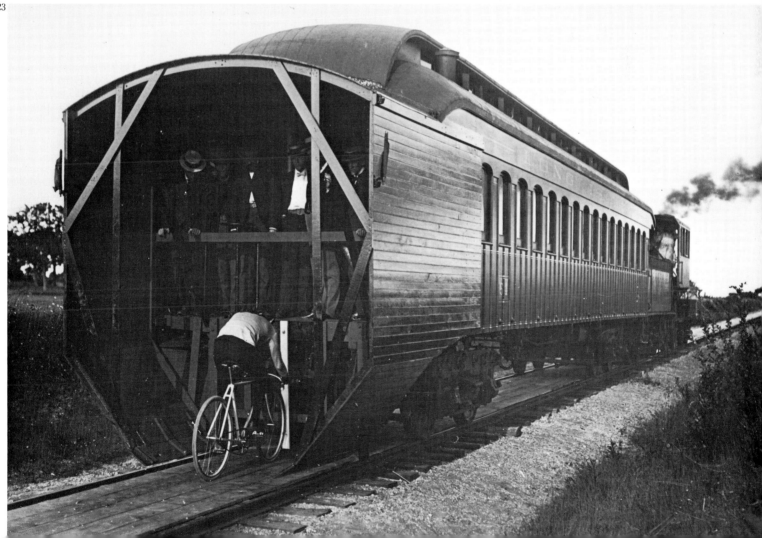

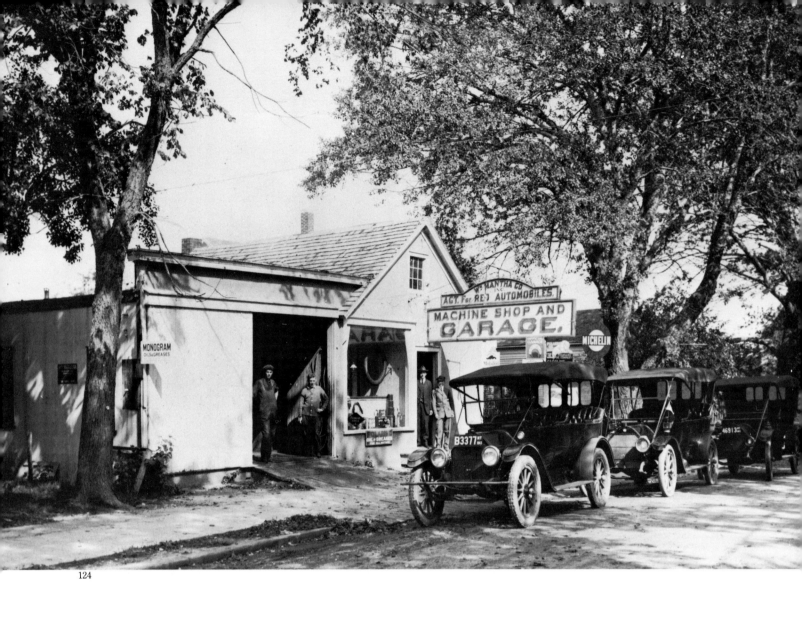

124

124. Wm. Mantha Co. Garage, Bayport, 1913. Cars were still mainly for the rich in 1900, when there were only about 8000 automobiles in the entire United States and the cost of an automobile exceeded $5,000. In 1908, however, the Ford Motor Company was able to mass-produce 15,000 cars, bringing the automobile within more popular reach. Two years later, 460,000 cars were on the road. By 1913, cars were revolutionizing transportation. The Wm. Mantha Co. was one of many garages opened on Long Island for the maintenance and repair of automobiles. Besides providing Monogram Oil and Greases, Michelin tires and Mobiloil gasoline, Mantha's garage was an official agent for Reo automobiles, the car driven by the itinerant photographer Korten. *(Photograph by Henry Otto Korten; Nassau County Museum.)*

125. Merrick Road, Amityville, ca. 1905. The old South Country Road, which ran east from Jamaica along the South Shore, was called Merrick Road by the cyclists who traveled the busy path to Merrick. On April 14, 1900, Merrick Road was the location of the first auto race held in America. One spectator wrote in the *South Side Signal*: "As I watched the automobiles speed along over the South Road . . . I thought that, wonderful as they are, I would not exchange a fleet-footed, reliable, intelligent horse for one." This picture, in which a lone worker is sweeping the dust from the road, belies the usual activity along "the famous Merrick." *(Lightfoot Collection.)*

126. Cars Ready for the Road Races, Southampton, June 10, 1905. The once-popular coaching parties on Long Island soon yielded to group outings of "horseless carriages." On April 14, 1900, the Automobile Club of America introduced a 50-mile race on Long Island from Springfield to Babylon (Al Riker won in 2 hours, 3⅓ minutes). With speeds approaching a mile a minute, the club formulated racing rules in time for the famous Vanderbilt Cup Races, which started in 1904. Early races, such as this one in Southampton, were apt to be a matter of endurance, often ending in unexpected mechanical failure. A year after this photograph was taken, the two-mile-a-minute speed record was achieved. *(Photograph by Hal B. Fullerton; Suffolk County Historical Society, Fullerton Collection, #6013.)*

125

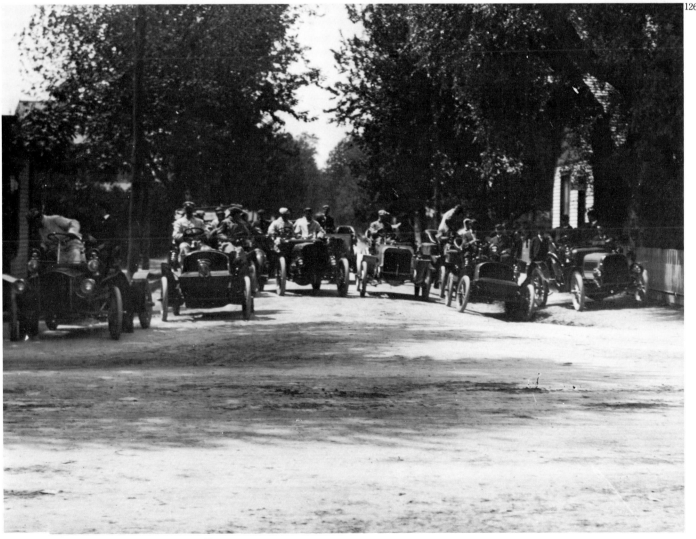

126

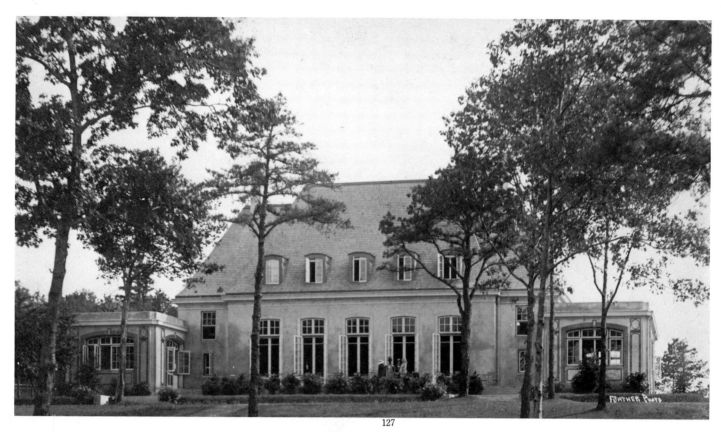

127

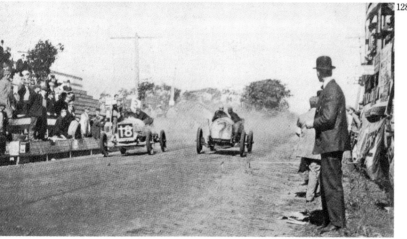

128

127. "Petit Trianon," Motor Parkway, Lake Ronkonkoma, ca. 1915.
In 1911, when William K. Vanderbilt, Jr. was forced to cancel road races on
public highways, he built a highway designed specifically for cars. This was
the famous Motor Parkway, the first crossing-free, limited-access automobile
toll road in America. The road ran from Hillside Avenue in Queens to Lake
Ronkonkoma, a distance of 48 miles. Architect John Russell Pope designed
the highway with 12 identical gate lodges at each access area and this French-
inspired inn at the eastern terminus. Sent to France to study the Petit Trianon
at Versailles as a model, Pope borrowed only such features as the general
rectangular shape and symmetrical facade with tall French windows. The inn
was a favorite dining spot of Sunday drivers until the Motor Parkway was
liquidated and taken over by the state in 1938. For some years, it continued to
serve as a club and night spot, but was destroyed by fire in 1957. *(Feather
Photo; Lightfoot Collection.)*

128. Long Island Auto Derby, Riverhead, 1909. In addition to local
competitions, several professional auto races took place on Long Island. The
Vanderbilt Cup Races (1904–11), which ran from a starting line in Nassau
County, had their counterpart in the Riverhead-to-Mattituck race of 1909.
This course, a round-trip distance of 22 miles, was called the "fastest in the
world," reporting speeds of up to 70 miles an hour. During the 1909 derby,
driver Herbert H. Lytle was critically injured and his mechanic was crushed
when his car lost a wheel. Because of many fatalities to both participants and
spectators, some of whom insisted on getting out into the road for a better
view, long-distance races on regular roads were abandoned. *(Photograph by
Spooner & Wells, New York; Lightfoot Collection.)*

STEAM:
RAIL AND BOATS

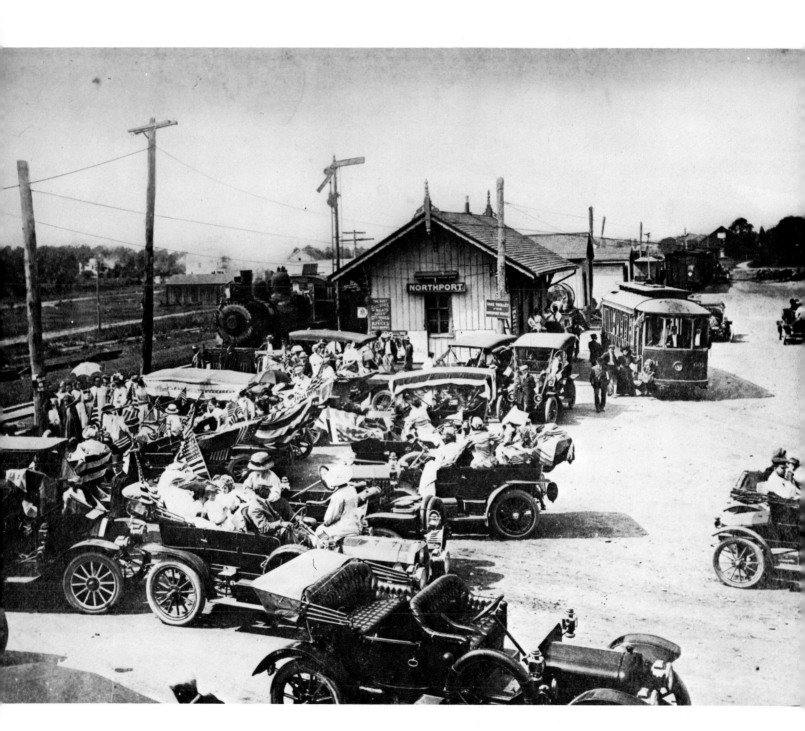

129. Northport Railroad Station and Trolley, 1910. This photograph was taken on the festive occasion of the arrival of the first trainload of passengers to Northport by way of the new tunnel under the East River. The trolley belongs to the line that joined Northport's business section to its railroad station. *(Collection of Ron Ziel.)*

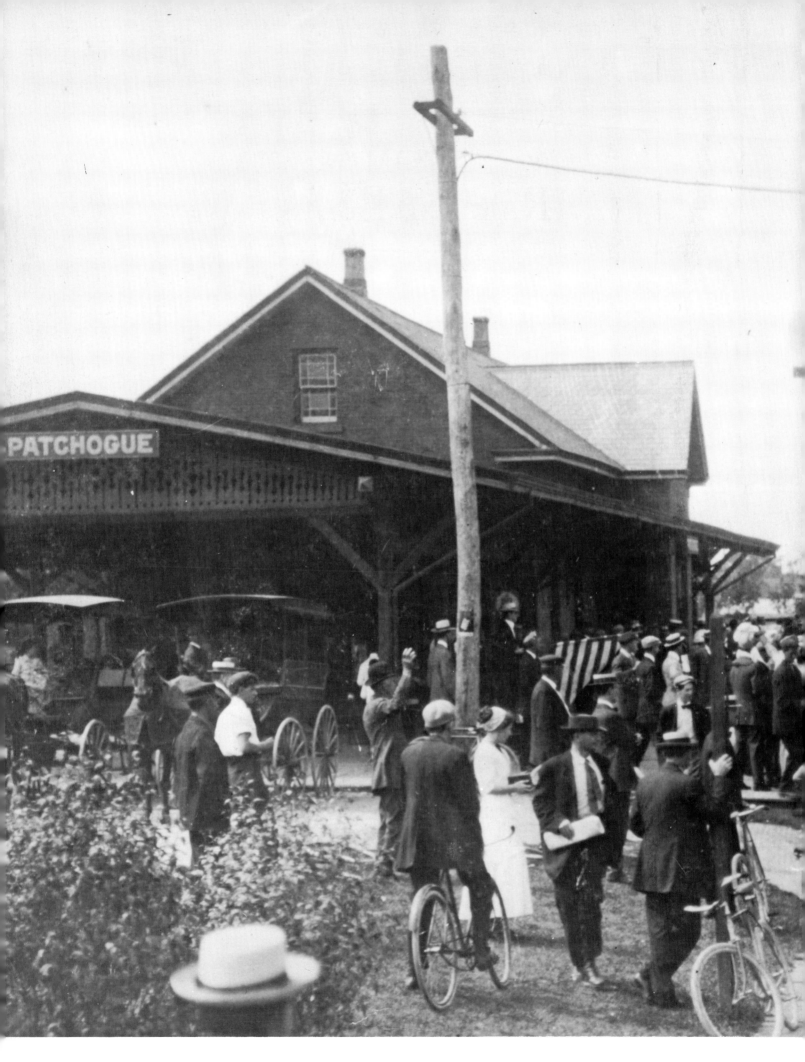

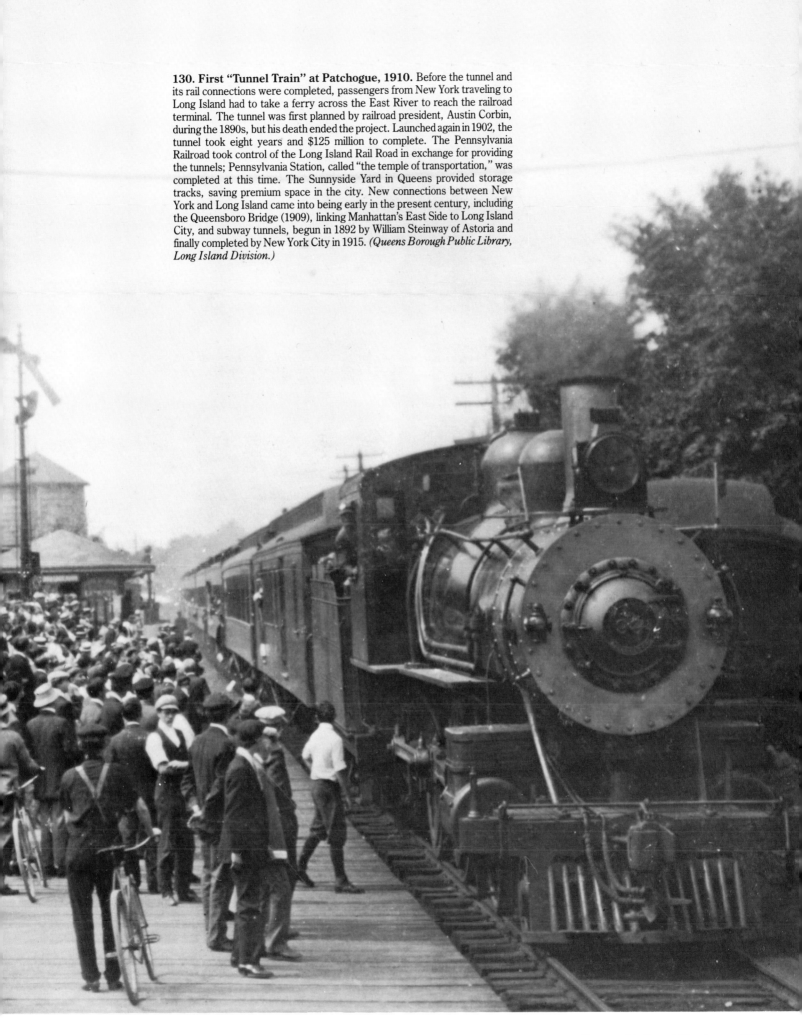

130. First "Tunnel Train" at Patchogue, 1910. Before the tunnel and its rail connections were completed, passengers from New York traveling to Long Island had to take a ferry across the East River to reach the railroad terminal. The tunnel was first planned by railroad president, Austin Corbin, during the 1890s, but his death ended the project. Launched again in 1902, the tunnel took eight years and $125 million to complete. The Pennsylvania Railroad took control of the Long Island Rail Road in exchange for providing the tunnels; Pennsylvania Station, called "the temple of transportation," was completed at this time. The Sunnyside Yard in Queens provided storage tracks, saving premium space in the city. New connections between New York and Long Island came into being early in the present century, including the Queensboro Bridge (1909), linking Manhattan's East Side to Long Island City, and subway tunnels, begun in 1892 by William Steinway of Astoria and finally completed by New York City in 1915. *(Queens Borough Public Library, Long Island Division.)*

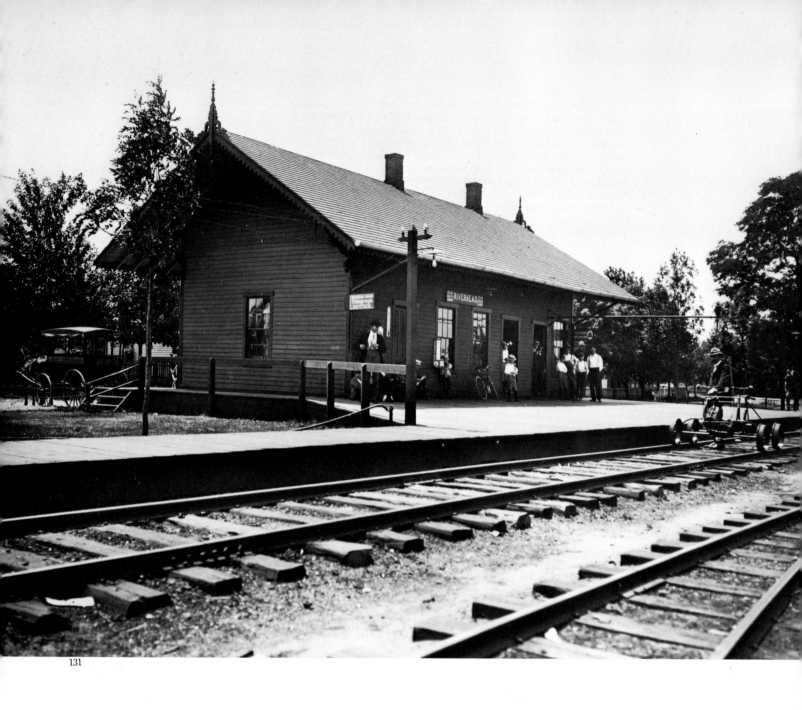

131

131. Riverhead Station, ca. 1900. This charming wooden station, with its Carpenter Gothic decorations, served Riverhead until 1910, when a larger brick structure was erected. On the tracks, a gentleman tries out a four-wheeled handcar; in the station doorway, the father of Congressman Otis Pike (wearing a straw hat) peers out at the photographer. *(Collection of Ron Ziel.)*

132. "Three-Day" Train at Greenport, ca. 1897. This photograph of a train that took three days to reach Greenport recalls the story of a major hazard for the railroad: heavy snow. The train is preceded by a wedge plow, which locomotives of this period, sometimes doubled up, used to clear the line. Railroad stories tell of snowdrifts between Riverhead and Greenport 1000 feet long and 13 feet deep! Nineteenth-century locomotives were lower in weight and horsepower than twentieth-century models, making plowing more difficult. In the winter of 1856, when snow fell eight times at short intervals from December 22 on, the tracks to Greenport were blocked until St. Valentine's Day. More than 3000 men were needed to clear the drifts. In November 1898 a rotary plow was delivered to the railroad and quickly proved superior to the wedge plow for clearing tracks of heavy snowfalls. *(Photograph by Frank Hartley; Collection of Miriam Hartley.)*

133. Greenport Railroad Yard, ca. 1905. Greenport was the terminus of the original main line of the Long Island Rail Road, the purpose of which was to carry passengers and mail from New York to Boston, passing through the empty pine barrens of the middle island. Begun in 1836, the road reached Greenport in July, 1844. By 1850 the so-called impassable route through southern Connecticut had opened up, making the original purpose worthless. During these years and many that followed, the road struggled against angry farmers whose cattle were struck by trains or whose fields went up in flames, ignited by live cinders from passing locomotives.

The railroad was a major force in the development of Long Island, promoting villages along the right-of-way and trying to build population. The station at Greenport was very important, for the town was a center of fishing, oystering and boatbuilding; steamboats owned by the railroad operated from its docks to New London, Block Island, Montauk, Sag Harbor and New York. In the photograph, a steamboat can be seen leaving the dock in the background, just right of center. In the yard, at the turntable that reversed locomotives for their trips back west, is a camel-type locomotive, with the engineer's cab over the boiler. Engines were maintained in the roundhouse until 1921. *(Collection of Louis Black.)*

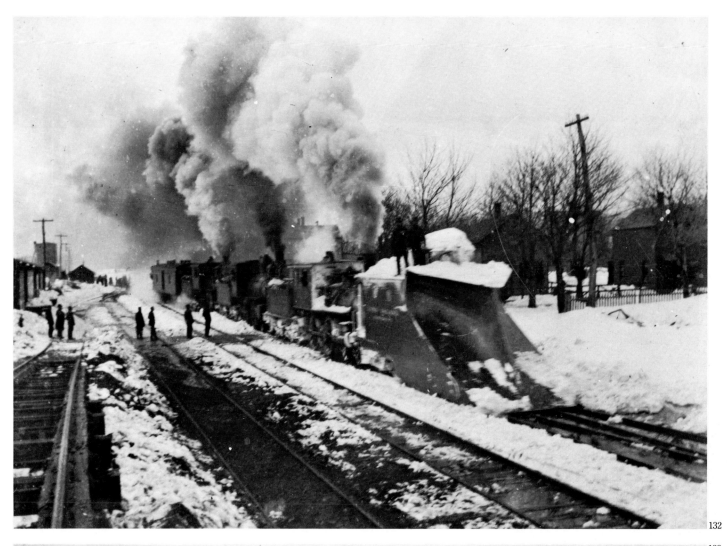

132

133

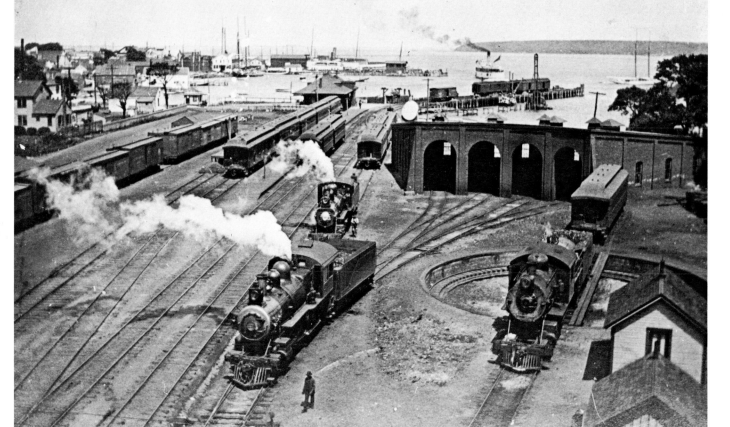

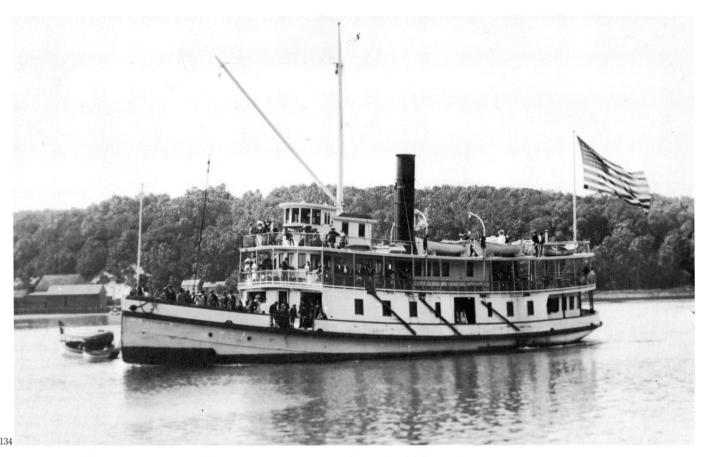

134

135

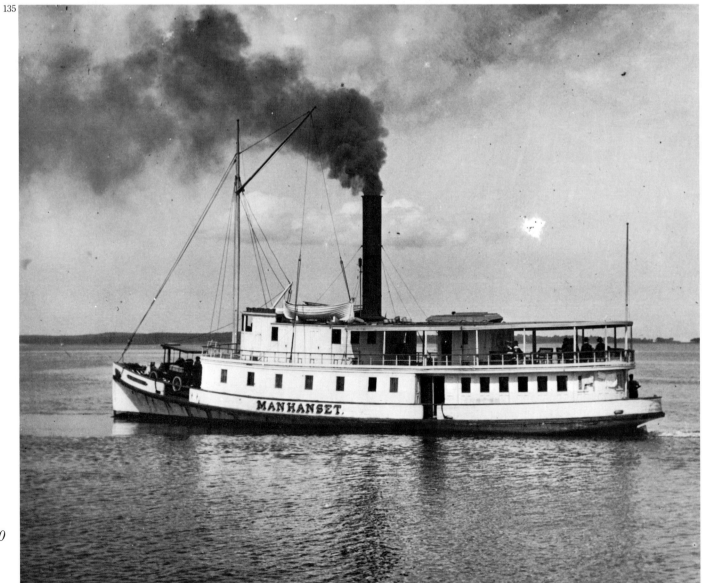

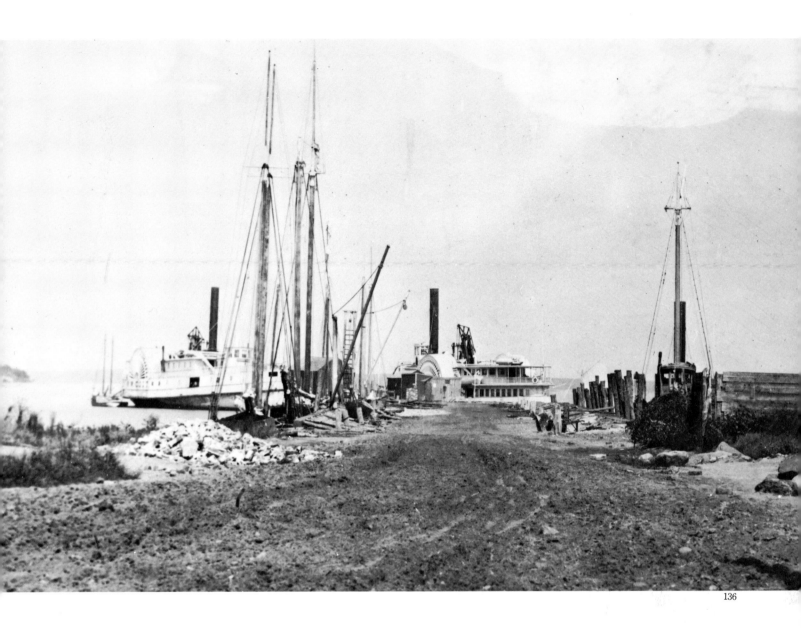

136

134. Steamer *Huntington*, ca. 1905. Independent steamboat lines operated successfully from New York along the sound shore as far as Northport, but they never proved profitable on the run to Port Jefferson. There was a durable line between Port Jefferson and Bridgeport, Connecticut, patronized in part by local women who took a boat to Bridgeport to do their shopping. Another prosperous line that crossed the sound was that of the Huntington, Norwalk and Bridgeport Steam Ferry Company, organized in 1855. It traveled mainly to New York City. The second boat of the line, the steamer *Huntington*, was launched at Athens, New York in 1888 and operated until 1916, when the company closed. *(Lightfoot Collection.)*

135. Steamer *Manhanset*, ca. 1904. Captain George C. Gibbs of the *C. W. Coit* founded the Montauk Steamboat Company in 1886 and soon ordered large boats to handle the rapidly growing freight and tourist business in the Peconics, Montauk and Block Island. The Long Island Rail Road, unable to defeat him after 35 years of opposition, finally conceded defeat and put up the money to buy a controlling interest in his company in 1899. The *Manhanset* was one of the smaller boats on the line, ideal for local traffic but unable to breast the heavy storms of the sound. An automobile is on the forward deck. Wagons had often been carried on these boats; stories are still told of

one wagon, being unloaded at the Shelter Island dock, that fell into the bay and was never recovered. *(Photograph by Hal B. Fullerton; Suffolk County Historical Society, Fullerton Collection, #1012.)*

136. Wharf, Sag Harbor, 1880. The Long Island Rail Road, which ran a number of steamers at its western terminus, first shuttled steamboats between Greenport, its eastern terminus, and Connecticut in the 1840s, when the through mails between Boston and New York went over its line. When the mail contract for Boston was lost in the 1850s, the railroad gave up its steamboats, but new entrepreneurs started steamboat routes from Sag Harbor, Southold and Greenport to Connecticut and New York. After the Civil War, the *C. W. Coit* was the most popular boat on these routes; she is shown in the photograph at the main wharf in Sag Harbor. The wharf was in dilapidated condition by the 1880s; the prosperity of the harbor had suffered from the loss of the whaling industry. During this period, the Long Island Rail Road tried to regain control of the steamboat trade, but the independent owners, having the loyalty of the public, kept themselves solvent by sending the boats to southern waters when winters froze Long Island bays. *(Photograph by George Brainard; Collection of Ron Ziel.)*

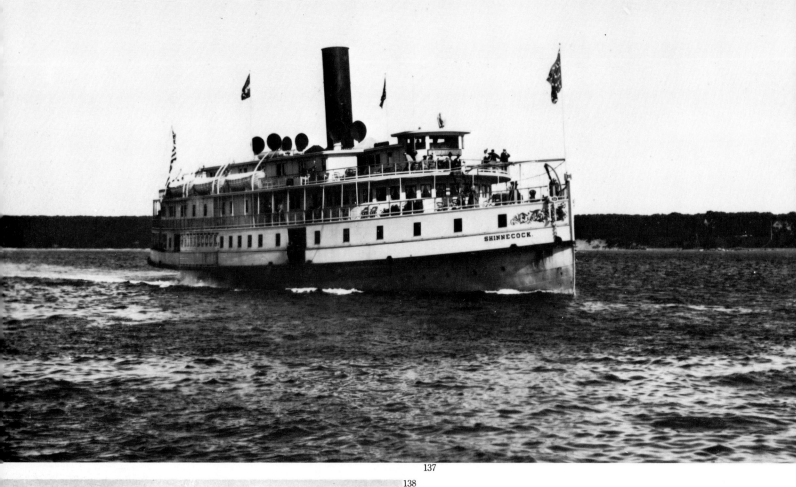

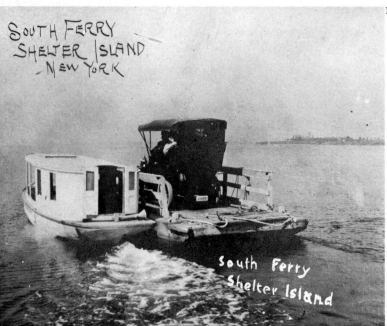

SOUTH FERRY
SHELTER ISLAND
- NEW YORK

South Ferry
Shelter Island

137. Steamer *Shinnecock*, ca. 1903. The most magnificent boat of the Montauk Steamboat Company was the *Shinnecock*, named after the group of Indians. The *Shinnecock* was 234 feet long and 35 feet in beam. She could accommodate 60 automobiles. She had been purchased from a New England company, where she had borne another Indian name, *Tagadahoc*. Because of her draft of 14.3 feet, she was run aground at various points in Peconic Bay, and was known as a bit of a hoodoo for the number of troublesome incidents on board. She was converted to a barracks boat at the Quarantine Station on Staten Island during World War I, but was reconditioned in peacetime and returned to her old run with a capacity of 2000 passengers. Although the ride from New York to the East End aboard the "white boats" compared favorably with the often hot and dirty train ride, automobile and truck competition ended the steamship business by 1928. *(Photograph by Hal B. Fullerton; Suffolk County Historical Society, Fullerton Collection, #L13B.)*

138. South Ferry, Shelter Island, ca. 1905. An amusing contrast to the large steam ferry that served summer people on the north side of Shelter Island was the small one that ran between the south side of the island and North Haven. In the early 1900s, this was nothing more than a small barge towed by a motorboat. The southern side of Shelter Island was as yet undeveloped, while the north side, being convenient to the railroad, had been purchased, in part, by a camp meeting of the Methodist Episcopal Church in 1879. Tourist activity on the island, which had been an independent town since 1730, began in the 1870s. Part of the land grant of William, Earl of Stirling, the island was sold to a small group of merchants in 1651 for 1600 pounds of "good merchantable Muscovado sugar." By 1666, it was in the possession of Nathaniel Sylvester and his brother Giles, who traded in Barbados; their title was confirmed by Richard Nicoll, Governor under the Duke of York, in return for the annual payment of one lamb on the first day of May. The Sylvesters, like other Long Islanders of their period, imported slaves from the West Indies. In 1776, 33 slaves still lived on Shelter Island. *(Lightfoot Collection.)*

139. "Daddies' " Ferry to Shelter Island, 1914. Following the construction of Pennsylvania Station and the railroad tunnel, many city guests at Long Island resorts made a lasting commitment to the seashore and countryside by buying summer cottages. For the prosperous, a cottage was likely to be a ten-room house. Accommodating the weekend visits from the fathers who spent all week on Wall Street, the Long Island Rail Road ran special fast trains, such as the famous *Cannonball*. Shelter Island profited from increased tourist business. Year-round population of Shelter Island was 100 people in 1730; by the turn of the twentieth century, 1066 people shared its 8000 acres. *(Collection of Miriam Hartley.)*

140. Side-Wheel Steamer *Senekes*, Moriches, 1897. For those who could not afford a boat or felt apprehensive about running one, there were still many ways to enjoy the pleasures of boating. At some ports, large catboats with baymen at their helms were available for taking a safe and leisurely sail. There were also regular excursion trips on steamboats from New York to public picnic groves at Cold Spring Harbor and points east. These boats were sometimes supplemented by towed barges to accommodate very large crowds. The throngs of day-trippers were welcomed by the merchants of the North Shore, but soon the groves were bought up by wealthy New Yorkers for their large shorefront estates and the good times ended. On the South Shore, the graceful side-wheeler *Senekes*, shown here in a creek at Moriches, offered a round trip to Smith's Point Pavilion every Sunday, for only 25 cents. Passengers could bring along their food or buy it at the pavilion, which also offered music and dancing. *(Photograph by Hal B. Fullerton; Suffolk County Historical Society, Fullerton Collection, #1950A.)*

139

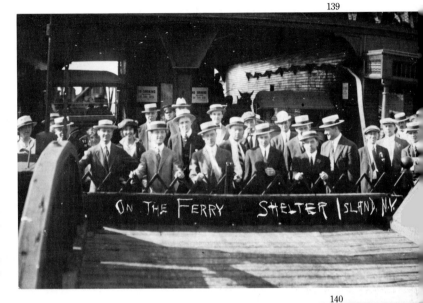

140

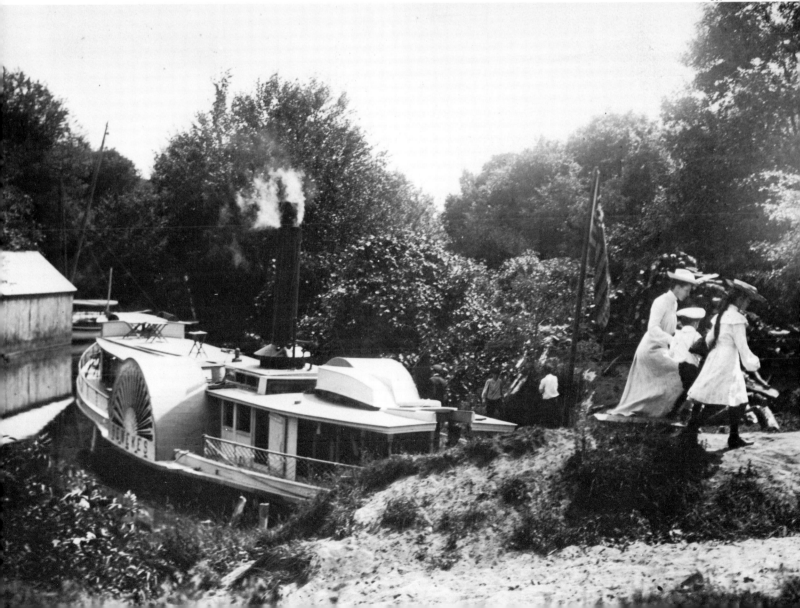

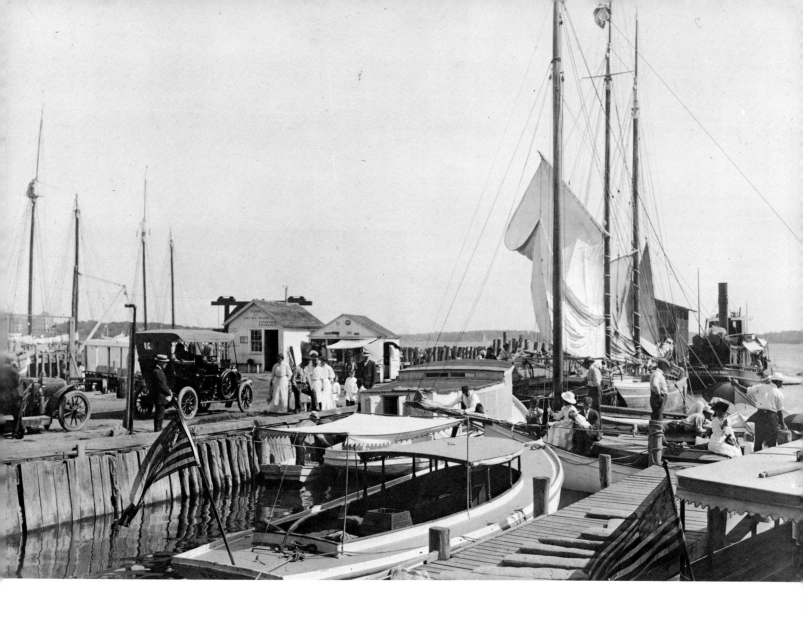

141. Waterfront, Greenport, ca. 1905. This photograph of the wharf, looking toward the Shelter Island ferry departure point, shows how busy the waterfront was in summer and how intimately and harmoniously tourists and commercial enterprises mingled. The small awninged boats in the foreground are part of a large fleet that used to congregate at Jessup's Neck and other favorite fishing spots in May and June to haul in weakfish. Seven bait dealers were kept busy supplying the needs of thousands of sportfishermen. Beyond these boats and some sailing yachts are commercial vessels, including a two-masted schooner and a tug. Other schooners lie at the dock to the left of the ferry. *(Lightfoot Collection.)*

At Leisure

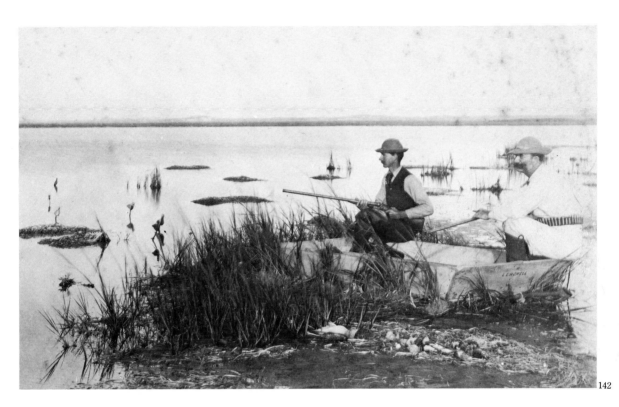

142

142. Waiting for Snipe, Shinnecock Bay, ca. 1888. Sportsmen were attracted to Long Island by its rich and varied bird life. Before 1885, 388 of New York State's 412 species of birds had been recorded there. This great abundance of bird life was sharply reduced when thousands of market gunners, still unrestricted by law, fired randomly into flocks, killing huge numbers of wildfowl. When this photograph was taken, hunting on Shinnecock Bay still yielded broadbills, brant, whistler, black duck and sheldrake. Snipe, whose erratic, dipping flight made them targets only for experts, were greatly prized by hunters. Formed in 1896, the Fish, Game and Forest Commission enacted laws to prevent wanton killing. The Shinnecock National Wildlife Refuge, established in 1937, still provides a resting place for migratory waterfowl in the Hampton Bays. *(Lightfoot Collection.)*

143. Helping to Draw the Seine, ca. 1905. Long Island's commercial fishermen used several kinds of nets to capture their fish. Summer visitors soon adopted the haul-seine method of professional netters. At some shore resorts, a seine would be run out along the beach and, like Tom Sawyer and his whitewashing, anyone who came by would be recruited to help haul it in. The reward was the excitement of seeing what the net contained. *(Lightfoot Collection.)*

143

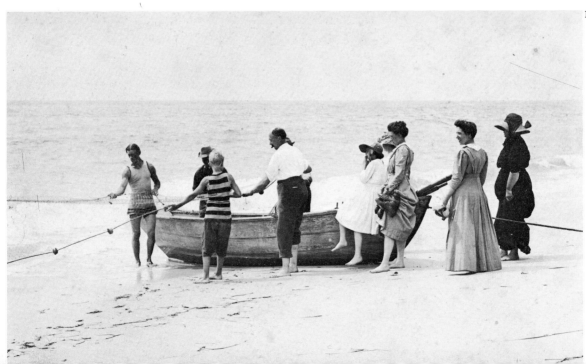

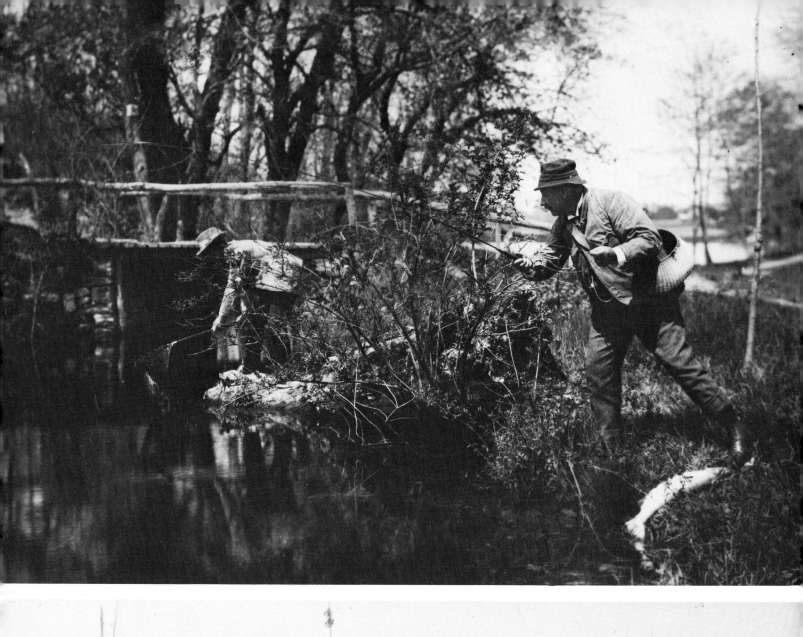
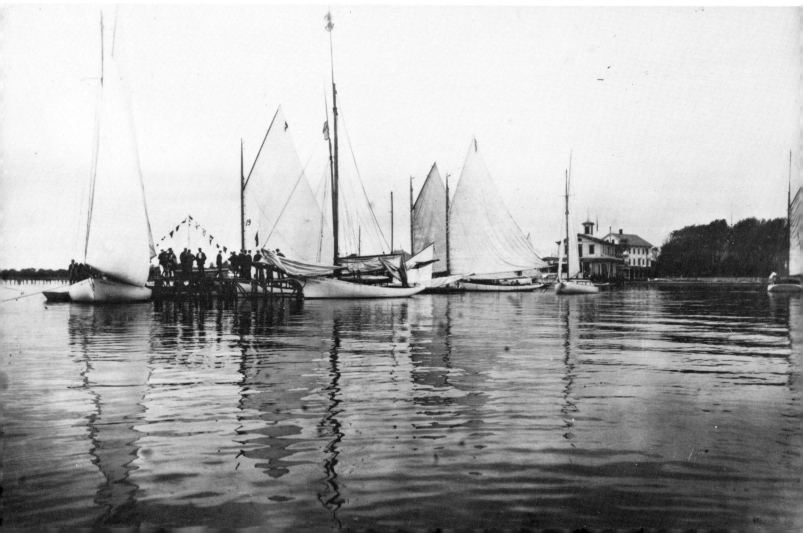

144. Ed Thompson Fishing from Daniel Webster's Bridge, Smithtown, 1903. Many wealthy sportsmen were also attracted to Suffolk by its excellent trout fishing. Brook and brown trout were plentiful in the days before the felling of forests caused a severe drop in the water table, forever reducing many freshwater streams and ponds to a trickle. Local men who owned land near trout streams catered to such prominent anglers as Daniel Webster by providing shelter and acting as guides. Groups of monied anglers bought up large blocs of land and built luxurious clubs, such as the Great South Bay Angler's Club, the South Shore Rod and Reel Club, the East End Surf Club and August Belmont's exclusive Suffolk Club in Bellport. This photograph, which shows a trout of respectable size already on the bank, depicts members of the fishing club at Smithtown. *(Photograph by Hal B. Fullerton; Suffolk County Historical Society, Fullerton Collection, #L215B.)*

145. Yachts at Dock in the Patchogue River, 1899. Yachting on Long Island had an early precedent in the whaleboat races that were held before 1800. By 1856, the *New York Herald* called the yachting revival "the most expensive, the most healthful and the most delightful of amusements." Yacht racing was at its peak about 1895. Clubs were formed wherever enough yachts congregated. The Great South Bay Yacht Club at Bay Shore was famous for its spirited regattas held on Saturday afternoons throughout the summer. Islip was noted for small-boat races and vied with Patchogue for yachtsmen's favor. Because the shallowness of Great South Bay restricted boat size, most of the yachts used in its waters were smaller than those in the Peconics. *(Photograph by Hal B. Fullerton; Suffolk County Historical Society, Fullerton Collection, #2012A.)*

146. New York Yacht Club Station No. 5 at Dering Harbor, Shelter Island, ca. 1905. In 1844, Long Islanders were among the charter members of the New York Yacht Club. At Dering Harbor, they established this station, where members could receive mail, messages and weather reports. The club used Long Island Sound for its squadron runs and regattas, preferring the inland waters such as Great South Bay for racing small sloops and catboats. Some of the New York Yacht Club's earliest racing vessels were produced at Long Island shipyards. R. H. Wilson's Port Jefferson sail loft became famous when it outfitted the *America*, the first American schooner to win the international cup in England's Royal Yacht Squadron race. After the club abandoned this station, the building was barged to Sag Harbor to become the clubhouse of the Sag Harbor Yacht Club. *(Collection of the Suffolk Times.)*

147. Waukewan Canoe Club, Amityville, 1900. After the New York Canoe Club was formed in 1871—the first local organization of its kind—canoeing became another sporting rage. On Long Island, canoes joined racing skiffs and other small boats operated by manpower. Founded in 1880, the American Canoe Association sponsored paddling and sailing races at its annual meet; it first offered its International Challenge Cup in 1885. The best canoes were not cheap and required dedicated team practice. *(Lightfoot Collection.)*

144

145

146

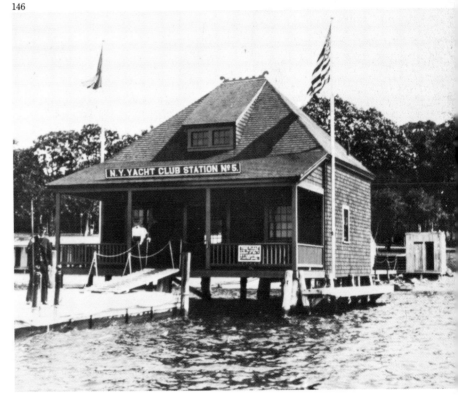

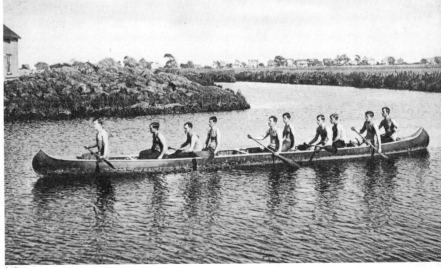

147

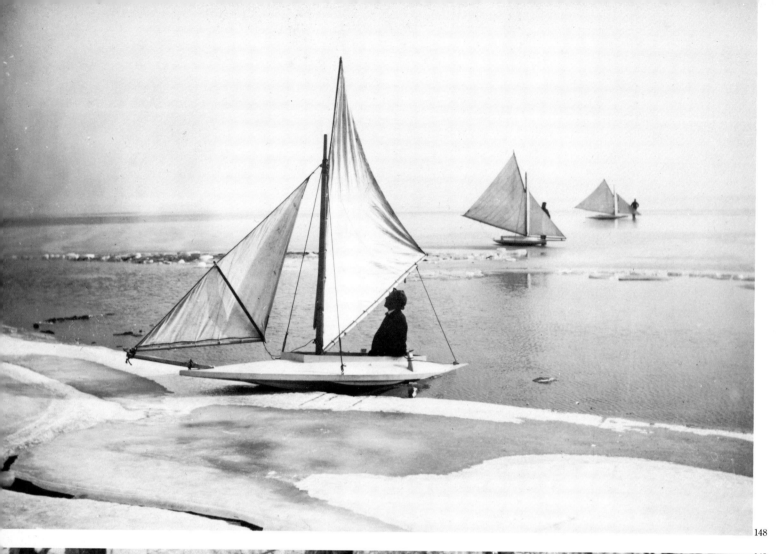

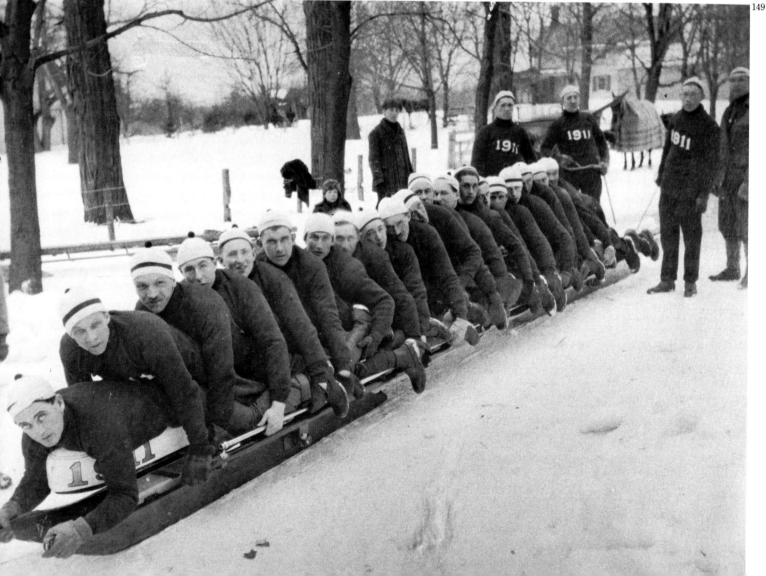

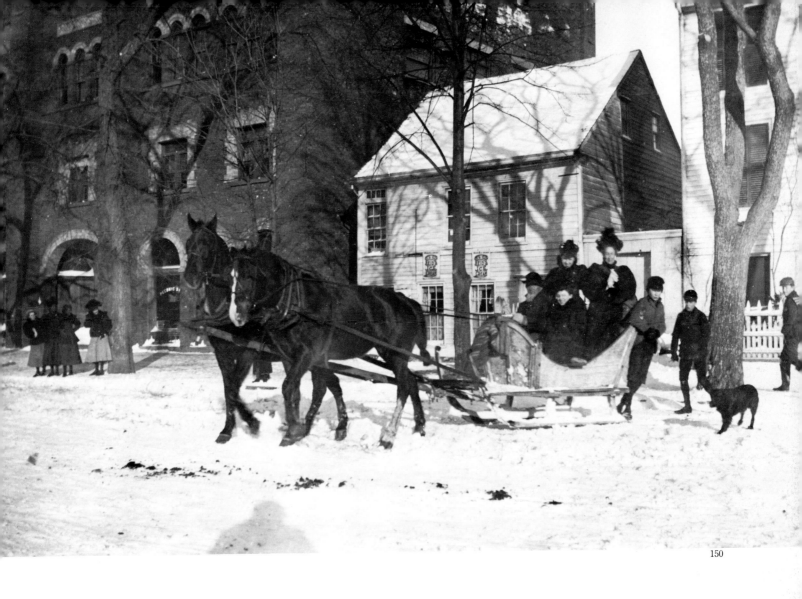

148. Group of Scooters, Bellport, 1903. Iceboating was a popular winter sport on Great South Bay and parts of the Peconic. As far back as 1837, Daniel Hildreth and Charles Howell of Southampton had built an iceboat capable of going a mile a minute. At Bellport, in 1874, Captain William R. Corwin created the "scooter," a one-man boat with runners that skimmed over the frozen bay to transport baymen, market gunners and supplies. Corwin perfected the scooter by beveling the runners, giving them a rocker shape and adding a jib sail for steering. Practical vehicles during winter, ice boats soon were used for racing. Bellport, whose village emblem and seal is the ice scooter, was the location of a unique ice-yacht group known as the Scooter Club. *(Photograph by Hal B. Fullerton; Suffolk County Historical Society, Fullerton Collection, #1183F.)*

149. "1911" Bobsled Team, Huntington, 1920. For 13 years, Huntington was known for its Winter Carnival, especially its bobsled races. On February 27, 1907, the first bobsleds roared down an iced course running from the top of Cold Spring Hill, past New York Avenue, to the library. Seen here is the "1911" team, owned by Zeb Wilson of Bayville, which took both firsts in speed and distance. Dressed in matching green sweaters and caps, the team also won first place for their appearance. During the 1920 race, tragedy struck when an all-girl team, the "Greyhounds" of Canada, hit a rut and slammed into a tree while being photographed. After that, the bobsled races were discontinued. *(Huntington Historical Society.)*

150. Sleighing, Sag Harbor, ca. 1910. Long Island's winters were often harsh. Early settlers endured the great snowstorm of 1717, which buried houses in Orient to the second story. Margie Crossman, an 11-year-old living on a West Neck farm, described the famous blizzard of 1888, when "nothing but heavy wood sleighs could pass" after five days of heavy snow. Still, during normal winter weather, sleighing was a popular leisure-time activity. In their kid gloves and bonnets, ladies like these would drive through the village, perhaps on an outing to some nearby inn. *(Lightfoot Collection.)*

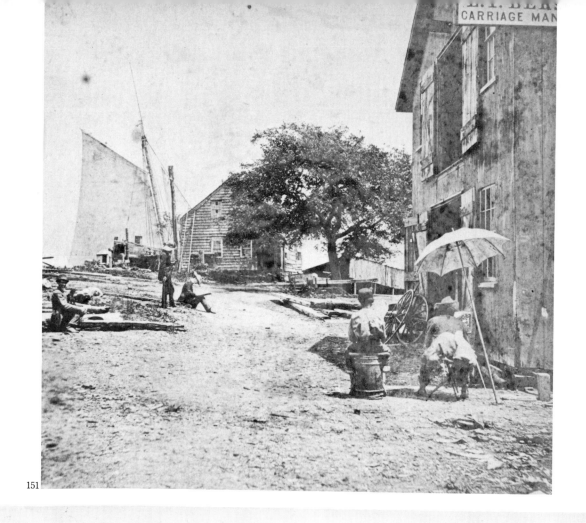

151

152

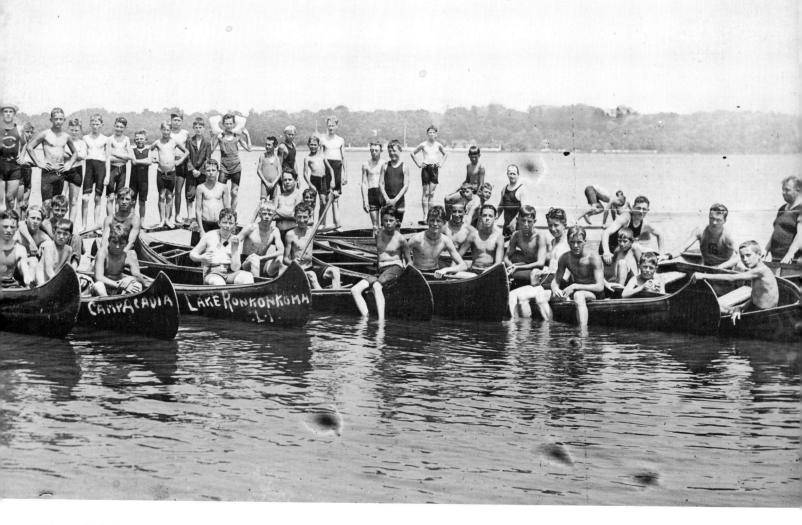

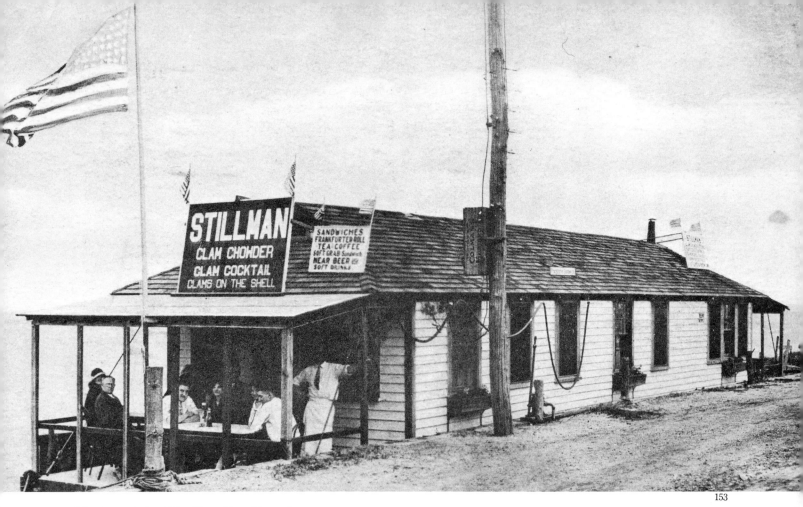

153

151. Member of the Tile Club Sketching, Greenport, 1879. Members of the Tile Club discovered Long Island's East End in the late 1870s. Founded in New York City in 1877 by F. Hopkinson Smith, the club offered common fellowship to artists. From its original intent to paint on tiles, the group soon extended its activities to sketching. Working together, members would follow excursions with critical appraisals of their work. The Tile Club was the first group to give incentive to the Long Island art-colony movement. Thomas Moran was the most famous member of one early group formed at East Hampton. Another, under the aegis of landscape painter William M. Chase, branched off in 1891 to Shinnecock Hills. Today, many artists and writers still come to Long Island's summer art colonies. *(Lightfoot Collection.)*

152. Lake Ronkonkoma, ca. 1905. Lacking sea breezes to ameliorate the summer heat, the center of Long Island attracted visitors to areas where there were lakes. One such oasis was Artist's Lake, where the illustrator Alonzo Chappel moved in 1869. Another was Lake Ronkonkoma, which filled a giant kettle hole created by a glacier during the Ice Age. (Believing that this lake was sacred, Indians had thought that anyone who violated its sanctity would drown and his body would flow underground to Great South Bay.) The groves around the lake, noted for an abundance of deer, were a favorite site for picnics and camp meetings. The many boardinghouses and summer cottages built around the lake were especially popular with European immigrants, who preferred freshwater resorts. *(Lightfoot Collection.)*

153. Stillman's Floating Diner, Blue Point, 1930. Local shore dinners were a special treat for vacationing gourmands. Some of the best food was served in such unprepossessing restaurants as Stillman's floating diner at Blue Point, a location famous for its large, succulent oysters from Great South Bay. Local fishermen provided the freshest of seafood, while nearby farms supplied fresh-picked vegetables. Lavish courses of steamed clams, chowder, lobsters, fish and oysters were served, along with piles of corn on the cob. Sandwiches, frankfurters and chicken were available for landlubbers. *(Photograph by E. E. Brown, Patchogue; Lightfoot Collection.)*

154. Pool Hall, Greenport, ca. 1900. The pictures of battleships hung inside this poolroom suggests that it is about 1900, when pride in the Navy and its victories in the war with Spain was widely expressed. By 1900, poolrooms and billiard halls, which had once attracted the upper class, were in low repute, so photographs of them were rarely taken. *(Stirling Historical Society.)*

154

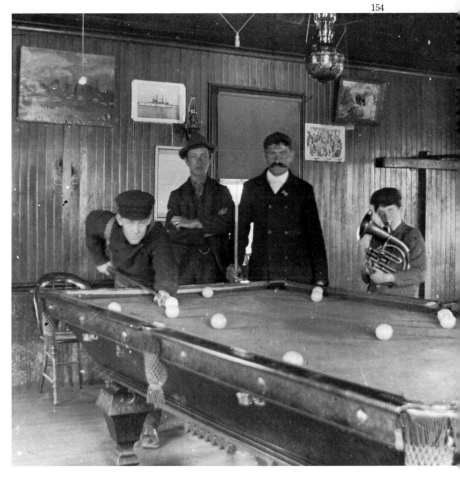

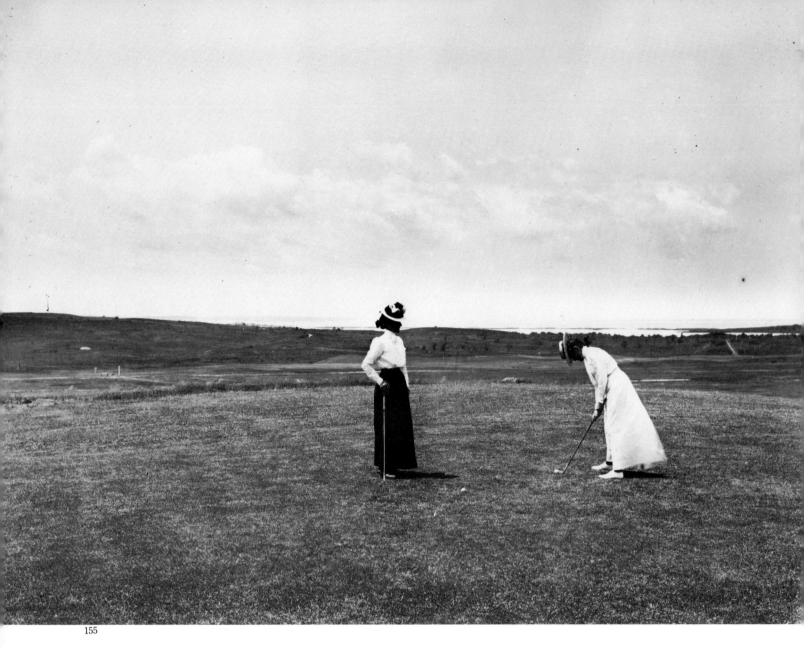

155

155. Miss Beatrice Hoyt, Champion, Shinnecock Golf Course, 1901. Substantial colonies of socialites were established at East Hampton, Southampton, Westhampton and the Shinnecock Hills. One outcome of this invasion was the introduction of golf to the United States, which occurred partly because the Shinnecock Hills' terrain struck a Scotsman, Duncan Cryder, as being similar to the part of Scotland where golf originated. In 1889, Cryder, William K. Vanderbilt, Jr. and E. S. Mead went to Europe to locate someone who could lay out a golf course for them. The 12-hole course at Shinnecock, built by Willie Dunn, was completed in 1891. Golf's popularity soon spread all over the island. At Shinnecock, a women's nine-hole course and accompanying clubhouse were added. *(Photograph by Hal B. Fullerton; Suffolk County Historical Society, Fullerton Collection, #L117A.)*

156. Peace and Plenty Inn, West Hills, 1902. Still standing today, the Peace and Plenty Inn dates back to the seventeenth century, when it was an important stop along the stagecoach route. At the turn of the twentieth century, it continued to serve as an inn and was a favorite lunching stop for Teddy Roosevelt, who used to drive over from Oyster Bay. The inn's owners, the Chichesters, pose proudly on the porch with portraits of their ancestors. *(Photograph by Hal B. Fullerton; Suffolk County Historical Society, Fullerton Collection, #1177.)*

157. Clarke House, Greenport, 1910. A favored stopping place in Greenport, this hotel was established in 1831 by Captain John Clark on the west side of lower Main Street. Besides being the proprietor, Clark was village postman and ran the post office from the hotel's basement. After Clark's death, the hotel was conducted by Mrs. Clark and, until 1928, by their daughter, Betsy Clark Post. For nearly a century, many visited this "home-like" but exclusive hotel, whose fireplace was painted with the words, "Shall I not take mine ease in mine inn?" Its guest register boasted such illustrious names as John Quincy Adams, Winfield Scott and George Dewey. The hotel was closed in 1928, after Mrs. Post's death. *(Photograph by Henry Otto Korten; Lightfoot Collection.)*

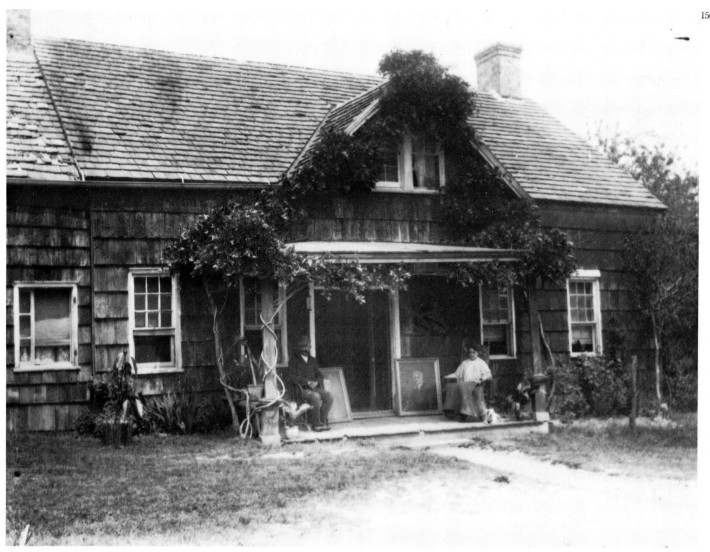

156

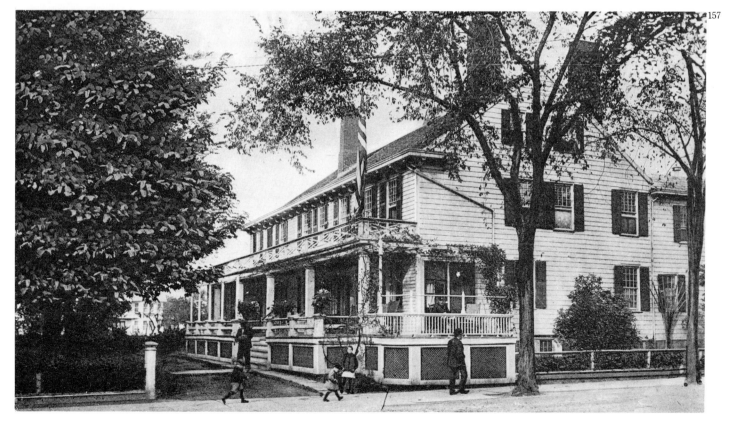

157

At Leisure 113

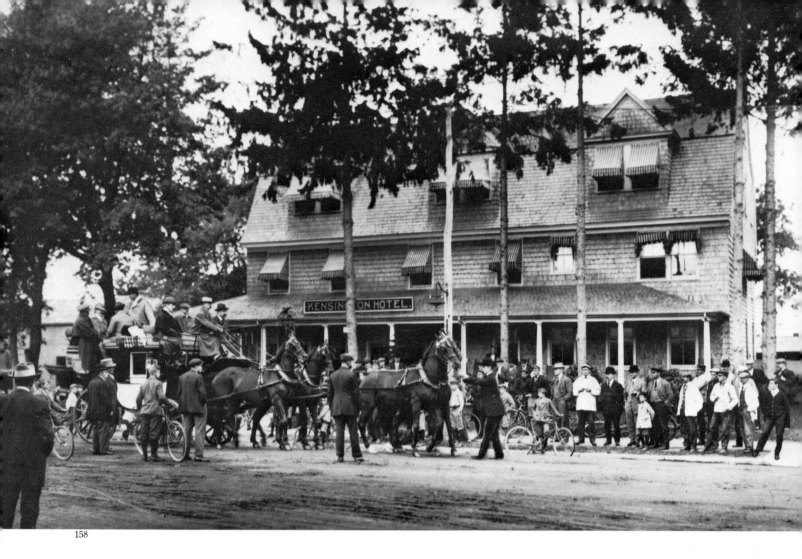

158

158. Kensington Hotel, Sayville, ca. 1908. It was in the rooms of the Kensington Hotel, then called the Bedell Tavern, that a conference was held in 1838 to choose a better name for the hamlet known as Over South. The name Seville was selected, but the secretary who entered it in the official Washington records misspelled it as Sayville—the name used ever since! A. S. Kennedy was the Kensington's proprietor when this photograph was taken of an English-style coach in front of the hotel. Coaching parties became a regular pastime for affluent summer visitors, especially after William K. Vanderbilt invited a New York City coaching club to his Islip estate. The desire to emulate other activities of the English nobility led to the introduction of fox hunts, polo and horse shows on Long Island. *(Photograph by Henry Otto Korten; Lightfoot Collection.)*

159. Old Inn, Montauk, ca. 1898. Resorts on the South Shore boomed after the South Side Railroad extended its line to Patchogue in 1868 and the Long Island Rail Road ran a spur line to Sag Harbor in the following years. In 1879, a wealthy New Yorker, Arthur W. Benson, purchased the tip of Montauk Point, including the old buildings known as First, Second and Third Houses, formerly used by cattle grazers. Third House, also called Stratton's, after the family that ran it, was turned into an inn renowned for its superior food. Benson formed the Montauk Association and contracted with Frederick Law Olmsted, one of the designers of Central Park, to improve the lands. After Benson's death, Austin Corbin and Charles M. Pratt bought 5500 acres from his heirs with a plan to make Montauk the terminus of ocean steamships. Corbin extended the railroad to Montauk and a new inn, shown here, was built to replace Stratton's. It burned down in 1926. *(Photograph by Hal B. Fullerton; Suffolk County Historical Society, Fullerton Collection, #5415B.)*

160. Surf Hotel, Fire Island, ca. 1890. In 1858, David Spurgess Sprague Sammis, proprietor of Manhattan's popular East Broadway Hotel, opened the Surf Hotel near the Fire Island lighthouse. An 1875 article in the *Evening Post* noted that many summer vacationers were attracted to Long Island's beaches, which were "particularly agreeable to those afflicted with 'hay fever' or 'rose cold.' " The three-story Surf Hotel, with a beach frontage of more than 600 feet and accommodations for 1500 guests, soon became the largest summer hotel in Suffolk. Sammis provided steam-ferry service from Babylon to his Fire Island dock. On May 8, 1892, Sammis transferred his Fire Island property to New York State, which bought the hotel as an emergency quarantine station for steamship passengers exposed to cholera. In 1908, the area became a State Park. *(Photograph by Hal B. Fullerton; Suffolk County Historical Society, Fullerton Collection, #2035.)*

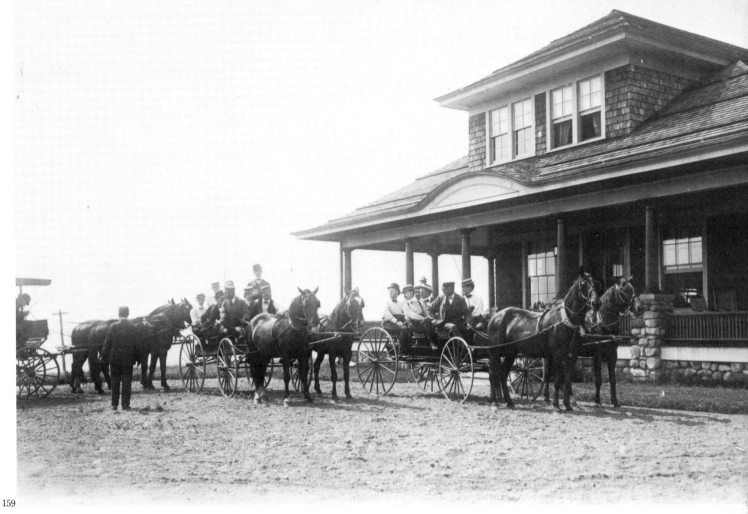

159

160

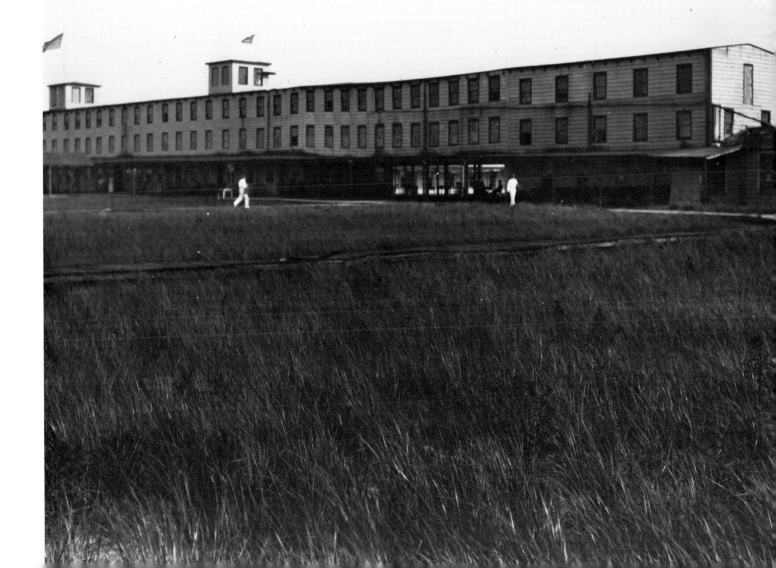

161

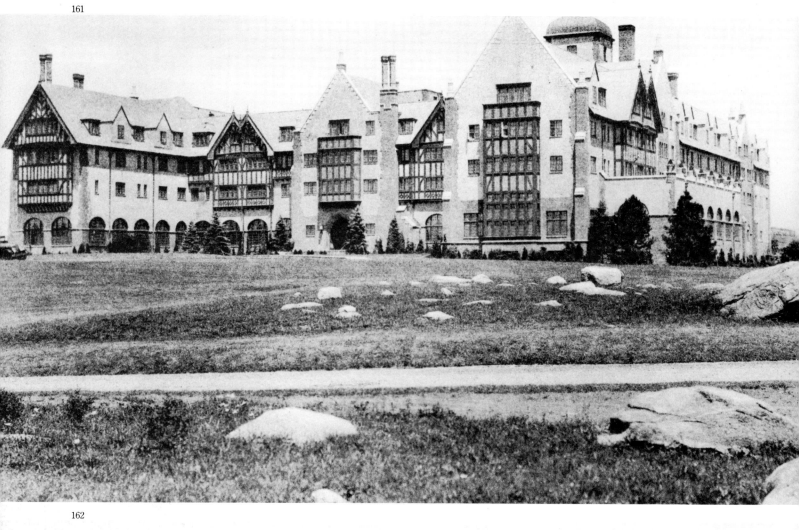

162

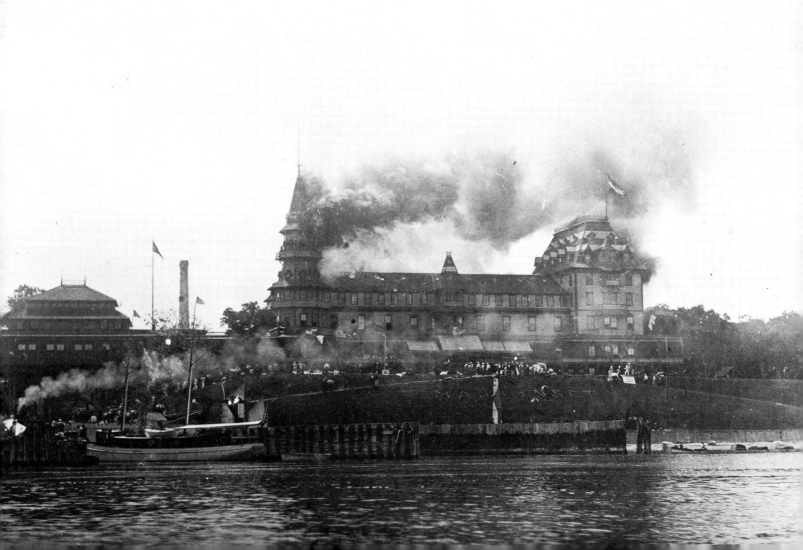

161. Montauk Manor, ca. 1920. The most
extravagant playground for the rich was
planned at Montauk by Carl Graham Fisher.
Fisher, a grade-school dropout, became a mil-
lionaire by selling bicycles, automobiles and a
gas automobile light before joining in the con-
struction of the Indianapolis Motor Speed-
way. Successful as a real-estate developer for
Miami Beach, Fisher dreamed of duplicating
the Florida pattern at Montauk. He acquired
9700 acres with nine miles of waterfront and
built 25 miles of roads, a large pier, sports
facilities, an office building, a Norman church
and a hotel—Montauk Manor. Unfortunately
for Fisher, the boom of the 1920s collapsed in
1929, dragging his $10 million project down
with it. Fisher died in 1939. The buildings he
left at Montauk sat idle for many years.
*(Queens Borough Public Library, Long Island
Division.)*

**162. Burning of the Manhanset House,
Shelter Island, August 13, 1896.** To al-
low members of the New York Yacht Club to
live in comfort on shore while they were at
Shelter Island, the opulent Manhanset House
was opened in 1873. Managed by the J. J.
Lannin Co., which operated the Garden City
Hotel, the Manhanset House featured a di-
rect telephone line to New York, its own post
office, a huge ballroom and stage, a billiard
parlor, barber shop, livery stable, bakery and
laundry. In 1896, a fire devastated the hotel.
Handicapped by lack of sufficient water on the
island, the firemen who arrived from Green-
port were unable to stop the blaze. Although
rebuilt, the luxurious hotel ultimately suc-
cumbed to a second fire in 1900. *(Stirling
Historical Society.)*

**163. "Box Hill," Estate of Stanford
White, St. James, ca. 1910.** While Suffolk
County never matched the intense con-
centration of wealth centered on Nassau
County's "Gold Coast," it was the location of
many large estates such as the sprawling
William K. Vanderbilt and Bayard Cutting
properties in Islip, and the Belmont and Cor-
bin places at Babylon. "Box Hill" was the
estate of influential New York architect Stan-
ford White (1853–1906). Located on Mor-
iches Road on what was once the old Carman
farm, the original house was remodeled and
enlarged by White. It was noted for its peb-
ble-dash exterior surface, early use of steel I
beams and unique tiled staircase. At "Look-
out Spot," where a statue of Diana now
stands, was a large wooden beacon used as a
landmark by mariners on Long Island Sound.
"Box Hill" is now on the National Register of
Historic Places. *(Lightfoot Collection.)*

**164. Ferguson's Castle, Huntington,
ca. 1908.** A famous landmark on the east
shore of Huntington Bay was "The Monas-
tery," the home of J. A. Ferguson, which was
known locally as "Ferguson's Castle." It was
filled with art treasures imported from Eu-
rope, including a sculpture attributed to
Leonardo da Vinci. Unfortunately, the house
was left unoccupied for many years and it was
badly vandalized. *(Photograph by Underwood
& Underwood; Lightfoot Collection.)*

**165. Circus Parade, Huntington, ca.
1920.** Traveling circuses were common on
Long Island in the summer, but few photogra-
phers recorded what would suddenly become
a thing of the past—the parade. This pho-
tograph shows camels striding down Main
Street. The advertising banner declares that
Essex cars are as durable as a camel. *(Pho-
tograph by Ben Conklin; Lightfoot Collection.)*

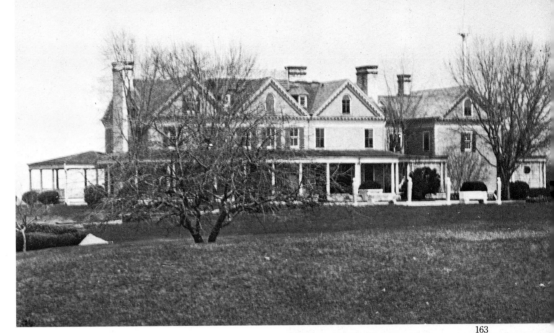

163

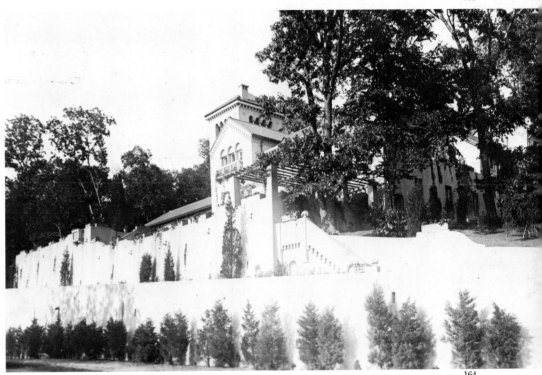

164

165

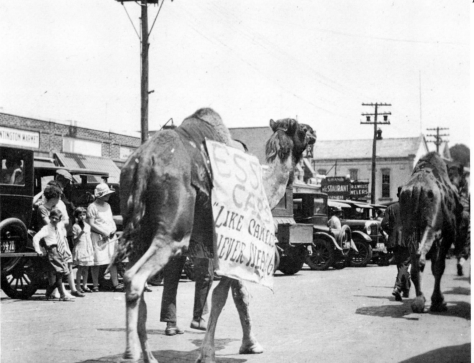

PORTRAITS

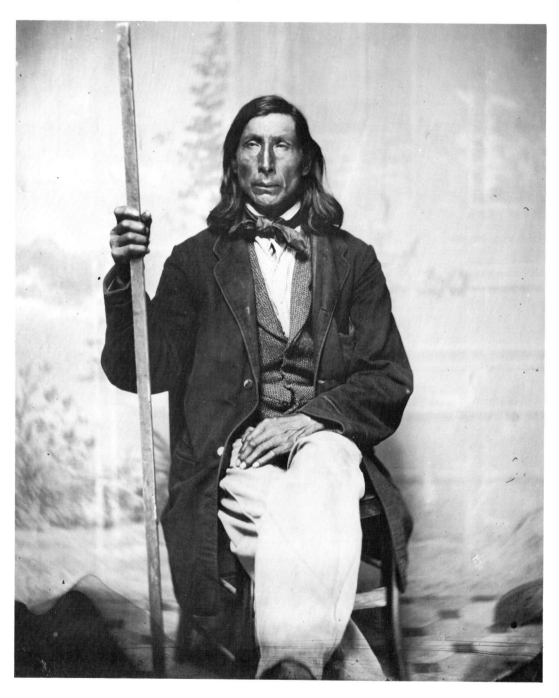

166. Stephen Pharaoh, Sag Harbor, 1867. Stephen Pharaoh (also known as Stephen Talkhouse), a lineal descendant of the Montauk sachem Wyandanch, was born in 1819 at Montauk, where about 68 of his people still lived. Another 40 had moved away as pressure by whites on their land increased. Stephen Pharaoh was bound out as a servant when he was a child, but his extraordinary abilities established his independence. He was a hunter and whaler, a forty-niner and a soldier with the Connecticut Volunteers during the Civil War. For a time he was displayed by P. T. Barnum as "King of the Montauks," and was put up against all comers as a champion walker. He walked faster than a horse and carriage could move on the old dirt roads, and was known to do a day's work and walk 40 miles within 24 hours. For a time he carried letters on foot between Montauk and East Hampton for a fee of 25 cents. In 1879 he was found dead in the woods. Shortly after, his fellow Montauks were dispossessed by the purchase of their land by the wealthy Brooklynite, Arthur Benson. They were given new homes at Freetown, in East Hampton, but tried for many years, by recourse to law, to regain their ancient right to camp on Montauk. Stephen Pharaoh's ancestor, Wyandanch, was signatory to many deeds of the seventeenth century exchanging land for trade goods. He is well remembered for his friendship and alliance with Lion Gardiner. Another Montauk of the seventeenth century, Cockenoe, is locally famous as one of the Indians who helped the Puritan minister, the Rev. John Eliot, translate the Bible into the Indian language. *(East Hampton Public Library.)*

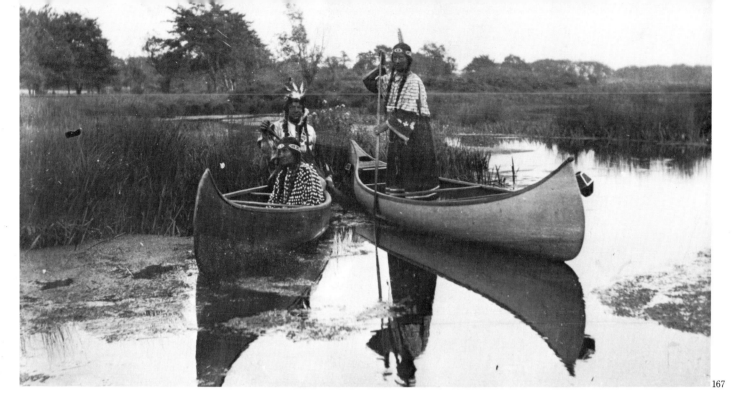

167

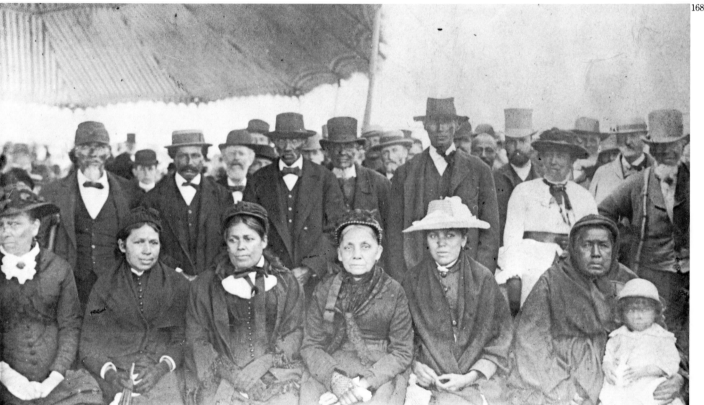

168

167. "Squassock's Indians," Mastic Beach, ca. 1905. Korten's post-card view emphasizes a romantic view of the untouched landscape at Mastic, where the Poosepatuck reservation was established in 1666 by the colonial government in the name of the king of England. It is possible that his "Squassock" may be a version of Sassacus, the chief sachem of the Pequots, by whom the Mohegans were ruled in the seventeenth century. The Poose-patuck were an Algonquian group of hunters, fishermen and, in the postcon-tact period, whalers. In 1884, 20 families lived on the land; present estimated population is 160, living on 60 acres that are not under federal jurisdiction. Poosepatucks intermarried with whites and blacks, and, as a result of their triracial ancestry, were never permitted to vote on the Indian Reorganization Act that would have entitled them to federal benefits. They are the smallest tribe on the smallest reservation in New York State, tenacious reminders of the people who fished in Poosepatuck Creek, Forge River and Moriches Bay before the European settlers came. *(Photograph by Henry Otto Korten; Nassau County Museum.)*

168. Shinnecocks, Shinnecock Hills, June 18, 1884. The Shinnecock people seen in the foreground of this photograph, taken at the Long Island Rail Road semicentennial celebration, lived on the 400-acre reservation set aside by the colonial assembly that remains the home base of their people today. It is a peninsula that juts into Shinnecock Bay from the South Shore of the South Fork and is protected by a stretch of Southampton Beach from the Atlantic breakers. Materials about the Shinnecock language are too sparse to allow any definite statements about its affiliation with other Algonquian languages, but Thomas Jefferson noted, in 1791, that the three groups of eastern Long Island Indians, Unquachog, Shinnecock and Montauk, spoke mutually unintelligible tongues. Many people from these groups left Long Island after 1775 to join Samson Occum, a Mohegan Presbyterian minister, who established a "praying town" of Christian Indians at Brotherton, New York. Some of the Brotherton people eventually moved to Wisconsin. Today, most of the 350 Shinnecocks who remain on Long Island work off the reservation. They elect three land trustees every two years. *(Photograph by Henry Otto Korten; Nassau County Museum.)*

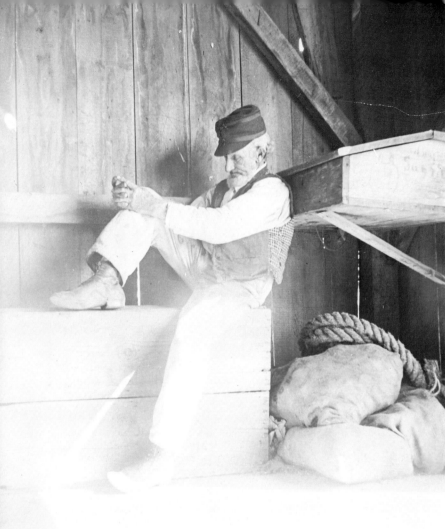

169. Captain John Homan, ca. 1880. The steamboat agent at Sag Harbor, John Homan was known familiarly by the lighthearted nickname "Toot-Toot." Yet here he is caught in a meditative moment. Suffolk County records show that two Homan brothers from Patchogue, 20 years or so younger than Captain John, went off to the Civil War in their late teens: Benjamin Laws Homan died at Andersonville in 1865 and his brother, John Gilbert Homan, was left crippled by a leg wound sustained in the Second Battle of Bull Run, 1862. *(Lightfoot Collection.)*

170. John Terry, Miller, East Marion, ca. 1900. John Terry of Orient, about 70 years old at the time of this picture, ran one of the mills still turning at the beginning of the twentieth century. His family name is well known in Long Island history, two forebears being among the people known to have been in Southold town before 1653. The miller had to be both strong and skillful to operate and maintain his mill. Every bushel of wheat had to be carried up a flight of stairs to the hopper that poured it onto the millstones. There were some men who were able to carry as many as five bushels at a time up the steps. The miller also had to pull the huge sail wheel around with a hooked stick to mount the sails. Running a mill was no job for a daydreamer. If the wind shifted, the sails had to be rotated to face it again. If the wind picked up too much, sail might have to be reduced. It was also necessary to adjust the spacing of the millstones so that they ground well, but did not jam. *(Photograph by L. Vinton Richard; Oysterponds Historical Society.)*

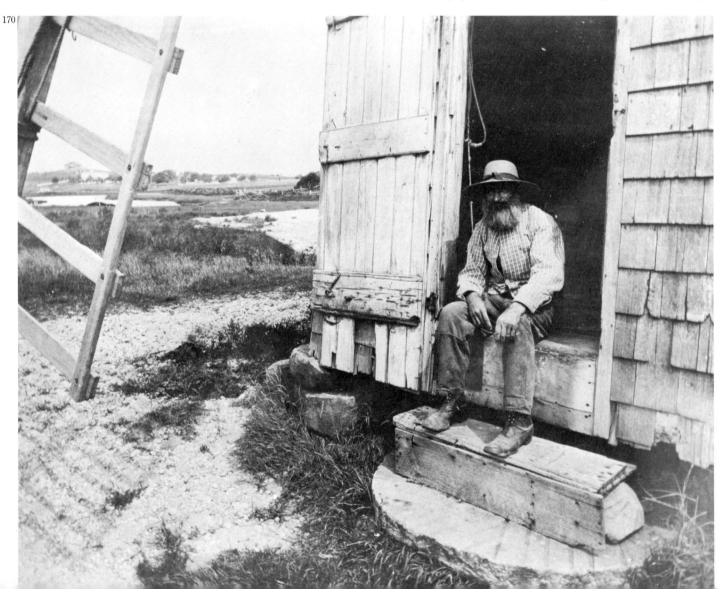

170

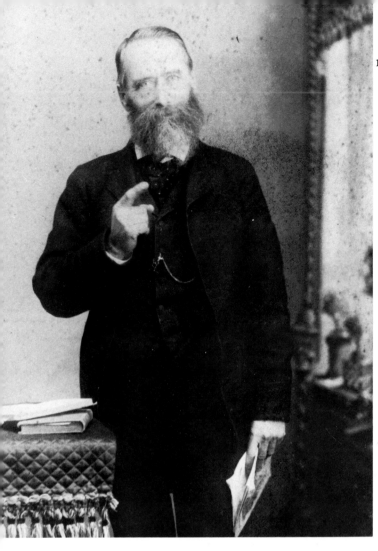

171. Charles A. Codman, Modern Times, ca. 1880. Charles A. Codman joined the utopian community of Modern Times (the site of present-day Brentwood) in 1852. It had its origin in the ideas of Josiah Warren, who had been a member of Robert Owen's community at New Harmony, Indiana. In 1827 Warren established a Time Store on Long Island, where people could trade labor for goods. He soon set out his principles in *The Practical Details of Equitable Commerce.* They included the importance of individuality and the establishment of a circulating medium based on the cost of labor. Codman, who as a young man had been in the sign and decorative painting business, was influenced by the intellectual ferment of the early nineteenth century, when enthusiasts held out hope for every kind of social and economic reform, including abolition. He became a public speaker after he invested his savings in one of the lots with log cabins in this reputedly healthful locality, where members of the community were called "individual sovereigns." Modern Times was renamed Brentwood in September 1864, and gradually lost its character as a place of social and economic reform. *(Suffolk County Historical Society.)*

172. Gathering of the "Old Crows," Indian Neck, ca. 1910. Starting at Jamesport in 1814, groups of farmers along Peconic Bay formed fishing companies to catch the mossbunker used as fertilizer, sometimes hiring fishermen to do the work, but more often operating the boats and seines themselves. A shack was built on the beach to house the farmers for the several weeks in spring when the bunker run was heaviest. Catches of 100,000 to 200,000 fish a night were reported for individual companies as late as 1904. After this practice died out, the farmer groups survived as social clubs that met annually for an outdoor feast. The "Old Crows" called their meeting a "Caw Caw." *(Stirling Historical Society.)*

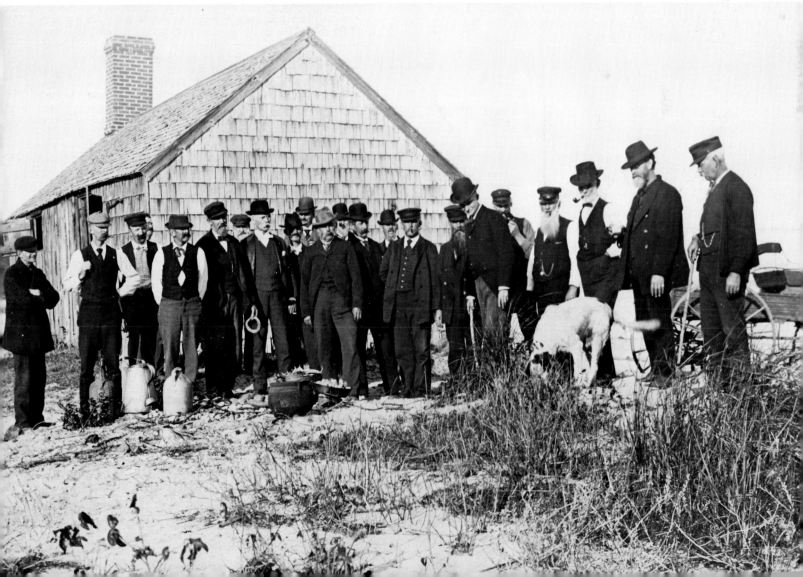

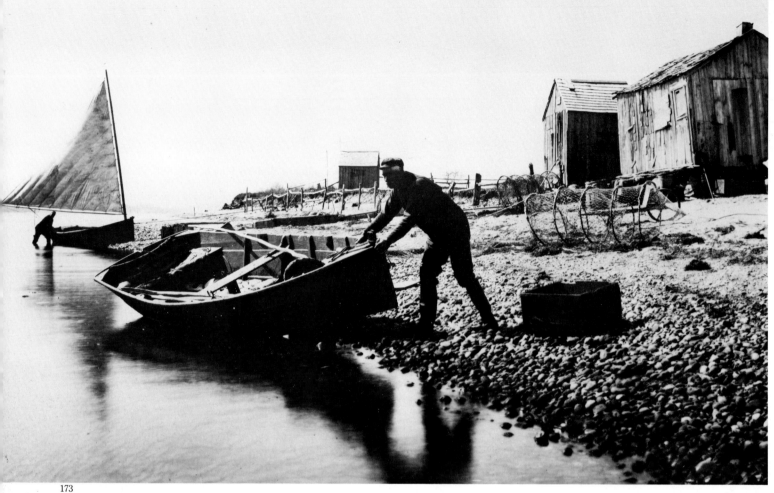

173

174

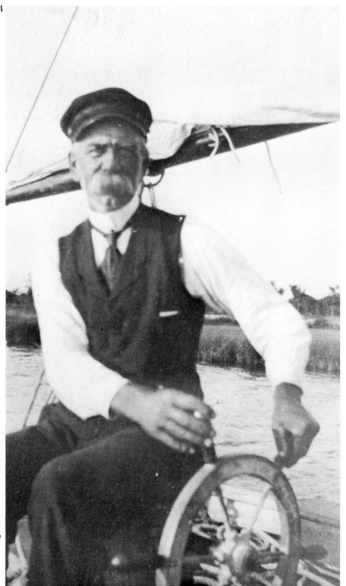

173. Captain Josh Fournier with His Boat and Fishing Outfit, East Marion, ca. 1902. When Francis Fournier first emigrated from France to Southampton during the American Revolution, the family name was erroneously spelled "Fornay" by Anglosaxon officials. Josh Fournier was a direct descendant of this family, many of whom are now buried in a private cemetery at Red Creek. Captain Fournier was, like many East Marion men, a trap fisherman. A trap usually consisted of a long "leader" net, placed perpendicular to the shore and supported by poles driven into the bay bottom, and a net enclosure at its offshore end. This net intercepted schools of fish moving along the beach which tended to head out along the leader into the net enclosure. Men came out to the trap, closed off the entrance and scooped out the fish. Some of the East Marion trap fishermen migrated as far north as Maine in the spring, sending their baled-up nets and ropes by rail and buying new poles locally to set up their traps. In the fall and winter, they might go as far south as the St. Johns River in Florida. *(Photograph by Hal B. Fullerton; Suffolk County Historical Society, Fullerton Collection, #L155.)*

174. Gil M. Smith, Boat Builder, Patchogue, ca. 1895. Born in 1842, Gilbert Monroe Smith was for 60 years famous as a builder of boats—over 400 in all. As a young man, he shipped out on a schooner to Cadiz and Cuba; during the Civil War, he sailed aboard coastwise vessels carrying supplies to the Union Army. After giving up the seafaring life, he began to escort gunning parties in Shinnecock Bay. Then, with his wife and five children, he moved to Patchogue in 1876 and opened his boatbuilding yard. His specialty was designing racing boats, such as the *Kittery* and *Rainbow*. As the first step in building a boat of his design, Smith constructed marvelously detailed half-models at his home on Amity Street. Some are now preserved in the Riverhead Museum. *(Queens Borough Public Library, Long Island Division.)*

175. Gang of Italian Railroad Workers, ca. 1903. From the 1870s on, there was a flow of Southern Europeans who emigrated to the U.S. in search of opportunity. Recruiting agents often intercepted new arrivals at embarkation points, offering employment at minimal wages. Crowded together in New York tenements, immigrant laborers made up a significant part of the unskilled work force. As the numbers of Italians increased, especially during the 1890s, men like those pictured here were hired for track gangs by the Long Island Rail Road. In Suffolk, many Italians settled at North Bellport, in a real-estate development known as "Boomertown," or at a section of Copiague called "Marconiville" because it was visited several times by Marconi. Many specially skilled Italians were employed as gardeners on Long Island estates. *(Photograph by Hal B. Fullerton; Suffolk County Historical Society, Fullerton Collection, #L775.)*

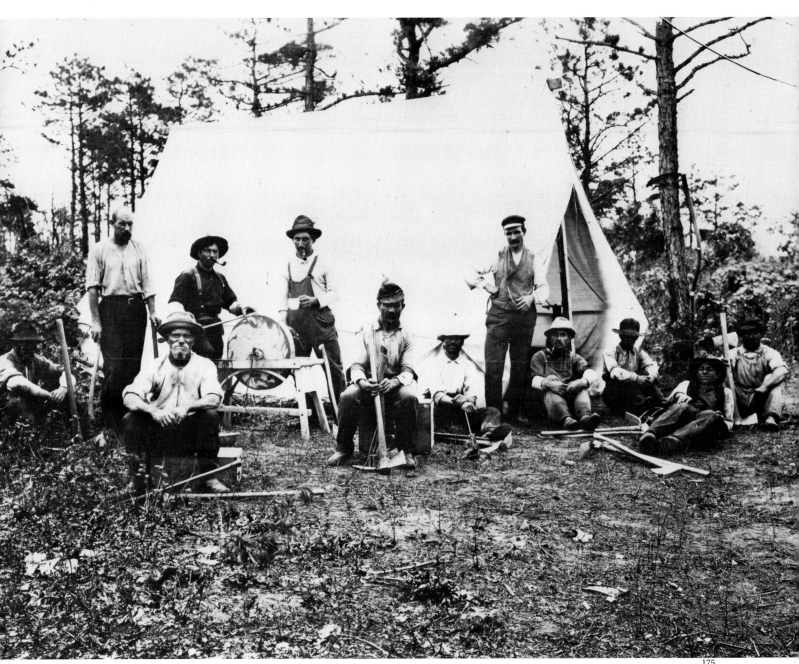

175

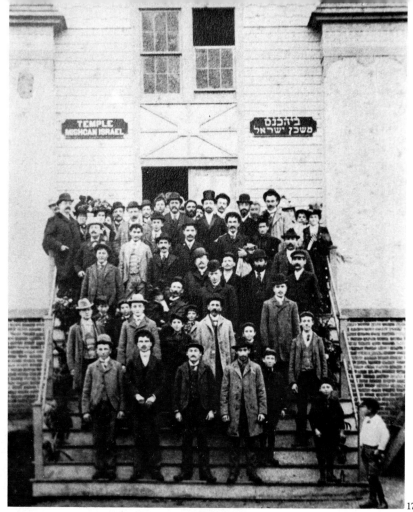

176

177

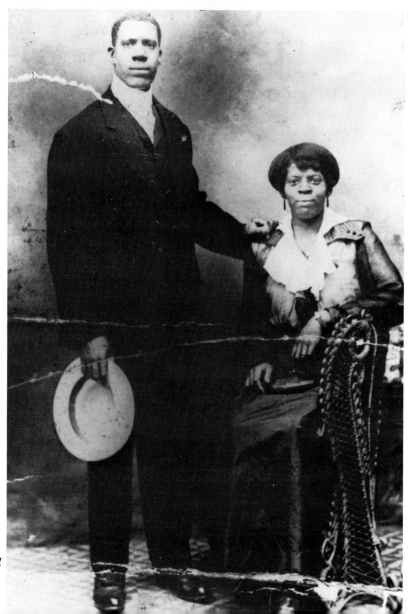

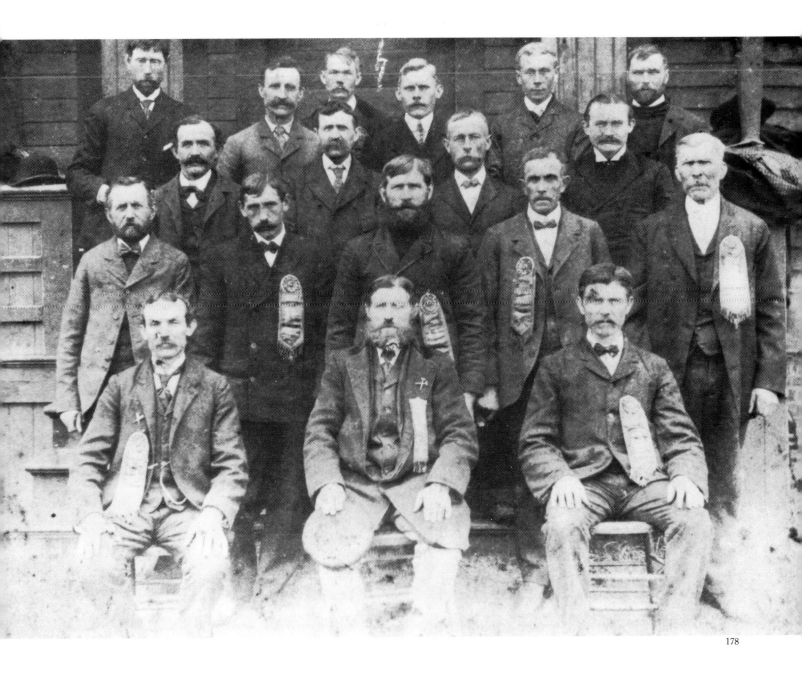

176. Jewish Association of United Brethren at Temple Dedication, Sag Harbor, 1900. New York City was the longed-after destination of many of the more than two million Jews who left Europe between 1880 and 1914. But some found the urban environment unappealing and traveled east on Long Island where they could reproduce the small-town life to which they had been accustomed. For those who had neither money nor inclination to farm, peddling was a solution. One man walked from New York to Greenport, selling as he went. Another earned enough by peddling to buy a farm in East Quogue, a place where traveling peddlers could meet and share meals of familiar food. When factories were established, some Jews took jobs there—for example, in the rubber factory at Setauket, the lace mill at Patchogue or the watchcase factory in Sag Harbor. Some became prosperous merchants, such as the Riverhead fur buyer or the owner of large dry-goods shops in Greenport. Another Jewish man became a doctor and, to the satisfaction of his neighbors, was called to treat a Ku Klux Klan leader. When enough Jewish people gathered in one place, they established a cemetery and built a synagogue. This synagogue at Sag Harbor was opened for the first service on Rosh Hashanah, 1900. *(Courtesy of Helene Gerard, from* And We're Still Here: 100 Years of Small Town Jewish Life. *Hier Publications, Box 146, Remsenburg, New York, 11960, 1982.)*

177. William and Annie (Booker) Hatcher, Riverhead, January 24, 1912. Posing proudly for their official wedding portrait are William Hatcher (b. 1890) and his bride, Annie (b. 1892). In 1920, after three children had died of influenza, the Hatchers relocated "for health purposes" from Mt. Vernon to Riverhead (where they had three more children). A cook by profession, Mr. Hatcher first worked as a farmhand when he came to Suffolk County. He eventually went back to cooking and worked at the Northport Veteran's Hospital until his retirement in 1965. Mrs. Hatcher, a housekeeper for some of the local families, was long active in the First Baptist Church. The couple still resided in Riverhead in 1984. *(Collection of Viola Campbell.)*

178. St. Isidore Society, Riverhead, 1895. Persecuted in their homeland after the partition of Poland, large numbers of Poles emigrated to the United States from 1870 onward. Although accustomed to hard work, they found it difficult to find even unspecialized jobs, especially since they spoke no English. Polish people were attracted to the Riverhead area of Suffolk because of the opportunity for farming there. On October 14, 1895, soon after a Polish community had grown in this vicinity, the men officially organized a Polish fraternity, The Polish Roman-Catholic Society of Fraternal Assistance under the Patronage of St. Isidore, the Patron of Farmers. Its pioneer members were, from left to right: first row—John Liszewski, Joseph Przyborowski, Isadore Rosko; second row—John Romianski, Bruno Panewicz, Ignatius Ruszkowski, Anthony Fafinski, Andrew Sendlewski; third row—Joseph Kliniewski, Joseph Filmanski, John Rykaczewski, Julius Kusiel; fourth row—Joseph Szuler, Lawrence Ronkowski, Bernard Balse, Andrew Sendlewski, John Romianski, John Sendlewski. Desiring to have services conducted in their native tongue, the group purchased the property for St. Isidore's Church, which still serves the Polish community in its building on Pulaski Street. *(St. Isidore's Church Parish.)*

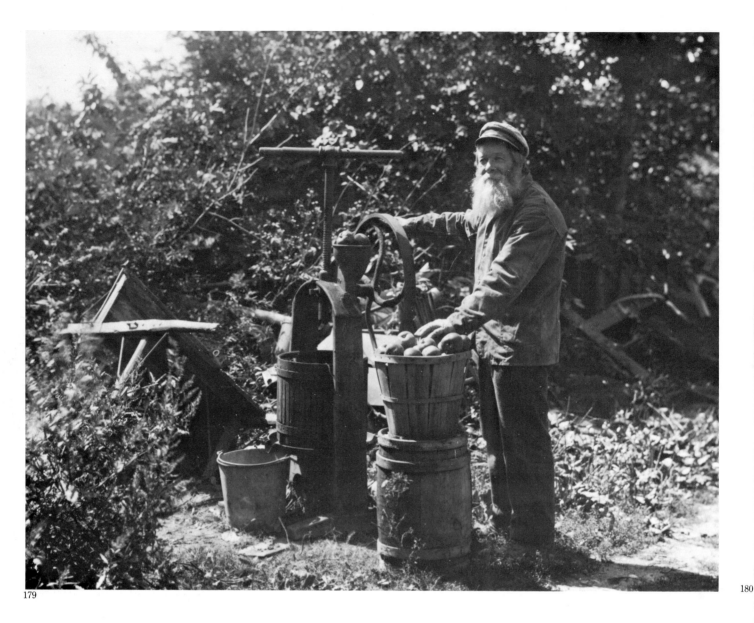

179

179. Haggerty's Cider Mill, Huntington, 1902. A pleasant occupation for a Suffolk man on a crisp autumn day was a visit to Haggerty's Cider Mill, where a half bushel of apples could be turned, by a few minutes' work, into a delicious drink. Fruits of all kinds were skillfully bred on Long Island from the mid-eighteenth century, when William Prince laid out a piece of land in Flushing for the propagation of apple, plum, peach, cherry, nectarine and pear trees. Despite a setback during the Revolution, Prince's nursery was a great success; the second William Prince enlarged it while he experimented with different varieties (the London Horticultural Society even named a variety of apple after him). Samuel Parsons, a Flushing neighbor, also engaged in the nursery business, sending young trees to farmers in Suffolk. In the 1850s strawberries were introduced in the Riverhead area, and were so successful that huge quantities of the fruit were sent to Boston in 1872 for the Peace Jubilee. *(Photograph by Hal B. Fullerton; Suffolk County Historical Society, Fullerton Collection, #L165B.)*

180. Teddy Roosevelt's Trip to Wading River, 1908. Teddy Roosevelt, who loved Long Island and was himself a summer resident, admired the energy and ambition of the Fullertons, so like his own in its prewar optimism. Hal Fullerton sits directly behind Teddy; Edith Loring Fullerton, who ran the Long Island Rail Road's two experimental farms with her husband, is at the wheel with Ralph Peters, president of the railroad, behind her. They are driving through the Long Island "wasteland" selected by the Fullertons to prove that even the worst of the barrens could be farmed profitably with know-how and dedication. When Mrs. Fullerton described their work in her book *The Lure of the Land: A Call to Long Island*, she wrote of the agricultural teaching venture: "The work of this development was given into Mr. Fullerton's hands, and I, being favored beyond most women, have been his full partner in this intensely interesting and valuable work." The Fullertons' point has been proven many times over in Suffolk County, but their energy and high spirits have seldom been equaled. *(Photograph by Hal B. Fullerton; Suffolk County Historical Society, Fullerton Collection, #5406.)*

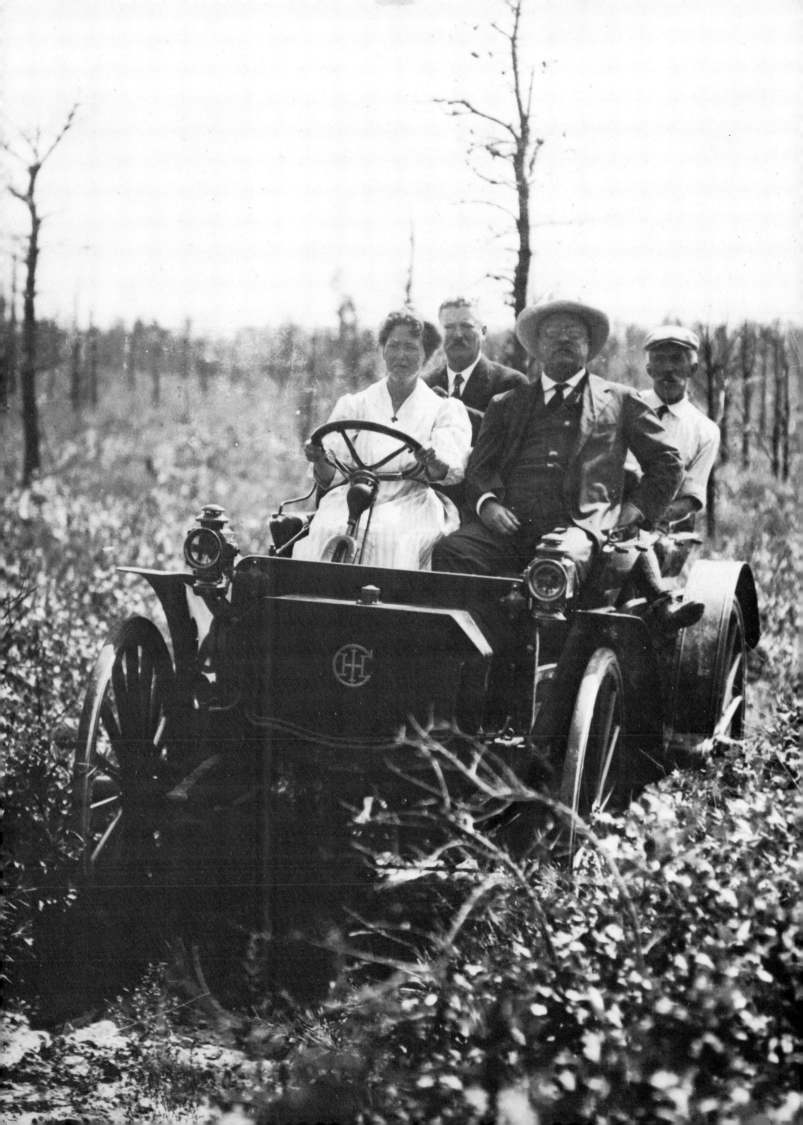

181

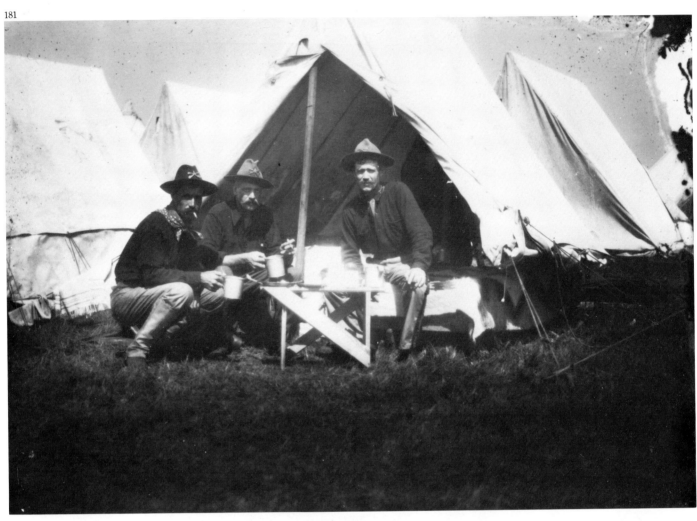

182

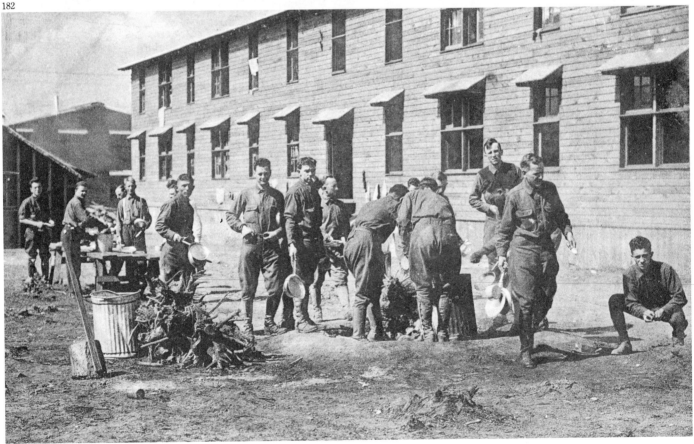

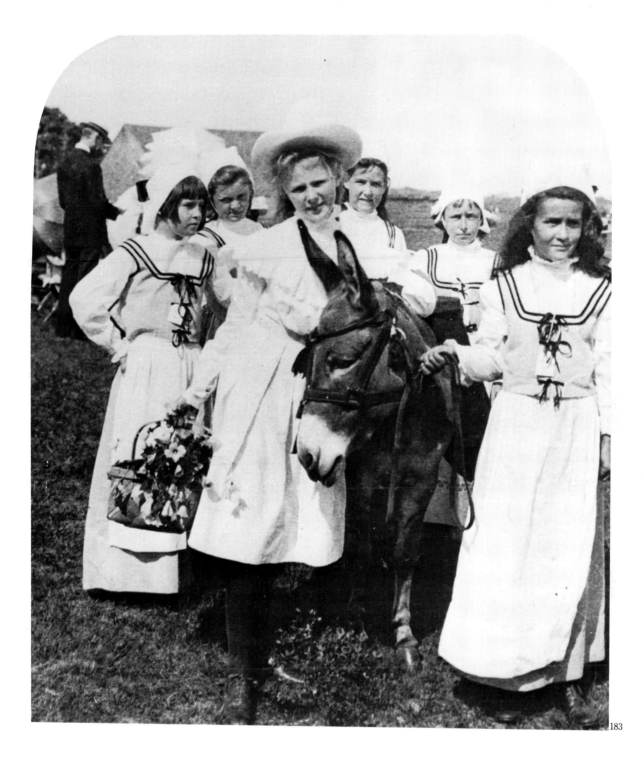

183

181. English, Irish and Texas Sergeants at Camp Wycoff, Montauk, 1898. During the Spanish-American War, the flat Hempstead plains of Nassau County were used for training troops at Camps Black and Mills. The military camp in Suffolk, Wycoff, was located at Montauk. Caught in a rare quiet moment, these sergeants are relaxing in front of their living quarters. When President McKinley, himself a Civil War veteran, heard that the soldiers were not receiving adequate care at Camp Wycoff, he personally visited the wounded veterans there in September 1898. Nevertheless, 263 men died at the camp. The survivors were brought to New York aboard the *Shinnecock* in an exercise that occupied 22 days. *(Photograph by Hal B. Fullerton; Suffolk County Historical Society, Fullerton Collection, #1069A.)*

182. After Mess, Camp Upton, 1918. The greatest impact of World War I on Suffolk was the construction of Camp Upton on a tract of about 10,000 acres at the site now occupied by Brookhaven Laboratories. During the very hot and rainy summer of 1917, up to 15,000 men worked to rush the completion of the camp; by the end of October, about 30,000 soldiers had been sent there. A two-mile spur from the railroad line to the camp provided a direct link for troops and their visitors to and from New York. Broadway

entertainers traveled to perform at a theater on the campgrounds. Irving Berlin wrote his famous "Oh, How I Hate to Get Up in the Morning" at Camp Upton (the song appeared in the musical, *Yip, Yip, Yaphank*). After the camp's purpose had been fulfilled, its buildings and equipment were sold at auction in August 1921. The land was retained by the government. *(Lightfoot Collection.)*

183. "Peanut Girls" at the Maidstone Club, East Hampton, 1904. Maidstone is the county seat of Kent, in southeastern England, and as the old home of many settlers, it was adopted as the informal name for East Hampton in the early period. The Maidstone Club, a resort and golf course, was founded in 1891. It grew in popularity with the rise in summer visitors to East Hampton after the arrival of the railroad in 1893. A fire destroyed its splendid building in 1901, but it was rebuilt at the cost of $50,000. The five "peanut girls," young debutantes tagged for some summer event, attend the girl in the center. The Maidstone Club, located right on the ocean south of Hook Pond, is still a golf resort. *(Photograph by Underwood & Underwood; Lightfoot Collection.)*

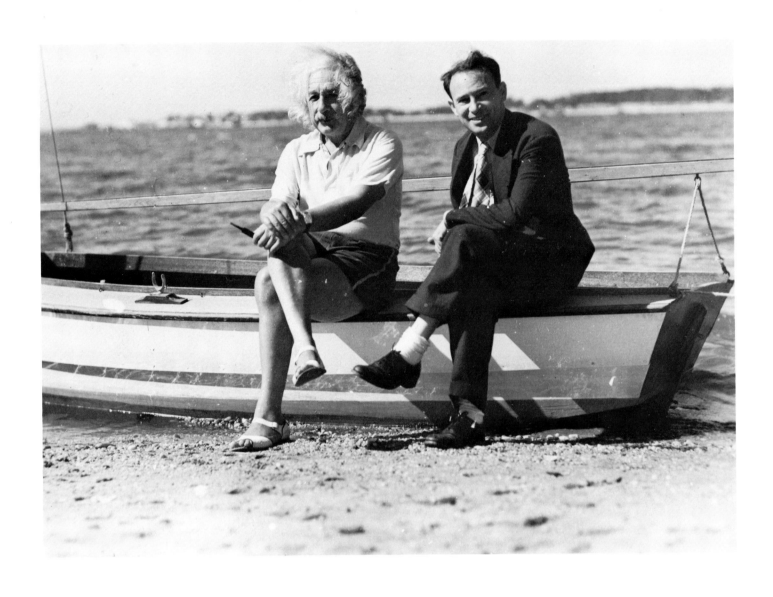

184. Albert Einstein with David Rothman of Southold, 1939. In 1939, the year Einstein came to vacation on Long Island with his sailboat *Tinef*, he was visited by three atomic scientists—Eugene P. Wigner, Leo Szilard and Edward Teller—who sought his endorsement of an atomic-bomb project. From a cottage at Nassau Point, Einstein wrote his now-famous correspondence to President Franklin Roosevelt advocating the development of the atomic bomb. Einstein befriended David Rothman, owner of a Southold department store, who shared his interest in music and philosophical discussions. The two men went sailing together and, after Einstein left Long Island, kept in touch, coordinating efforts with refugees. A cultural leader in his community, Rothman was also a friend of musicians Benjamin Britten and Peter Pears and helped to establish the local Concert Association. Rothman died in 1981. *(Rothman family album; Lightfoot Collection.)*

INDEX

This index lists persons (including photographers named in credit lines), businesses, buildings, ships, constructions, monuments and estates mentioned in the captions to the illustrations. Villages and land locations cited in headings are included; streets, neighborhoods, rivers and other sites are not. The numbers used are those of the illustrations.

Rwm